talking
pictures

A Lookout Book *In association with the International Center of Photography, New York*

talking

people speak about the photographs that speak to them

pictures

Marvin Heiferman **Carole Kismaric**

CHRONICLE BOOKS

SAN FRANCISCO

To Sylvia and Chuck,
who knew the importance
of pictures and liked
to hear a good story.

The *Talking Pictures* exhibition and its national tour
are sponsored by Philip Morris Companies Inc.

The exhibition and its national tour of *Talking Pictures* are orga-
nized by the International Center of Photography and curated by
Marvin Heiferman and Carole Kismaric.

Printed and Bound in China

Library of Congress Cataloging-in-Publication Data
Kismaric, Carole, 1942-
 Talking pictures: people speak about the photographs that
speak to them / Carole Kismaric. Marvin Heiferman.
 p. cm.
 includes index.
 ISBN: 0-8118-0382-1. —ISBN: 0-8118-0376-7 (pbk.)
 1. Photography, Artistic. I. Heiferman, Marvin. II. Title.
TR183.K57 1994 93-31740
770'.1—dc20 CIP

Talking Pictures is a Lookout Book, developed for Chronicle Books
by Marvin Heiferman and Carole Kismaric, Lookout Books, New
York.

Distributed in Canada by Raincoast Books, 112 East Third Avenue,
Vancouver, B.C. V5T 1C8

10 9 8 7 6 5 4 3 2 1

Chronicle Books
275 Fifth Street
San Francisco, California 94103

CONTENTS

Stare. It is the way to educate your eye, and more. Stare, pry, listen, eavesdrop. Die knowing something. You are not here long.

Walker Evans

EVERY PICTURE HAS A VOICE

Marvin Heiferman
Carole Kismaric

Every picture has a voice. Some have volume switches you can adjust, like the images that parade across your television screen day in and day out. Some scream at you with the hurricane force of multiple speakers and digital sound at the multiplex movie theater in the mall. But still photographs talk, too. They grab our attention and challenge us by saying, "Look at me. Buy me. Remember me. Be like me." If every photograph has a job, it is to say something. The picture on your passport gets you across borders. What you see on the outside of a food package is supposed to tell you what's inside. The way world leaders pose for a news photograph at a summit conference tells you who is really in power.

In every decade of the twentieth century, more cameras, better cameras, simpler cameras, and cheaper cameras have created an endless stream of pictures: moving pictures, wire service pictures, color pictures, television pictures, 3-D pictures, and instant pictures. But most of us can remember when pictures were innocent and there were fewer of them. When getting your picture taken was a special event. When snapshots were carefully pasted in albums, rather than glanced at once at the photo processors and then tossed in a drawer. When magazine covers pictured something you had never seen before, rather than the same three supermodels' faces. When you anticipated a television show, rather than scanned sixty channels to find one to distract yourself. When looking at pictures told you about a world you could aspire to, rather than buy. When movies landed you in Shangri-La, not in the death seat in a car chase. When you never, never worried about a picture being manipulated. Once we stared at and savored pictures, because they made fleeting life feel permanent. Don't misunderstand, we're not longing to return to the past, but it is clear to us that not only have more pictures entered the mainstream, the way we look at and use pictures has changed.

No longer do we live life and then document it in a picture. Photographs themselves describe the life that we are supposed to be living. Pictures have changed the way we see ourselves and our very consciousness. And if our literacy rate has gone down, our visual literacy has increased, because in our culture our desire for pictures is insatiable. We've come to rely on pictures that speak faster, louder, and clearer than words. We are so surrounded by pictures, so dependent on them, that it is impossible to imagine a world without them.

We don't just look at pictures, we pose for them, make them, respond to them, interact with them. We hate pictures that say what we don't want to hear—that we're too fat or that there are dead bodies across the street, on the other side of town, or on the other side of the world. While we walk right by certain pictures, we cherish others for the memories and experiences they make available to us, and for how they can still register history as the world changes.

Living in this image world, the idea for *Talking Pictures* came to us. Because of our lifelong respect for and love of photographs, we wanted to find out if there were, for each of us, pictures that do not disappear, pictures that mattered because we could not, or would not, let go of them. So we decided to talk to people about the pictures that were important to them. If it is true that photographic images have changed our lives, we wanted to know why. How have photographs shaped our personal histories and our collective imagination? How do we read pictures? What do we read into them?

And so, for over one year, we interviewed people. Some of them are famous and influence or reflect our contemporary world. Some are people who make pictures or who were made by them; others use photography as a tool or for pleasure. Some are just like us, people who look at pictures every day. We asked each person to come up with the one picture that mattered most. The image that seduced, inspired, taught, frightened, amused, offended, obsessed, informed, or provoked him or her. We made it clear that the picture could come from anywhere—from a family album, a movie, an advertisement, television, a newspaper, even from a matchbook. But from all the pictures in the world, we were asking for just one.

We learned quickly that we were asking for a lot. Some people could not think of a single picture and said simply, "No thanks." A few people hung up after telling us that they had seen so many pictures, there was no way to pick just one. For some people a photograph came to mind instantly, while others wrestled with their choices and took weeks or months to make their decision. Others answered the question conditionally, making it clear that what they picked was the picture for now, but if we asked them next year, they might select a different one. Some people took our question as a challenge, others as a test, others as a game. But when it was time to talk, people did so seriously, and they showed a real commitment to unraveling why they chose one picture over all others.

Every person included in *Talking Pictures* took a risk. We never knew how much people would reveal of themselves, how willing they would be to let go, to follow the avenues, associations, and feelings that a picture could provoke. Sometimes the tiniest part of a picture—a detail or a gesture—led to a deeply felt truth or conviction. Every picture turned out to have layers—emotional, intellectual, and social. Helping to peel them back was a joy, because we proved to ourselves that pictures are as important to people as we believed.

We interviewed people informally, in many cities, in offices, homes, and restaurants, and only on a few occasions over the telephone. Sometimes the conversations felt like therapy sessions, because a good interview is a process of discovery built around trust. With the picture in front of us, we talked for hours about what it was about, where it came from, what it meant, what it suggested, and why it was unforgettable. It was fun, and often a challenge, to sit with a stranger and talk about a single picture for ninety minutes. Sometimes it was hard to find the right words to express what a picture was saying. There were eerie periods of silence when we'd wait for a picture to send out a spark. Since we weren't after sound bites, we provoked a three-way conversation between the person being interviewed, the picture selected, and ourselves. And we always got hooked, because there's nothing like hearing a good story. We could never predict whether we'd be laughing or crying over something we were hearing. Every interview, like every picture, took us on a journey.

The pictures selected still surprise us. Almost no art photographs were chosen, because in most instances, what a picture was about was more important than its aesthetic qualities. There are far fewer famous or historically important pictures than we expected. In a world where most photographs are in color, we are stunned that so many people picked black-and-white pictures. When we asked why, we were told repeatedly that they leave more room for the imagination. Nobody picked a sunset, a waterfall, or a field of flow-

ers. When push came to shove, beauty was not terribly important. We still cannot believe that in a world dominated by television, not a single person picked a TV picture, even though many people describe how the media has changed our lives. And no two people picked the same picture, even though there are photographic icons that touch all of us. And if some pictures were selected because they are so clear, others were chosen for their maddening ambiguity.

All of the people interviewed chose the photograph that was, in its essence, them—what they stand for. People say there are no role models left, but heroes and heroines are alive in pictures. These photographs show us people who know how to live and die, whose strength can be read in gestures and in their eyes. It is said that we have lost track of history, but iconic pictures don't let us forget the nightmarish cruelty of war, or how individuals make history as they fight for human rights. We are told that pictures lie and some do. But some are the only and absolute proof that what is in the picture was really there. People say that you don't know what you can't see, but luckily, pictures can make some mysteries concrete, whether in a science laboratory or in spiritual realms. The pictures selected are metaphors for subjective, complicated emotions, probably because they describe the best and the worst of human nature.

Talking Pictures demonstrates that people are a lot smarter about pictures than they are given credit for. Each of us knows how to unravel the messages packed in pictures, and how pictures are used to inform, manipulate, and distract us. As we flip one magazine page after another, as we trade in our cameras for camcorders, as we grip remote control units in our hands until we fall asleep, as electronic and digital imagery threaten to put photographers on permanent unemployment rolls, *Talking Pictures* is a reminder that a single picture has the power to stop us in our tracks and reveal to us just who we are.

I've always delighted most in my work in television, in wishing to, hoping to, and, perhaps, being able to bring an audience to its knees. If they're gonna laugh, they're gonna laugh. If they're gonna feel, they're gonna feel. *This* picture brought *me* to my knees. It calls up feelings at the extreme end of "sweet," "hope," "love," "faith," "peace." I saw it for the first time in the fifties in the book *The Family of Man.*

The mother's got a wonderful face, and the baby has a wonderful ass. From the first time I saw it, I felt a kind of ultimate sweetness. In fact, I can't imagine a sweeter moment, or a sweeter depiction of a moment. It is the moment of a mother's spiritual, emotional recognition of a child. I've always assumed the child's eyes are open as the moment's evolving. There's something so deep here. The umbilical connection is a look, and that look is so powerful. They are separate individuals, but they are so tied together, eye to eye.

You know, there's a wonderful, ancient piece of wisdom—I don't know whether it's Talmudic or Hasidic—that goes: "A person should have a garment with two pockets. In the first pocket there should be a piece of paper on which is written: 'I am but dust and ashes.' In the second pocket there should be another piece of paper on which is written: 'For me the world was created.'" It's that *second* piece of paper that's so important, because we are all, at least when we think about it, aware of how insignificant we are in the great scheme of things. It is harder to recognize that we deserve much of what we want, which is something I believe to be true. This mother could be thinking, "It's created for you, sweetheart. It's created for *you.*" And it *is.* If you think about it, you can't open your eyes or look at anything in this world without thinking, "Hey! It's there for me. It's there for *me.*"

Certainly this child is about innocence. But for me, the most telling, the bigger part of human nature, is what happens to us after we leave the state of being an absolutely pure being, and grow to be this mother. For her, this moment is as pure as any, but she also *suffers,* as we all do, between such joyous moments. She suffers with the same problems that make us all forget the purity from which we originate. Moments like the one in this picture are there so rarely, but they are there far more than we're able to experience them. The great challenge is to find a way to live in the moment and experience *more* of them, but to say that becomes so cliché.

I'm convinced that people are born basically good, but it is so bloody difficult to be a human being. Evil grows out of the complexity of what we become after we're born. For some reason, the challenge is just to get *through* it. Because, no matter how much we have of everything, we can't stop from making ourselves unhappy. We do it to ourselves too much of the time, and if it happens only a *bit* of the time, it's too much, given the bounty that's out there.

This picture has always stayed in my mind. I can remember looking at it at various times in my life and thinking, "God, will I ever have this in my life?" Because the mother looked so at peace, and, actually until seven or eight years ago, I never thought I *would* ever see or find a person who represented as much peace as is in this picture. I have, by the way, but I couldn't believe it would happen to me.

I've spent forty years writing, and most of those years being fairly successful, but when I sit down to write again, I'm as nervous about it, as unconvinced that I can do it, as I was the first

Mother and child, New York, 1951. Elliott Erwitt

NORMAN LEAR (b. 1922) is a television writer, director, and producer whose hit television series include "Mary Hartman, Mary Hartman," "Maude," "All in the Family," and "The Jeffersons." He founded People for the American Way, an organization opposed to the Moral Majority.

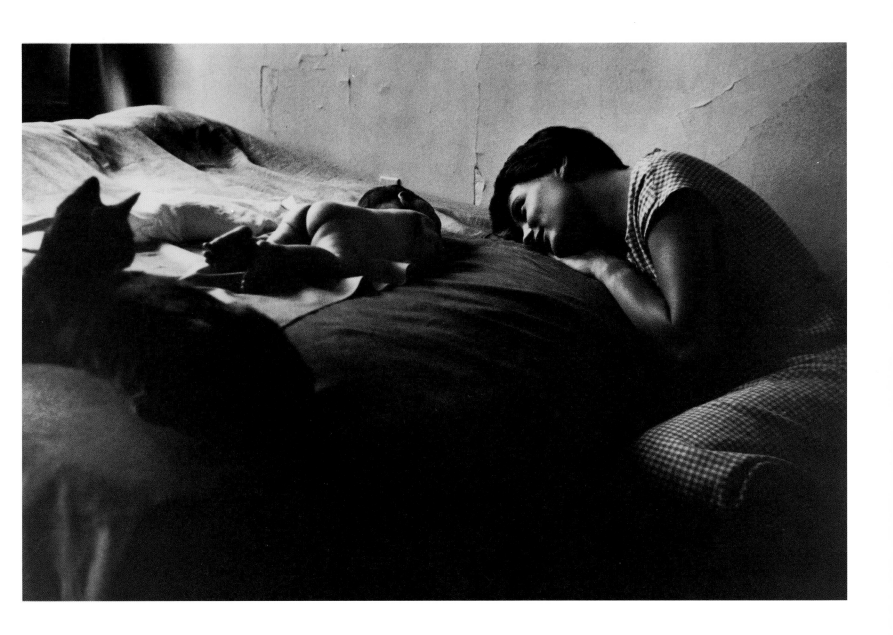

year I was attempting to write. Who knows what that is? *That's* the challenge of being a human being. I've always said that, for me, my shows, at their most dissonant, at their loudest, are celebrations of life *and* family. I've done moments as quiet as this one on television. I can show you scenes from "All In the Family" of Archie and Edith in bed, when she thought the way to get Archie out of his problem was to make love, and he was so deep in his concern about not being able to provide for the family, he couldn't. There were long moments of *such* sweetness in all kinds of situations. That was the big joy of that show, getting laughter and tears side by side. On the way to tears, there were moments like you can see in this picture, some of the greatest moments for me. Those are the moments when you wring the most juice out of life.

In the third episode of "All In the Family," Edith is looking at some photographs of Michael's friend's trip to London. "Isn't this *interesting?*" she says. Archie looks at a picture of two people on a London street and says, "What Edith? They're *strangers!* What *is* it?" "Imagine," she says, "the photographer snaps the picture, and a second later, they was all *moving* again. Then maybe she went home to dinner, or to the store to pick up something—and *he* went to pick up his kid from ballet school because maybe she was crying..." Edith goes on about the picture until Archie flips. I'm like Edith. I've never looked at a still picture when I haven't thought about the subject or subjects *after* the shutter snapped. It is just like passing by in a train, looking out the window, and wondering who lives *there?*

The word *still* in still photograph is very significant. You can spend time with it. Even if it's diabolically threatening, you can spend time looking at it. I've always had a fascination with still pictures. *This* picture is a kind of meditation, ultimately the most quiet meditation. If everybody in the world could or

would meditate ten or twenty minutes a day, my guess is this would be an entirely different world. Slowing down all the systems of the mind and the body for twenty minutes a day is wonderful. I struggle to do it because it makes such common sense to me. I try, but I've never successfully done twenty minutes. I know people everywhere who do it, and they are not people who will ever shoot anybody or kill anybody. It would also be a different world if everybody felt the way this mother does about her child, and if everybody looked at things as carefully and as lovingly as this mother.

I turned seventy recently, but what I'm about to say doesn't have anything to with age or mortality. I've become increasingly aware of the joy I feel in the search for meaning, for understanding. I'm constantly reminded by seeing an old rerun of something I did twenty-five years ago, or meeting an old friend, or spending an evening with someone who knew me when I was thirty-two, or being reminded of places in my life where my capacity for this kind of love was there all the time. There are constantly striking reminders of the fact that love is congenital, that it was always there, and this picture is one of those reminders. Why would I have picked this picture after all those years—thirty-eight years—but for the fact that what I recognize as one of the great joys of life is something that was stirring in me back then.

I lived on a ranch until 1942, and there were just no pictures around. When my family moved to Archer City, Texas, the town in *The Last Picture Show,* there was not a great deal of visual material available either. There were just the little comic magazines you got in Sunday school, which were Biblical in nature and not very inspiring.

There was only one drugstore in town, and the magazines they got were *Life* and *Look, McCalls,* and *Ladies Home Journal.* Maybe *Field and Stream* or *Sports and Field,* and one or two movie magazines. The first significant photograph I saw was a magazine cover of Jeanne Crain, and it probably was between 1944 and 1950. Say you were looking for something in the way of beauty when you were a kid around ten. It was likely to be images of women; at least it was in my case, the ones I could find in the drugstore, or at the newsstand in Wichita Falls twenty-five miles away.

I went to that drugstore every week to see the new magazines. Naturally, I was drawn to beautiful actresses on the covers of the movie magazines. It's hard to say exactly why I was struck more by Jeanne Crain than, say, Jane Russell. I suppose I imparted a superior sensibility to Jeanne Crain, which she probably had. There are subtle, socioeconomic distinctions. It also must have had something to do with potential attainment. Jane Russell seemed unobtainable, so unreal you could not start to think about "obtaining" her. There was an element of exaggeration about her that I didn't like. It put me off somehow. I definitely did not like the harder blondes like Lizabeth Scott or Gloria Grahame. On the other hand, I didn't like extremely soft, June Allyson or Doris Day types. Too fluffy, too silly.

This was not true of the slightly more homey, more domestic women like Jeanne Crain. Or even Esther Williams. But I

wasn't much of a swimmer, because I'm blind when I take my glasses off. I could never catch Esther Williams in a pool. Jeanne Crain seemed to have a level of dignity and grace that was in between the sex symbol type and the giggly blonde.

The first Jeanne Crain movie I saw was *Pinky,* and that wasn't until 1949. I remember feeling I hadn't been misled by her photograph. When I saw her move, the photograph, in a sense, came alive, and I was satisfied. She embodied beauty of a type not common in Texas, or in our town at least. Now, I suspect I did have one crush on a woman not unlike Jeanne Crain. But, as the mother of three of my closest friends, there was a barrier of sorts. It was easier to fantasize about Jeanne Craine, although I don't think I imagined myself having a life with her.

There was an irritating paucity of imagination in the way the movie magazine covers were designed. So I'd always flip to the stories, hoping to see a person standing up rather than sitting on a diving board, or in the backyard with her husband, or in a convertible. I went for those stories, but I didn't read them to find out who someone's boyfriend was, or how many times she'd been divorced. I just wanted to look at the women, to see any little detail—what their houses looked like, the kind of furniture they had. I was already extremely dissatisfied with my environment. I knew everything was bad. I knew the furniture was horrible. I knew the lighting was bad. I don't know *how* I knew. I was only a little cowboy at the time.

As a kid, I had no friends to talk with about this. They were looking at sports magazines, if they were looking at magazines at all. I don't know what they were doing or thinking, but I had no sense of whether everyone in town was turned on by Jeanne Crain or not.

LARRY MCMURTRY (b. 1936) is a Pulitzer Prize–winning novelist whose books include *The Last Picture Show, Terms of Endearment,* and *Lonesome Dove.* He has written screenplay adaptations of his work, as well as original screenplays for motion pictures and television.

When I got old enough to start collecting, I remembered certain pictures, and I searched out and acquired many of them. When I was in my early twenties, there was a store in Dallas that was influential in my life. I went up there looking for movie magazines, but instead came out with my first literary magazines, issues of *Broom, Transitions,* and an art magazine called *Tiger's Eye.* I was seduced away from movie magazines quickly. From looking at magazines in that one drugstore, I now own fifty thousand books and have an incredible number of magazines, mainly just for passing the time visually.

I find it disturbing—very jarring—to see people I know on magazine covers, like Diane Keaton or Cybil Shepherd. I don't recognize them. I don't want to look at them, or have them around. It disturbs me in some way—not that it's deeply traumatic, or something I'm losing sleep over. But there's a tension between what I know about these women and the way they're presented in images. You can't say it's misrepresenting or distorting. It's interrupting the motion of a person and stopping them at a particular, contrived moment in an artificial way. If you are interested in the motion of a person, you don't want to see them stopped.

I think about this idea a great deal because I must have taken fewer pictures than almost anyone alive. I doubt if I've taken ten snapshots in my life, and then only if someone thrusts a camera in my hand and says, "Take a picture of us." Like my mother and father did on their anniversary. I really don't like to take pictures, and I'll tell you something else. I don't like to have pictures of people I know either, because I want to *remember* them. I have one little box of photographs that represents fifty years of the life of my family, all the women in my life, and the children in my life. My memories of someone I know intimately are much fuller than a photograph. I suppose

I resent the diminution. I'm even very reluctant to be photographed. So I don't take pictures and I don't keep pictures. I can't think of anything I can't remember that I would rather have a picture of.

Film Album magazine featuring Jeanne Crain, Fall 1948. Frank Powolny

FILM ALBUM

15¢
FALL
ISSUE

JEANNE CRAIN

Einstein! The real Einstein!! I've seen real pictures of him since I was three years old. They made this picture because he was one of the most famous men in the world, a scientist, a writer. Famous.

Einstein lived a long time ago, maybe forty years. He's probably about eighty in this picture. Well, maybe seventy-nine. In one week, it will be his birthday. He wants new pens, new pencils, new sketchbooks, more pads, folders, and a pencil sharpener for birthday gifts. He looks like he was born in July.

I like his face, his mustache, and the color of his eyes. His hair's about six inches long; he could put it in a ponytail. He looks mostly handsome and a little not. He looks smart, too. He liked having his picture taken. I think it was made in his house, at night, at one A.M. He was by himself, because his wife went out shopping. He decided he wasn't going to smile. He didn't want to wear a sweatshirt for the picture; he wanted to wear a tuxedo. But he had to wear the sweatshirt because the photographer thought it would make a better picture. Einstein wanted to look handsome, but the photographer talked him out of it. He said, "If you wear a sweatshirt, I'll give you forty bucks." That's a lot. So he was paid to be in the picture.

Einstein looks mad. I don't think he had a sense of humor. I read a book about him. He never told jokes, but he did chase chickens and tried to make friends with them. He'd play with blocks, leaves, and the violin, and he snipped off his sleeves. His shoelaces were untied all the time, because he was always thinking about something else. They threw him out of school, because he didn't memorize his lessons. He wasn't interested.

That looks like a new pen he has, a pen you'd have these days. Did they have metal when he was alive? I think he was think-ing about writing when they took this picture, or maybe about infinity. I'm interested in the idea of infinity, because it's the highest number of all. It's not really a number. Nobody can say that number by counting. You'd count forever. I like the idea that things can go on and on and on, like people and blocks.

STEFAN BONDELL (b. 1981) is a student at Saint Ann's School in Brooklyn, New York. He enjoys painting, photography, writing, soccer, tennis, and dance, and plans to be a film director. He was interviewed when he was six years old.

Albert Einstein, 1947. Phillippe Halsman

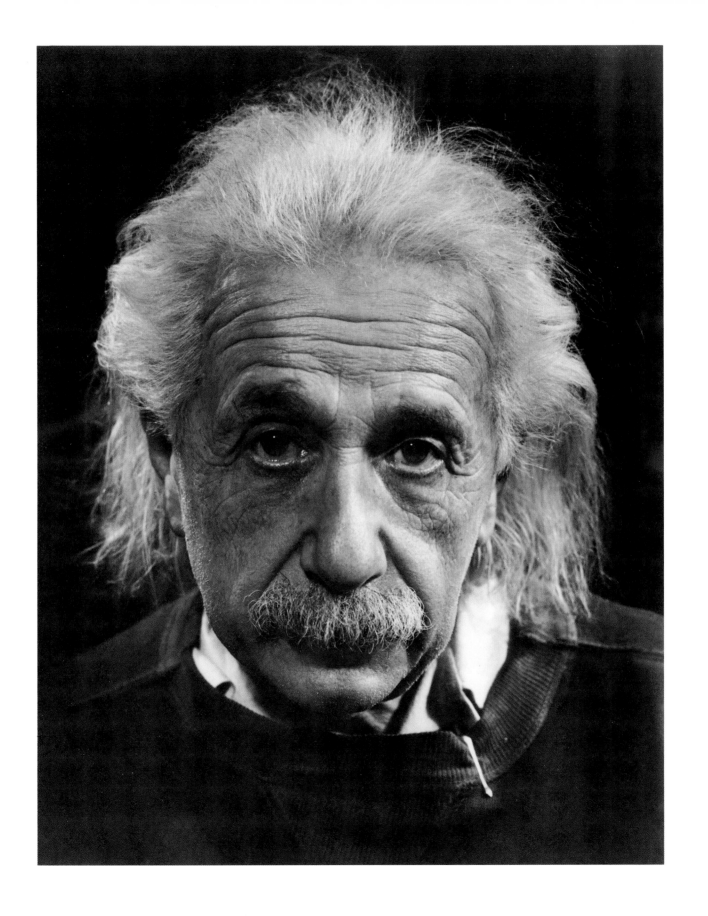

I really started listening to rock music a long time ago, around 1980, when I was in the sixth grade. My older brother was into music, buying albums, and going to concerts. My parents were into music, too. They liked Barry Manilow, Barbra Streisand, and Neil Diamond. They drove us to concerts and cut our T-shirts up. When MTV came out, we were one of the first families to have cable. A lot of our friends in the city would come to our parties. Back then, MTV was all rock and roll, and Saturday night was the good night. We'd tape it. That's how we'd see people perform.

Music was something to escape to, probably. I wouldn't study homework. I'd come home and study the words of songs, because they were more important to me. I could relate to them better. My parents put up pictures of movie stars on our living room walls. My brother put a lot of record album covers up on his walls, and I had lots of posters in my room. They symbolized "This is us, this is what we're into." I was in love with David Lee Roth back then. It lasted five or six years.

When I get interested in someone, I want to be surrounded by lots of pictures of them. I want to be able to see them, to have them near me. I pick up on their expressions. I pay attention to their looks and their attitude. I feel in tune with them. Who knows what they're really like? I don't feel like I know them through pictures, but what they're showing me in a picture, I like. I read about them, listen to them, go to concerts. I get to *know* them at concerts. Especially Axl Rose. He's out there, screaming to a million people, "Fuck off, I'm not going to take that shit." He is just playing great music, just getting it out. He'll talk about anything he wants. He represents how I feel. That's what I love about him. He's original, has courage and confidence. He's *honest*. My door is covered with pictures of him! Pictures of Axl with the attitude.

Axl's pissed off at the world, and he's not afraid to tell people. He's rebellious and *real* angry. He gets criticized every day because people don't like his attitude, but he's had a lot of rough things happen in his life. His family and childhood pissed him off. He's got problems with his life, and he works on it. He's got a therapist who goes on the tour bus with him. Music's like therapy for him, getting it all out. I do the same thing. I get it out when I go to concerts and shows. I get together with my friends and the band and the music, and we slam around, whatever, but I get it out! The day after I've gone to a concert, I go to work with these straight bankers, full of energy, and I bounce off the walls all day. Music's my release. Axl's music touches me inside. It gets my aggressions going. It makes me aware of the feelings I have.

When I first heard Guns N' Roses, I knew something new was happening. After David Lee Roth left Van Halen, there were no bands for years, nothing new was out there. At first Guns N' Roses just sounded *different*. It took a while to get used to it. Whoa! Wake up, catch up to this. There was energy there. When I saw pictures of them in a rock magazine, I thought, "Who *are* these guys?" They look good. Rebellious. They've all got long hair that they don't brush for anyone. They wear sunglasses. No one smiles, because they don't give a shit. When they want to, they do. It's freedom. You do what you want to do. You are who you are.

When I first saw Axl on MTV, I thought he looked kind of ruthless. I always go for singers, though. They expose themselves more. So I said, "Got it!" Then I got the album and wanted to see him live. So I went to see Axl at a fund-raiser put on by a local radio station. People were just nuts, slamming

GINA GRECO (b. 1967) works as an administrative assistant in the corporate headquarters of Great Western Financial Corporation. A Guns N' Roses fan club member since 1987, she is active in the Los Angeles music scene.

Axl Rose, The Ritz, New York City, 1988. Larry Busacca

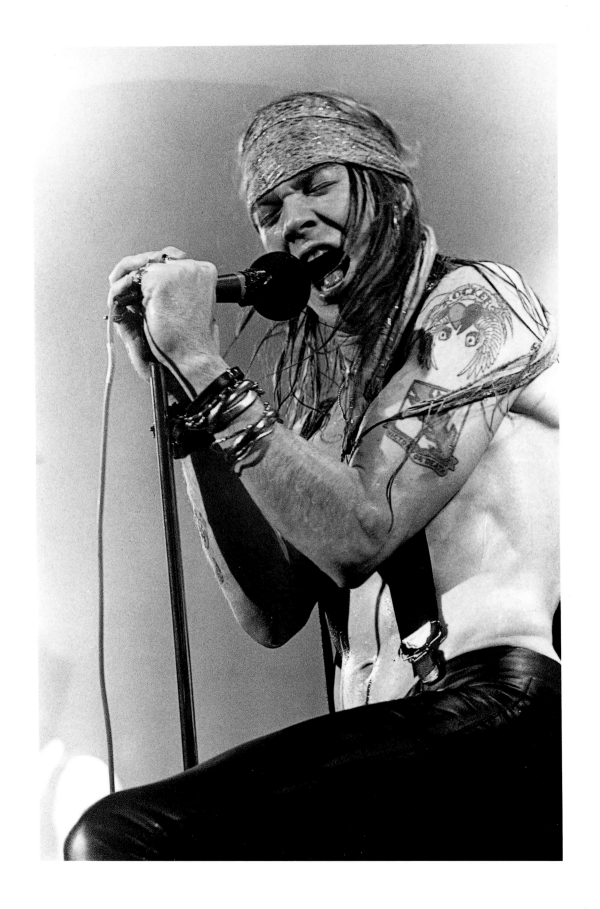

into you. I went up front and Axl was right there, screaming in my face, just being who he is. I needed that. He had a light blue bandanna on, and was right down in the crowd, screaming into the mike. I liked the way he looked. He's got a real baby face. He can look sweet if he *wants* to. I'm sure he's a decent human being. He's very sensitive. He seemed much more alive than he did in his photographs.

Axl's attitude is like my attitude. My parents didn't lie to me, and they didn't criticize me. I was able, pretty much, to be who I wanted to be. They were separated when I was sixteen, and my mom moved out. Before that they weren't home all the time, so I was pretty much an adult by the time I was twelve. Guns N' Roses represents my world view, which is fuck off, don't touch me. There's a song of theirs, "Welcome to the Jungle," that goes, "You can have anything you want, but you better not take it from me." Their songs are about living life at the edge—sex, drugs, satisfaction, craziness, pain, loneliness, anger, survival—real life situations. And there is a lot of love in the songs that they sing, too, and you need love, definitely. Love makes life worthwhile. Life's hard to know. I've gotta find reasons all the time.

When I go the office, I have nice conservative dresses, heels, and nylons. I have to do that. I play a different role than when I go out to hear the bands. That's where I'm more comfortable. Those are my people. I wear cut-off shorts, fishnet black lace, boots, concert T-shirts, some kind of little tank top, or little tight skirts to show off my body. When I go to see Guns N' Roses, I wear my garter belts and little bustiers. I always wear black.

I have pictures all over my house and a lot of snapshots in my photo album. They're pictures of my brother, all of my friends,

and me when we were young, and when everyone just started dying or going to jail. I know so many friends who died or went to jail. One friend of mine got shot and killed over a drug deal. Another got stabbed in a fight and died. Another killed someone and went to jail. A boyfriend of mine broke into the principal's office in junior high and stole a BB gun. He was running down a creek, when the cops called out, "Stop," and he turned around with his little BB gun, and they blew him away. I cried for a day straight. That's where my anger comes from. You know, when you're growing up, you think the world is a fun, safe place to be. It turns out it's *not*. You can't do what you want, you can get killed. Then people turn on you.

You can see how hard it is to put it all in one picture, but this screaming one is the picture that represents Axl for me. It shows his rebellion. He's got a lot of jewelry and heavy chains. He's wearing leather pants and his headband. You can see his tattoos. This picture will probably scare a lot of people. He looks like a wild monster, like he looks at every concert. Maybe he's screaming, "Welcome to the Jungle," or "Don't Damn Me," or "Fuck off." He's angry, and he's not afraid to show it. He's giving out that energy, just being himself.

At 3M, we make everything from glues and magnetic coating to synthetic ligaments. The company is hugely diversified with about fifty divisions that share technology information. With a lot of new ideas, you don't have the words to describe it. You need to *see* a technology before you can think of other ways to use it. So we have a lot of show-and-tell events, where anybody can get up and talk with someone else. We encourage networking. Everyone can spend fifteen percent of their time working on whatever they choose in technical and marketing areas. So most new products come from somebody who has a particular set of skills, who can see what nobody else sees. It's *seeing* the unperceived need that's the trick of invention.

In 1983 I won a Carlton Society Award which is like winning the Nobel Prize. The award reads, "Arthur L. Fry, for the novel and creative approaches to the development of products based on his repositionable adhesives and for his tenacious dedication and commitment to the program that resulted in the Scotch™ Brand Post-it™ Notes." Tenacious, huh? The difference between tenacity and stubbornness, or genius and crackpot, is the difference between success and failure. I was stubborn until I became a success. Then I became tenacious.

When I was a kid, I was always making things. We lived in a little town in Iowa. It was before TV, and we did things to amuse ourselves. I'd build small things, put them in the fireplace, and start with another batch. Dad would take me to the dump, and we'd bring home stuff, tear it apart, and put it together in different ways.

I started at 3M as a summer technician in 1953 when I was still in school, and asked, "Can I invent things too?" And my boss said, "Sure." But I found out that inventing a successful product is difficult. You can't fool customers. They may buy your

product the first time, but if they're going to buy it the second time, or the thousandth time, there's got to be a real need for it. I couldn't invent Post-it notes on my own. I needed the help of polymer chemists, special engineers, packaging people, marketing and sales people, patent liaisons, and cost accountants. We had to put together a team and start building that baby from scratch as a business.

Post-it notes started as a technology looking for an application, a solution looking for a problem. A colleague, Spence Silver, in the central research laboratories, was looking at ways of improving the properties of pressure-sensitive sticky adhesives. Remember our old cellophane tapes, how bad they were? How brittle they got? Well, when Scotch Magic™ Tape came along in the 1960s, it didn't do that. Spence's assignment was to make adhesives even better. So he came up with a liquid that was full of little adhesive particles. You could coat it on a film and have the particles laid out like sand grains, shoulder to shoulder, or you could coat it so the adhesive particles were separated. Then you got something that didn't stick as strong. You'd coat it on something, then press that against something else, and it would come off. But this adhesive had excellent aging characteristics, and you couldn't melt or freeze the stuff. I looked at his adhesive in a seminar, scratched my head, and thought it was interesting. That was in 1973.

In 1974, I was singing in the church choir during Christmas season and, being absent-minded, I'd mark my music with little scraps of paper. When a scrap fell out when I'd stand up to sing, I had to scramble to find my place. One morning during a dull sermon, my mind was wandering, and I had a "eureka" sort of idea. I wondered if I could make a bookmark with Spence's adhesive that would stick *lightly* to my music and not fall out, one that I could pull off without damaging the book.

ARTHUR L. FRY (b. 1931), inventor of the Post-it Note, was a corporate scientist with 3M in St. Paul, Minnesota, for thirty-eight years. Now retired, he works part-time with the company.

I went back to work, got some adhesive, and coated it on the edge of a piece of paper, because I wanted the part sticking out from the book not to be sticky. Well, I had a bookmark, but the adhesive didn't stay put very well. In some of the hymn books I tried it out on, the pages stuck together a little bit. One day at work, I was writing a big technical report, and I took one of my bookmarks, wrote a question to my boss on it, and stuck it to the report. My boss wrote his answer on the bottom. When I saw that, I said, "Aha, what I have here is not just a bookmark, it's a communication device. It's a self-attaching note. You don't have to paper clip it on. You can even stick it on the coat rack or on someone's door."

On a coffee break, my boss and I sat down and listed all sorts of ideas for different types of products. Then I went to work on it as a bootleg project in my fifteen-percent time. I learned a long time ago that with new-to-the-world things, all you have are words, and they don't really mean anything till you can experience the product. You have to show an embodiment of it that is worthy of your dream. It took nine months to make rough samples to see if the idea was valid and if the product worked. After an awful lot of testing, you could pull these things off of the paper they were attached to and they would cleanly remove. I'd never seen anything like it before.

But what really convinced people that our invention worked—what proved how it worked—was this picture. It was made around 1976. Our central research laboratory's scanning electron micrograph made it to show how and why the adhesive was working. It has a 500 percent magnification. What you see are the paper fibers with bumps of adhesive on them. Each of these globules is very sticky, but because there are just a few of them, they're like the Lilliputians in *Gulliver's Travels.* One little string wouldn't have held the giant down, but enough of

them could. This picture also shows the primer that holds the adhesive to the paper.

When I looked at this picture, it was the first time I really saw that everything was working right all at once. What a *thrill!* Before I had this picture, a lot of my colleagues couldn't really understand what I was doing. I'd draw diagrams for them, but there's nothing like really seeing it. *Nothing.* In this case, a picture was really worth a thousand words.

So this picture is *very* important to me. I kept it on the wall of my office, and I'd look at it whenever someone tried to kill the product, so I would know we really had something. I kept it up at work for years and years. Now I have it in my office at home. It reminds me that *any one* of us can do amazing things if we set our dreams to the task and persist. The thing that stops most people is themselves. People give up because it's so important to be right. It's drummed into people that the consequences of being wrong are often fatal. And sometimes they can be. If you eat the wrong mushroom or make a mistake when you prop up your building, you can have terrible consequences. But even in the simplest instances, people have a strong drive to be right. If they're not sure, they'll back off. They don't like to look like a fool.

But if you're not afraid of asking dumb questions, you find out that you can learn, and that the thing you thought perplexing, by golly, it turns out that nobody knows about. You can pursue it, and it's like the glimmer of light in the window. Eventually, you open the door and look at what's inside.

Five-hundred-time magnification of Post-it adhesive on paper fibers, 1979.
3M Microscopy Department

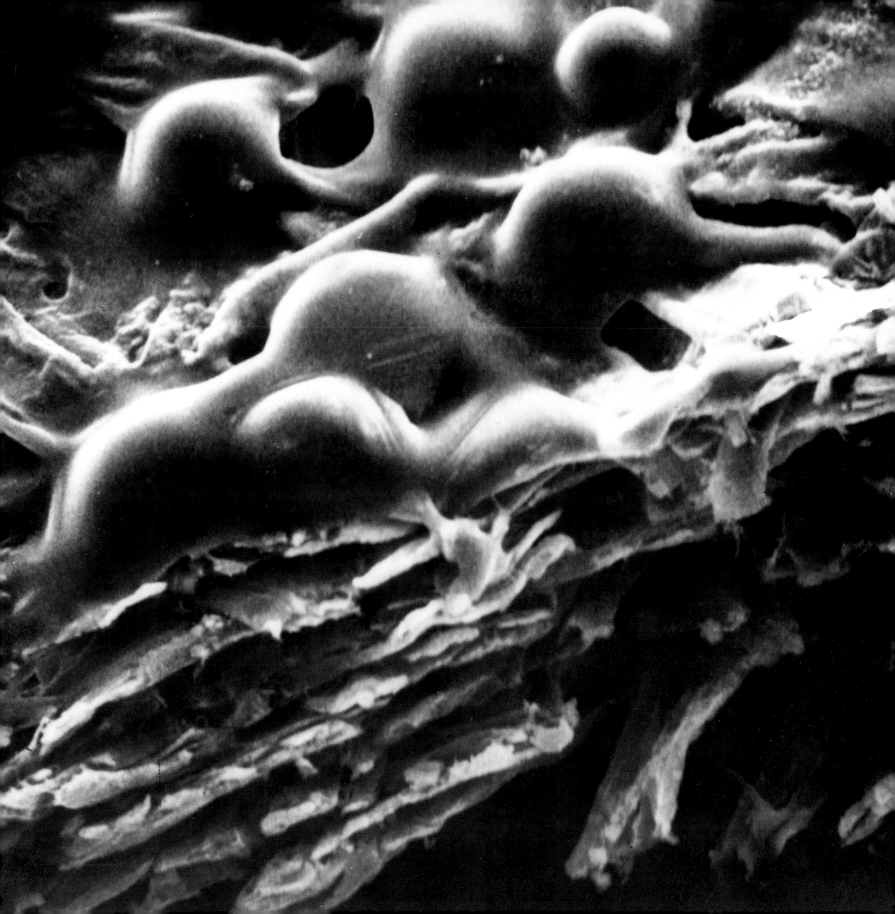

My mother was pregnant with me when she watched Luna Park burn. The fire was at night, and she remembers worrying that it might not be safe when she began to feel the heat from the fire. She backed up but continued to watch it burn. That must have been in early 1944. I was born in November. We lived in Coney Island in a house surrounded by rooming houses, which were occupied by carnival workers and sideshow freaks. A typical neighborhood scene was a four-hundred-pound woman painting her toenails on the porch. The real world was the beach and what went on there.

In a funny way, Weegee was the court photographer. You would see his photographs with Coney Island settings in the newspapers, next to pictures of Harry Truman and public ceremonies. There was always something different about a Weegee picture. The stockings had runs, the shirts had sweat under the arms, and everybody looked unshaven. A Weegee photograph was like a production still. If the mainstream world was MGM, Weegee was Warner Brothers—real grit.

Around the Fourth of July, the New York newspapers always ran an anniversary Weegee picture of Coney Island above a caption such as: "One million people fill the beach at Coney Island." I remember looking at that picture very, very carefully—going cross-eyed staring at the grain in the newspaper—because I was sure my face was in there. I looked for Weegee on the beach, but I never saw him. I guess he was present to all of these faces staring back at him.

The beach was a giant theatrical construct. This photograph is presumably about someone dragged out of the water, but it would not be strange for the lifeguards to sing a duet. A figure is slumped over, people grabbing at it—typical Weegee people. There's the audience on the boardwalk as a family circle. Like

most Weegee photographs, people bulge, sweat, and look uncomfortable. You wouldn't be surprised if somebody had two heads or an extra leg. Everything in the photograph affirms that it's part of a large human construct.

The guy with the tattoos was probably sitting there drinking beer for most of the day. The tattoos say he was presumably in the Navy, and probably knew something about artificial respiration. He's got this sense that he's involved in something being recorded, a kind of friendly collaboration. No matter what craziness they're involved in, Weegee's subjects smile back. In a Weegee, there's a bonhomie that comes from shared class associations. You can imagine Weegee on the other side of the camera, sloppy, fat, and unshaven, having just rolled out of bed after the police radio called him, looking a lot like the people in front of the camera.

I could tell you just where this picture was taken, West Tenth Street and the Boardwalk. Behind Weegee is the Steeplechase Pier. These were the most crowded beaches, because they were at the terminus of four or five subway lines. There was not an afternoon on the beach when you did not see the spectacle of someone being dragged from the water and given artificial respiration. Somebody would bounce on the victim's chest. There would be jets of water, if he was lucky, pouring out of his mouth. He was either alive or dead. If he was dead, he was covered up and rushed off on a stretcher to a police ambulance waiting under the boardwalk. It was all entrances and exits, sex and death. Everything was heightened.

New York had a lot of picture newspapers when I was growing up: the *News*, the *Mirror*, the *World Telegram*, and the *Herald*

DAVID COREY (b. 1944) teaches undergraduate and graduate courses in comparative literature and film at Brooklyn College.

Coney Island, New York, c. 1952. Arthur (Weegee) Fellig

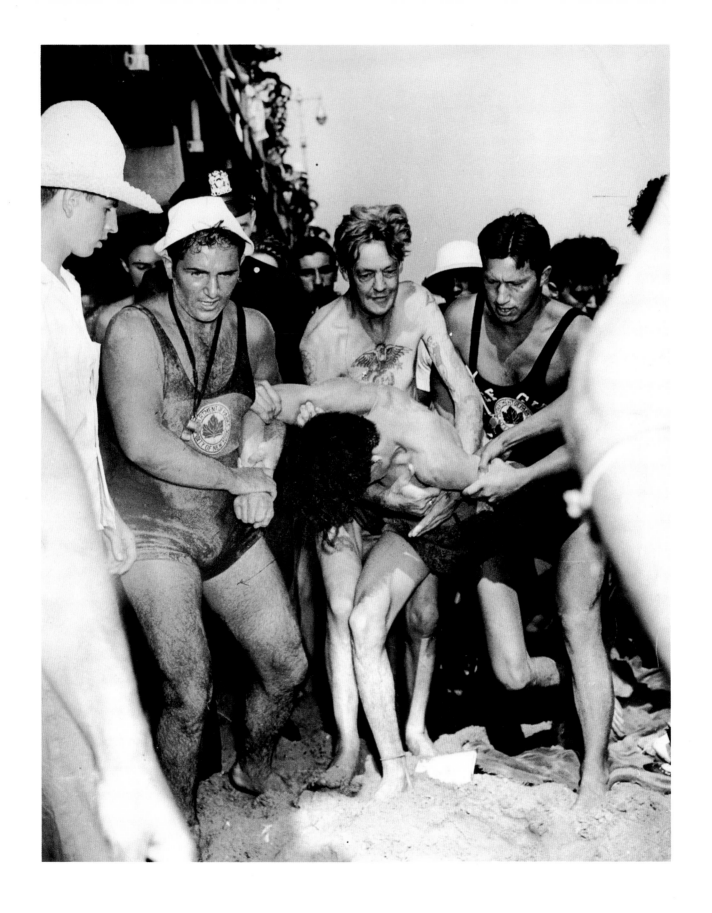

Tribune. The *News* and the *Mirror* were the natural settings for Weegee's photographs because his pictures were surrounded by ones that showed you what was going on in the world at the pedestrian level—jackknifed tractor trailers, or secretaries with crossed legs on their way to Bermuda. It was a world of moderate aspirations. There was an optimism, a sense that one could act; people were hopeful. There were always parades. My grandmother had a confetti machine, which you fed newspaper into and received bags of confetti for the parades. There was just a different sense of newspapers and the world.

Weegee was romantic against his will. He lived in a furnished room. It wasn't furnished as a bohemian atelier. It was a furnished room as a furnished room. It's the same in the world he records. In the midst of the most extraordinary crisis, human foibles make themselves known. He was witty and ironic about it. Very often, he did the same thing as Daumier when depicting human vanity—he managed to capture sin radiating through sanctimony.

Weegee was the mediator between us and his subjects, he allowed us to enjoy a kind of voyeurism with perfect safety. Rather than making us feel compelled or moved, Weegee fascinated us with his world's emotional and physical complexity. The situation he chose to depict is very serious to those involved; and they're doing the best they can. You can see the single-mindedness in the faces of the two lifeguards wearing their green Department of Parks uniforms with orange trim. The people running around in leotards, eroticizing the Coney Island landscape, were the official protectors of the beach. The figure in the middle is somewhat self-conscious; the tattoos tell you that. The cop knows perfectly well that the lifeguards are doing their job, and he's waiting to see if there's any need for an ambulance. There's a wonderful division of labor here.

We're seeing the configuration of an elaborate drama, a kind of schema for intense physical and emotional energy in graphic terms. Weegee was simply, as his name implies, the Ouija board; he was the medium.

When people try to take these kinds of pictures today, they're more arch and arty. If there's something truly heroic in scale or dramatic, it probably means that a vast number of lives are at stake or some enormous disaster is about to occur. These days, you want to flee from the picture; you don't stop to see the spectacle unfold. You just hope that the building isn't going to fall on you, or that the machine gun isn't aimed at your corner of the sidewalk. We're more cynical, much less willing to believe. We look at a documentary photograph, and what it documents is the complete inscrutability of the physical world. In this picture, you're a Weegee distance away. The scale of the heroism is very domestic, very human.

Now we have a roster of tragic situations in the world, and yet photographs seem to replicate one another. Poverty looks the same everywhere. Official visits look the same—snap off the Pope's head and put on Ronald Reagan's head. Pictures deliver the information that people want—the illustrations of what they're about to read—the standard view of an explosion, a courtroom, an auto crash. We read them all as glyphs. When you look at the space shuttle exploding, it takes a real push to energize yourself enough to imagine the emotions experienced by the astronauts' families.

Today, a Weegee stops you in your tracks. Instead of turning the page and going on, a Weegee photograph slows the clock and raises too many issues. Weegee doesn't tell you immediately what the specific crisis is. For all you know, the guy could be having an appendicitis attack, but that kind of ambiguity is not

efficient today. Today, imagination has been taken away. One of the things we've lost in a literate population is the notion of uncertainty. If we learn more and more about something, it's less easy to make the easy decision about it. Knowledge that comes in a hermetic package is really what we prefer. We want to learn things efficiently.

It would be hilarious to think about this photograph in relation to a ten-page series of Ralph Lauren beach house pictures, because it's entirely possible that Ralph himself was on the beach the day that Weegee was taking this photograph. Ralph probably took the train down from the Bronx.

The photographs in Ralph's ads are all about memory and loss. There are all of these neo-Hapsburgs weeping over their chintz couches, looking empty-eyed and sad, as if their whole world has vanished, and they're the last preservers of a way of life. You realize what an extraordinary lie it is, what a creation, what a carefully crafted piece of information is being presented. Weegee's beach is the world Ralph lost, not the imaginary one he invented. It's not that you have a choice when you look at the Polo ads. You only have one choice, the choice of the marketer. You see bereavement and loss in all of those people with their bent heads. It's an anachronistic, Fitzgerald world, but even he had a detached irony about how it had faded.

Suddenly, this world has been fully reinstated. The only thing you can do, if you want to be part of it all, is to say: "Yes, it is terrible that those people moved into the next estate down the bay, but hopefully our daughter won't go sailing with their parvenu son." The ad says, "We all know that it's slipping away from us day by day, but these products will make you feel better." It's a sense of bogus continuity. You know, there are the little Nazi babies on their chintz chairs, and there's the old grandfather, who looks as if he was in the Boer War, wearing some fabulous outfit. I mean, come on, for him to be dressed the way he's dressed, he'd have to be ninety-seven.

Within their big house, they've managed to reinvent the myth. It's crazy, a celebration of passivity. Now that Ralph can furnish the house with every piece of furniture, every fabric, every drape, you can be thoroughly passive. A wing chair is made to look like a wing-tip shoe, with all the associations of English or American patricianness piled on. At this point, the myth reaches the psychotic phase, babbling associations in any order. Mattress ticking has become stylish upholstery, like anything else Ralph wants to haphazardly put together.

You say, "Yes, I'll take it." Bring an empty space that's just the right size emotionally, and all you have to do is sign the charge slip for the stuff to be delivered to zombieland the next day. Mortality ceases to be an issue; timelessness prevails. What Ralph is giving you is the same as what the Pharaohs, who took all of their crap into the Pyramids with them, sought: a world that's going to protect you from death.

In Weegee's world, all the physical laws of the universe, gravity, mortality, whatever, *are* at work. Regardless of what happens on Weegee's beach under siege, you know that once the fleeting activity is over, in perhaps five minutes, the beach will heal itself. The people in this picture will finish their day and go on with the rest of their lives.

The first time I saw Omayra Sanchez was on TV, and I just couldn't forget her face. I had the impression she was looking at me. It was 1985, a hard time in my life, when I was moving jobs and deciding to be a writer. I had already published one book and written a second one, but I still didn't believe I could make a living by writing. My marriage wasn't working very well, and my kids were leaving and going to college, so it was a strange time in my life, a time of decisions. I had been in exile for a very long time. I was planning on getting away from Venezuela, maybe going to Mexico. I couldn't go back to Chile. It was one of those periods when you feel sorry for yourself. Then this tragedy happened, and this girl appeared in my life.

At that time, there were a million Colombians living in Venezuela, and many of them had come from Omayra's village. The eruption of a volcano had melted the snow, and a river of water, mud, and stones came on her village. The catastrophe was covered by the media worldwide: television, newspapers, magazines. There was technology to spread this girl all over the world in photographs, but not to save her. After four days of being trapped in this mud slide, she died.

Looking at her picture, I had the impression that her eyes were focused on me very intensely. One look at her black, perfect, almond-shaped eyes, and I realized what endurance, patience, and survival are. At that moment, I stopped feeling conscious about myself. I tore the picture out of a magazine and kept it with me.

When I came to America five years later, I wanted to write a collection of short stories, and I knew that the most important story in that book would be that of Omayra Sanchez. I tried to write one story, and instead I wrote a whole book! It's called *The Stories of Eva Luna*. Usually when I write a short story I try

it only once, because short stories are like apples, they come home fresh. If you overwork a story, you will miss it. You have to have the whole story in the first sentence complete, tight. I wrote Omayra's story several times, haunted by the girl, and when I finished it, I thought I was done with her. I tried to put her picture away, but I couldn't. Now she's back. She's back because this project brought her back, and because something terrible has happened in my life.

When I saw this picture in 1985, I thought nothing like this could ever happen to my children, but I now have a daughter who's very ill and may die. Just as Omayra agonized trapped in the mud, so is my daughter trapped in a body that doesn't function anymore. For two years I have been at her bedside and often the memory of Omayra comes to me, she has never quite left me, really. She will always be with me. She brings the same message now as she did before: of endurance and the love of life, and, ironically, the acceptance of tragedy and death. When I first saw the picture I thought, "Maybe she's asking for help." Then I thought, "No, she has not died yet. She's still alive." It reminds me of how fragile life is. She demonstrates such passion, she never begged for help, never complained.

In all these years, I've become acquainted with her and I identify with her. In some ways I am her; she's inside me, there's something between us that's very strange. She's a ghost that haunts me. I often wonder about what she feels. I don't think she's thinking, she just *feels*. Later it was discovered that when her house had crumbled, she was stuck between two pieces of wood and the bodies of her brothers. Her body *feels* the cold, the fear, the stress. She looks so uncomfortable in the mud, so

**Omayra Sanchez three days after being trapped in a mud slide, Colombia, 1985.
Frank Fournier**

ISABEL ALLENDE (b. 1942) is a best-selling Chilean author living in San Rafael, California. Her novels include *The House of the Spirits*, *Of Love and Shadows*, *The Stories of Eva Luna*, and *The Infinite Plan*.

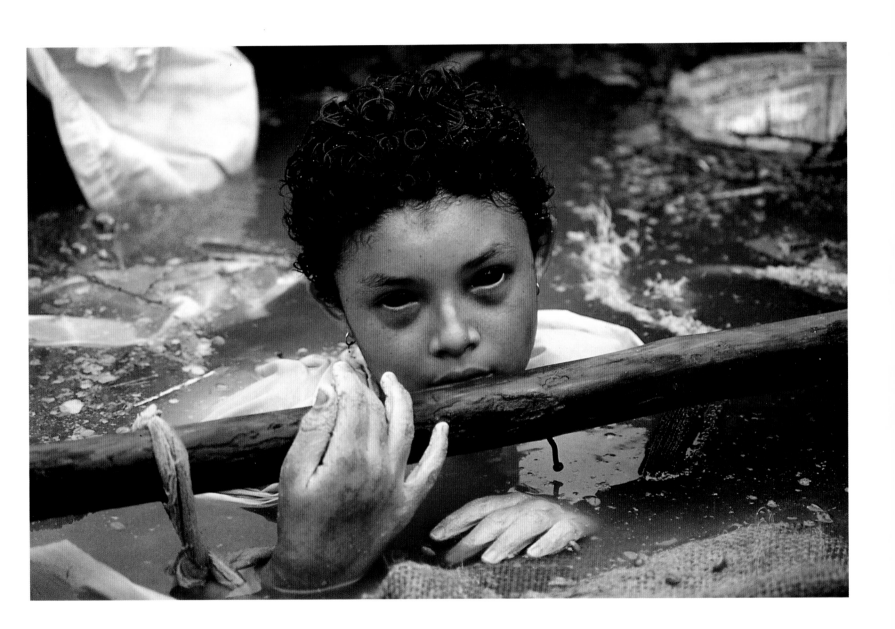

much in pain. And yet, look at her hands, they're so elegant.

The wonder of photography is that it does what no words can. I think in images. I remember my life in images. The earliest memory of my life, and the only memory I have of my father, is when I was two years old. My father and I are standing on the stairs of our house in Lima, where I was born. And I can see his legs and his shoes—back then, men wore shoes in two colors, black and white. And I remember my brother, who couldn't walk yet, wearing white pants and white shoes, and then, all of a sudden, he tumbled and fell, and there was blood. I have this image of my father's trousers stained with blood.

The lessons that Omayra has taught me are about life and about death. What I have learned, what she has taught me, is very complex. Every time I go back to this photograph, new things come up. This girl is alone. No one from her family is with her. I don't know if they were all dead at that time or if they had run away. The only people with her were cameramen, photographers, and people from the Red Cross who were strangers. She died alone, and I wish I had been there to hold her, the way I hold my daughter.

Western culture forces us to ignore anything that is inexplicable or uncontrollable, like poverty, death, sickness, or failure. But this is not so in the rest of the world, where people share pain more than they share happiness, because there is *more* pain than happiness most of the time. There's nothing surprising or horrifying about dying.

In this picture Omayra is not very afraid, maybe because she has seen so much death, and she has been poor all of her life. The life expectancy in Colombia isn't very high, so she walked around hand in hand with death, as most poor people do all over the world. Only people who live in very privileged bubbles think that they're going to live forever. This girl is dead, yet we're talking about her years later. We've never met her and are living at the other end of the world, but we've been brought together because of her. She never dies, this girl. She never dies. She's born every instant.

When I first started photographing men, people didn't understand what I was doing. They didn't understand why I felt it was important for such pictures to go out in the world. It was Imogen Cunningham's photograph of her husband that gave me great inspiration and courage. The first time I encountered Imogen's photograph of her husband, Roi Partridge, taken on Mount Rainier, was many years ago. I was about twenty-one years old and studying at New York University's film school. I used to go to Lee Witkin's gallery on Fifty-seventh Street a lot to look at Larry Clark's photographs, which were wrapped in a big envelope, and hidden away. When you looked at them, people would whisper. One day Lee said, "I want to show you something." He took me back into his office and showed me this picture. It was a small print, about 8 x 10, maybe even smaller, and it was in a black portfolio case with Imogen's name on it. It just hit me between the eyes.

This picture reminds me of something that Alfred Stieglitz said: that, as a photographer, you never had to leave your own backyard to find something to photograph. Imogen was a wife and a mother and a photographer at a time when women weren't accepted as photographers. When she would go away with her sons to the sea or hiking, she would take pictures of them. It must have seemed natural to climb a mountain and photograph her husband. I don't think she was consciously trying to break conventions when she took this picture. She was just photographing her life and what she was feeling about it.

It's always been acceptable to look at nude photographs of women, because they are an idealization of beauty. However, when people see a photograph of a nude man, they feel like they're on trial. They have to decide if they are going to be able to face it. But think of the way children live, how we run around the house nude until the age of three or four, and then,

all of a sudden, they throw clothes on us. Then, if you have your clothes off, people think it's odd, especially if you're hugging your brother or your sister. You don't feel free anymore.

What is beautiful about this photograph is that you feel Imogen's feelings for her husband, who is very beautiful. You feel her quest as an artist: to climb a mountain, to say something about herself and this man she lived with and had children with. I have always felt that this was one of the most romantic photographs I have ever seen. It makes a hero of Roi Partridge. He was a wild, bohemian-looking guy, and somebody he loved persuaded him to climb this mountain, to take his clothes off, and to be fearless, even though his body wasn't so perfect.

When Imogen showed this photograph to her circle of artist friends in San Francisco, she was misunderstood. They certainly didn't understand a woman taking a photograph like this at that time and were probably surprised to see a photograph of a nude man in any way, shape, or form.

Certain photographers around Imogen's time, and some who came later, really opened the doors for other people. Stieglitz's photographs of O'Keeffe and Edward Weston's nudes of Tina Modotti, or his pictures of Charis Wilson out in the desert, let photographers take a step closer. That step is important in looking at Robert Mapplethorpe's photographs, which I don't think are so much about sexuality, but about the desire to have sexuality. They are about a young kid who wanted to be an artist, maybe just like a kid let loose in a candy store.

Looking at a photograph and seeing what the photographer has revealed is a little scary. The viewer is confronted with somebody else's freedom, and they question themselves about the

BRUCE WEBER (b. 1946) is a photographer whose work in international fashion established a new openness about sensuality and male nudity. He studied photography with Lisette Model. Weber has also directed film documentaries, including *Let's Get Lost* and *Broken Noses*.

why and the how. Very often, they become uncomfortable. A person who takes a picture is going on a journey, but so is the person who looks at a picture. That's the great thing about a museum or even a supermarket. You see a photograph on a wall, on a package, or in a magazine, and it takes you somewhere. I started seeing, in so many works of art that I had looked at for a long time, personal journeys. I think that is what is fun about looking at photographs. Strangely enough, I feel that if you look at a photograph and it is imprinted on your mind, it belongs to you.

I look at this photograph and remember when I was making the photographs for a book I did called *Bear Pond*. Bear Pond is a beautiful little pond in the Adirondack Mountains, where I spent many summers with a lot of my friends and my dogs. We would take our clothes off and go swimming. I didn't think very much about it, really. It just happened. Then one day, I was lying on the grass, and I felt I wanted to have a record of the time for myself, so I could look back and see people I really admired and the animals I loved so much. So I just started taking photographs.

Sometimes when I take a nude photograph for an advertisement or my personal work, I wonder how it will be perceived when it goes out in the world. I realize you have to throw such questions away. Diane Arbus told me that when she woke up everyday she was frightened about going out and taking pictures. Each day was like starting all over again, which is hard. I always say to my assistants when they're about to go off on their own, "I hope you have a big fantasy life. Because it will be the thing that pushes you outside of the door every morning and stops you from putting your prints away in a drawer." I studied with Lisette Model at the New School in New York in the late seventies. She talked a lot about how when a picture

gets put away, whether out of fear or ignorance, it really kills the reason why someone went on the journey at all. It makes the journey impossible for a viewer to take. She would always ask, "Why did you take this photograph? Did you take it because you thought I was going to like it?" She tried to get us away from the idea of pleasing people. She would say to students, "Be judgmental about your own work, but don't be afraid you're going to offend somebody. A photograph may not be complimentary, but it might open someone's eyes."

When I look at this photograph, I see a garden. I see incredible passion, and I feel like a flower will be picked, put in a vase, and then will pass away. I also think of someone who is eighteen now, and how, because of AIDS, they can't go out and lose themselves with somebody as easily as we used to. AIDS has made people start to feel guilty about their promiscuity and their sexuality. Once again, it is hard for men and women to look at certain kinds of photographs. Some viewers are taking another step backwards. So there's a need for this kind of photograph, because it helps people simply get through the day. It makes the viewer think about the photographer, the subject, and themselves, and it makes them wish that they had been there with Roi and Imogen climbing Mount Rainier to the top.

On Mount Rainier #7, 1915. Imogen Cunningham

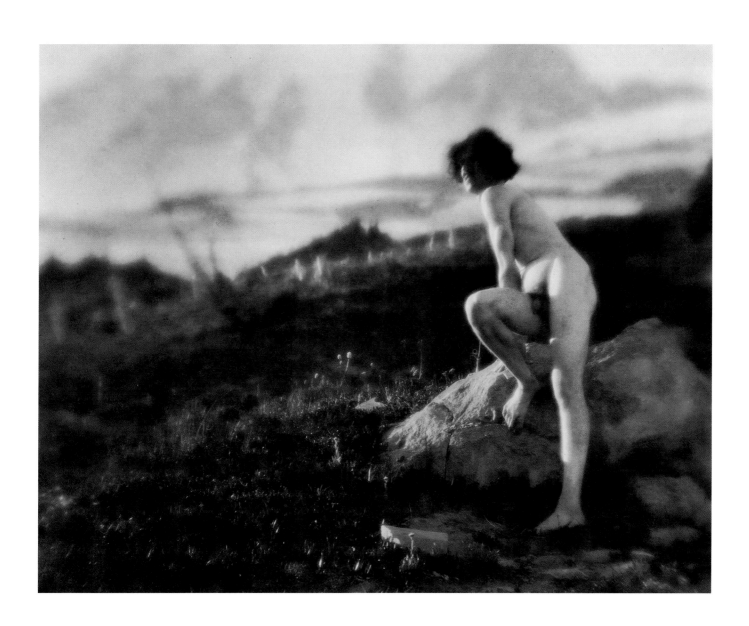

JOAN RIVERS

I first saw this picture when a friend of mine, Coral Brown—she was married to Vincent Price and was a friend of Lillian Hellman's—said, "Do you want to see the most incredible picture of Lillian?" She pulled out either *Vogue* or *Harper's* magazine, and there was this picture. I went nuts. It just represented everything about the women's movement, and women's lives, and a woman making the most of what she has.

I was used to seeing glamorous women in those Blackglama ads, but this was the first time they showed a woman with *everything*. Her life is on her face, which is so wise, so tired, and so smart. It's just saying, "Cut the bullshit." That's exactly what this picture is saying, "I know. I've done it. I've had it."

At the time, I was hosting the "Tonight Show." I had pushed my way into a man's world very much the way Hellman had, so I identified with the picture tremendously. I saw it at the right time. Everyone was going around saying, "How tough you are." I thought, "You just don't know what goes on in my house. You don't know what goes on behind all this."

The picture also showed that an ugly woman could have sensuality and femininity, which no one ever thinks about. At that point her book, *Pentimento*, had not come out yet. So many of us didn't know the extent of the grand passion between her and Dashiell Hammett. The mink coat says, "I also wear satin at times. I also feel passion." This is a woman who had candlelight dinners and waited for phone calls.

I was lucky enough to see her back in 1954 or 1955 when she came to lecture at my prep school. Theater stunk as a teenager. I should have known who she was, but I didn't, and I went to auditorium programs because we had to. When she came on stage and started to speak I went into shock. I thought she was

fabulous. I don't remember exactly what she said, but I know she *answered* our questions honestly, and I loved that.

When I saw this picture of her, I had exactly the same feeling I'd had years ago: that Hellman was a smart street fighter and, yet, had great sensitivity and femininity. This picture is all about womanhood and eternity and survival. It represents a woman who has gone through everything and won. I ripped the picture out of the magazine and kept it on my desk for a long time. It made such an impression on me.

Hellman was always a fighter. She didn't go quietly into the sunset. This woman you're looking at is not going anywhere quietly. Just look at that cigarette and the cavalier, tough angle of the watch. Look at the jewelry, the way the ring is pushed the wrong way on her pinkie. It has been there forever. Look behind the face.

You've got to remember that powerful women are two words: powerful and women, and the second word is the operative one. Cover everything else in the picture and just look at the eyes. The eyes are so sad and filled with longing. There are no shadows or veils in her face. This is also a lady who came through the Holocaust, even though she wasn't there. She carried its history with her and was a participant. She confirms the right way to be as a woman, and also the *tragedy* of being a smart woman, because there's a tremendous loneliness in the picture. She's hugging herself with one hand, and the other hand is trying to be so nonchalant. But I think Hellman walked into the photo session and said, "You've got ten minutes. Let's go. You're not going to do anything with this face."

Advertisement for Blackglama furriers featuring Lillian Hellman, *Harper's Bazaar*, December 1976. Bill King

JOAN RIVERS (b. 1933) is a comedienne, actress, and Emmy award–winning talk show host of *The Joan Rivers Show*. She performs regularly in comedy clubs and in Las Vegas, and she has written several books, including *Having a Baby Can Be a Scream* and *Enter Talking*.

36

What becomes a Legend most?

Blackglama

BLACKGLAMA® IS THE WORLD'S FINEST NATURAL DARK RANCH MINK BRED ONLY IN AMERICA BY THE GREAT LAKES MINK MEN

This is an iconic photograph for me of an important building that very few people know—the Baptistery in Parma. This building speaks very eloquently about the language of architecture. It tells you what it is, and what it could have been, and it tells you about the options for culture, as well as the spiritual, domestic, and civic life of the city. Everything is brought together in this building, which was designed by a little known architect, Benedetto Antelami, who started it in 1196. It was a transitional building, straddling Gothic and Romanesque, and it is a composite of ambiguity and confusion, built when people were trying to understand those styles.

This is, in layman's language, a very clunky building. One of the reasons it is so heavy looking is that the building gets its interest primarily from the surface. Being an octagon, it works by giving an animated front to the square. Each face is a front, and the faces adjacent to the major door are what architects call "blind." Blind niches on the facade first frame an opening, then cancel it. This is a kind of knowledge, by the architect, that is rarely seen. We don't expect somebody in the twelfth century to recognize what brilliant architects like Michelangelo only knew how to achieve much later. The blind niche is a rhetorical statement that I find absolutely glorious.

Look at the frieze, the top story, and you'll see many columns that are very delicate on supporting, round arches. That's understood as pure decoration. Below that are columns that don't quite align with the columns above. Today they would. In a Michelangelo building, they would have to. But here, you can't follow the line of columns down. What the architect is essentially saying—and this is another intellectual subtlety—is that these columns don't support anything. They are decorative and are there to animate the facade. Behind them are doorways that, we are told, acted as an entrance for a choir. Imagine

people standing on those balconies, singing out to the square. Not only was the building animated with chiaroscuro, the kind of light and dark shadows that the blind niches make, the presence of the people who appeared on those upper stories literally animated it!

It might seem blasphemous to people looking at this photograph, but this building became important to me when I was working on the Whitney Museum addition in the 1980s. My work posed a question I had to answer. I was filling out the block that Marcel Breuer had begun in the 1960s, and Breuer's facade is a rather big, brutish, black face. It has very little articulation as a facade because many contemporary art curators prefer to deal with a neutral interior. They don't like a lot of natural light. Well, neither did the Parma Baptistery, because its interior walls were painted or sculpted from the ground to the dome. The interior was lit with candles, because they knew that light would fade the paint. In my Whitney work, I needed to find a way to satisfy the no-natural-light problem as well as to work with the texture of Madison Avenue as it stands in opposition to the Whitney's austerity. The problem posed was how to animate the face. So the blind niches of the Parma Baptistery become very important to me.

This building, in itself, is important to me because I work from paradigms. Architecture is not invented from a whole cloth. If you consider writing, you realize that when you write, you think about the language, about the sound of the text, about other writing, as well as the story you wish to tell. Architecture works very much in the same way. After the shape of the Baptistery was determined, it was repeated and repeated and

The Baptistery of Parma after restoration in the Piazza Duomo, Parma, 1992.

Daniele Broia and Floriano Finzi

MICHAEL GRAVES (b. 1934) is an architect, interior designer, and designer of furniture and home accessories. He has designed office buildings, hotels, and cultural and educational facilities, including the award-winning Emory University Museum of Art and Archaeology in Atlanta.

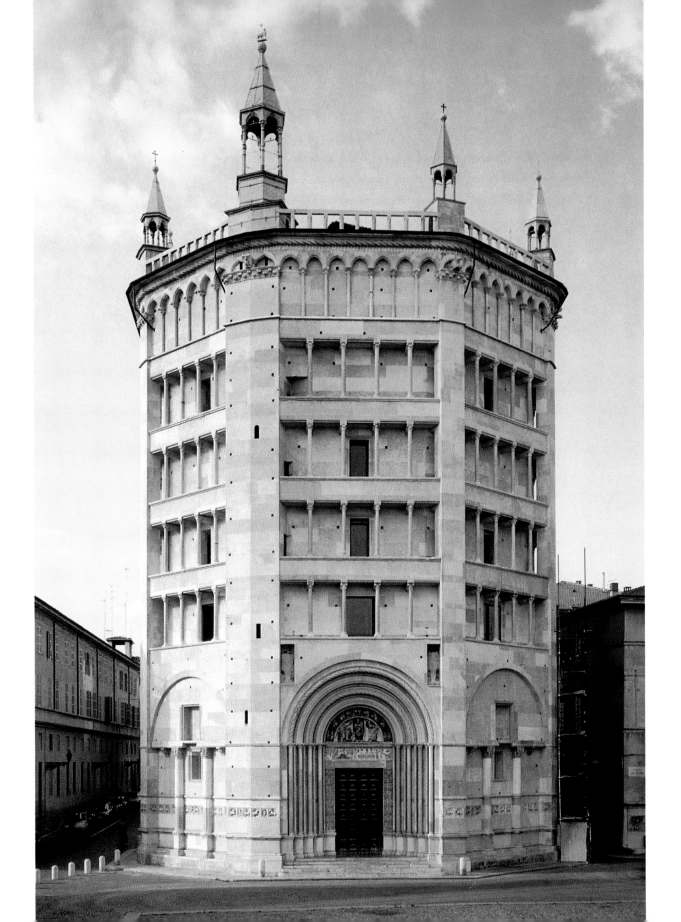

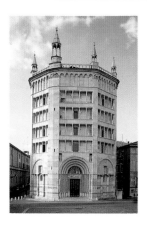

repeated. What interests me as an architect are the possible variations of the theme. As in literature, it is the variation of the conventional form or prototype that becomes the paradigm for architecture.

When I'm working, I make use of photographic images all the time. Architects don't read, and they should. I look at drawings, but primarily, I look at books of pictures. Drawings and photographs of a building like the Baptistery would both carry some similar information and ideas. What comes out in a drawing, if it is done by somebody who understands the tension of the building's mass, facade, and ambiguity, is a sense of the building's reality. However, I will always take a second look at the photograph, because it doesn't lie in the same way as a drawing. A photograph does things a drawing can't, it is both "of" the building and "about" the building simultaneously.

There are many photographs of the Parma Baptistery, but this particular image is important to me for a specific reason. For many years, the building had been under renovation. When the scaffolding was lifted, the building had been completely cleaned, and the people of Parma, by and large, didn't like it. Some of them said it looked like a confection. Over the centuries, the red Verona marble had faded, and pollution had taken its toll. The Baptistry had essentially become a pink building. The pinks are gorgeous now. To me, it's not a confection at all, because I know that in five years, it will start to have the kind of patina that's always been there. Because we can't recapture the authentic Verona coloration, we'll never really see what this building looked like originally. Today we see this building as it might have been conceived by somebody else, fresh and new and different.

I have a real connection with photography. I think it's because I'm a frustrated artist. Growing up, I was known as an artist before I was known as a person of letters. Also, I usually fall in love with, and live with, photographers. I buy photography books all the time. When I'm writing a book, I need pictures around me for when I get overdosed on language and need to look at pictures. Sometimes I use photographs as notes. I'll just look at my Mexican photography books, see something, and put it in my story.

I'm obsessed by books of Mexican photographs, house books, and style books, because I was so homeless for so long. I lived out of suitcases and looked at other people's houses. I've always been a voyeur of sorts. The thing we did as a pastime, when I was growing up, was to get in the car and drive into wealthy neighborhoods and look at the houses. I felt embarrassed. When I was a kid, the pictures that had the most profound effect on me were of houses I saw on television or in magazines.

I watched "Father Knows Best" and "Leave It to Beaver," and they had houses that were not anything like the house we lived in. I remember the idea of the house one *must have* was very deeply ingrained in my head. It was what I felt we didn't have. Even Dick and Jane and Spot had the same house that Beaver did, with the green lawn. The thing that surprised me was that there was grass that grew without a fence. You could run across it, or leave your bike on it, without having to chain it up, or drag it up into the hallway, so someone wouldn't steal it.

When I was growing up we had photographs on the television and on the coffee table. But I mainly remember the pictures that were made on our family treks from Chicago to Mexico. In them there was always one family member missing, the one who took the pictures.

One of those pictures is a catalyst to the book I'm writing now. It's from a trip we took to Acapulco. Everyone had been gathered on the beach for this important formal family portrait— my grandmother, my aunt, a spoiled cousin, my mother, my father, all the six brothers. We had driven all the way from Mexico City to Acapulco with all these people in one car. But when the photographer came to deliver the picture, I looked at it and I couldn't remember posing for the picture. I kept saying, "*When* did we take this picture?" My family said, "We took it on the beach on Thursday, *remember?*" And I looked for myself and I wasn't there. "But I'm not *here!*" And they said, "Oh, we forgot to call you! Where were you?" I was off somewhere, building a sand castle, or daydreaming. So that picture is very important to me because you always have to figure the one who's absent is the photographer. I'm the one who's not in the picture, so that means I'm the photographer. It was interesting to me because, being a writer, I'm the one that records the events. So it's right that I am not in that picture.

This is the picture I love the best. I saw it, for the first time, two years ago at The International Women's Day Show in San Antonio, at the Guadalupe Cultural Arts Center. I bought it and put it up right away. It used to be in my bathroom on top of the toilet tank. Not because I thought less of it, but because I liked it so much, I wanted it to be in some contemplative spot. I could see it from my bathtub. And I thought it would be very important for men to see it when they were standing and peeing, to make a connection between themselves and the man in the image.

This picture is part of a series that Mary Jessie Garza did of tattooed people. This picture's got the juxtaposition I find in a lot of Chicano art, the religious next to the sexual. Chicanos are

SANDRA CISNEROS (b. 1954), a Chicana author, has received two National Endowment for the Arts Fellowships, as well as the Lannan Literary Award. Her works include the novels *Woman Hollering Creek*, and *The House on Mango Street*, and a collection of poems, *My Wicked Wicked Ways*.

not afraid of those juxtapositions, the way Mexicans are. I really don't know if a Mexican man would pose like this. The thing that gets me, that's most incredible about this picture, is that it was taken by a woman photographer, who's been working on the west side of San Antonio, photographing these really tough-looking dudes. Prison guys who had either tattooed themselves or been tattooed. Now, here's a question I always ask myself whenever I look at this picture. How did she get this man to pull down his pants? *How'd she do it?* A lot of people will do things when they're in front of a camera, but not Chicano men. I don't think Latino men will take off their pants that way, unless you're going to do something sexually for them. I wonder if she knew this guy. Did she hang around with him? She's not the tough-girl type with lots of eyeliner and her hair up.

I know people are proud of their tattoos. I have mine, a very innocuous tattoo, and I show it at the drop of a hat. In the sixties, when I was ten, I saw a fashion spread in *Life* or *Look*, in which all the models had tattoos on their backs: figures from cards—diamonds, hearts, clubs, spades. I thought, "Women with tattoos, I want one!" So when I was twenty-three, I decided to get a little black club figure. So I know from my own little tattoo how much work went into this one to get all the detail. What really hurts is not the coloring, it's all the line work. This one took a very long time. And we're talking about a part of the body that's pretty sensitive. A big part of the pride you have in your tattoo is that it shows you withstood pain. It's kind of an "unto death" statement of character. It shows that you don't change your mind. My friend Joan, who's worked in prisons, said that the women there have lopsided tattoos all over their faces. They have real stupid ones, like Snoopy. They use their bodies like doodling pads in prison. They're all mutilated from the tattoos they've added or removed.

For a guy like this, it might be typical to put an image of la Virgen de Guadalupe on his back to protect him. But this woman is la Virgen de San Juan de los Lagos, Saint John of the Lakes, the patron goddess of the Tejanos, the Mexicans who live in Texas. And he's got her on his *thigh*! That's what I like about this picture. It's the Virgin—the holiest of people—so formal and stiff. And look where she is! Right near his pee-pee in a very erotic place. Who'd put that image in a place where someone might put his/her mouth?

But that's why I love this picture. He's a big guy. He's got real thick hands and pudgy fingers. Look at that big belly and those coarse boxer shorts. Look at the zipper's little teeth and that thread. You can almost feel it. It's a very erotic piece. I like the juxtaposition of the erotic with the religious. I mean, it's not just a tattoo of a woman, it's the *Virgin*. Look at those *I Love Lucy* hearts with the serpentine banner. Look at how beautifully it's all done.

Another reason this picture is so interesting to me is because, right now, I'm trying to write in an erotic way, and to figure out what's erotic as a Latina. Like images or things or sounds. What's erotic for me would not be erotic for my brothers or my girlfriend Cat, who's a white woman. I'm trying to define what eroticism is, what passion is, from a Mexican point of view. Eroticism, to me, is not just images. At this time in my life, it also involves language. A funny thing is that I don't have any language in Spanish for anything that is sexual or wicked. I grew up with English bad words and not with Spanish bad words. You need the bad words if you're having an affair with someone who's speaking Spanish. It's hard if you can't ask for, or say, or command, or create, the erotic unless you have the

From the series *Body Altars*, 1992. Mary Jessie Garza

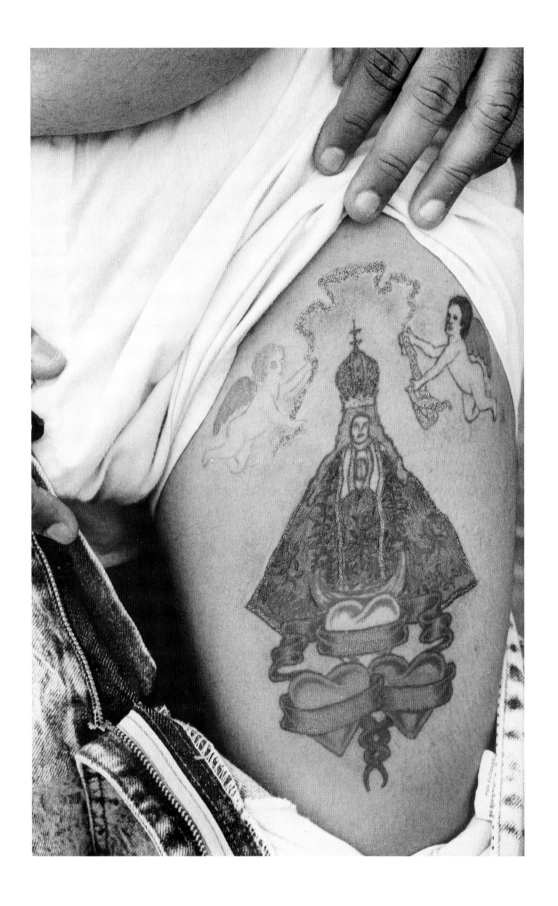

vocabulary. So, each time I go to Mexico, I ask people to teach them to me.

What's also erotic for me is buying gay magazines in Mexico. All of a sudden, you have brown men that look like the Mexican version of handsome. What was erotic for me was to see these guys with little mustaches. I thought, "Oh, my god, it's like my father!" They have stocky Indian bodies, and look like they should be in the Olmec section of the archeological museum with that brownness and those same curled little jaguar lips. It kills me, that idea of beauty, of color. Most Mexican magazines try to emulate the U.S., but you don't see it in the gay magazines. At least not the ones I've seen.

Maybe this is erotic for me because this guy is just the opposite of what a white person would think erotic would be. Look at the color of the skin, the duskiness of that thigh. I *love* this picture. I don't want to see any more of this guy. I don't want to see what he looks like. It would take away from what's fascinating about him to me. I want to put my head on that thigh. I really do. Looking at this picture really does make me define a new eroticism. I still want to know how she got that guy to pull his pants down! If this was taken by a male photographer, maybe it wouldn't intrigue me so much. But this was taken by a woman who isn't a *pachuca*, who's not an ex-con. How did she get the confidence of that man? Maybe it's because even though he's pulling his pants down, he's not showing anything, it's just the edge of the pants. It's very sensual. You can almost feel it.

Many years ago, Margaret Bourke-White photographed a breadline in Louisville, Kentucky, although it could have been in any inner city in America during the depth of the worldwide depression of the thirties. A number of black men, women, and one little boy wait patiently on line for whatever alms are being distributed at its end. They have absolutely depressed looks on their faces. They've given up.

They are standing in front of a billboard huckstering the benefits of owning what looks like a Plymouth. The vehicle is filled with an all-white family—a mother, father, and two children—all of whom are beaming triumphantly while their dog, also white, is poking its head out of the rear widow. An interesting thing is that the family is driving in the country. They're out of the urban mess, free and easy in the country. The air is good. The dog is leaning out the window. Everybody is so smug and happy, even the dog is smiling. Above this tableau is a broadside, undoubtedly in red, white, and blue, touting the "World's Highest Standard of Living," and, to its side, another proclaiming, "There's no way like the American way." If the car were suddenly able to materialize, it would certainly run over the queue of human beings standing directly in front of it.

I first saw this photograph many years ago at an exhibition of Bourke-White's photographs in New York. It made such an impression on me that I bought a print as soon as I could find one. It's been up above the fireplace in my law office for twenty years. Always in the center. Whenever I have been tempted to put out of my mind, even for a moment, the enormous gulf that exists between the races in this country, I look at Bourke-White's picture, and I am immediately at one again with the stark reality of my own environment. I have had many occasions to use it as a poignant reminder of the cultural, psychological, and economic gap between the races, a chasm that

seems to grow wider and deeper with every passing day.

Like so many white inhabitants of this land, I was indoctrinated early with the hypocrisy that on these shores opportunity is equal, the law is fairly applied, public education is uniformly administered, and the Bill of Rights reigns supreme. It took a heap of living and experience to teach me that Bourke-White's camera had caught the fundamental essence of the country, insofar as the black-white equation was concerned.

On the other hand this picture has an unexpected inspirational quality. Each time I see it, I make an inner promise to myself to do everything in my poor power to help make it an anachronism rather than a truism. Some day, I say to myself, the hapless expressions on the faces of those standing in line will change to ones of hope and promise. In addition, the smug smiles on the white nuclear family will disappear and be replaced by serious and thoughtful miens as they realize the racial masquerade is at long last over. For their own salvation's sake, they must understand and appreciate the real state of affairs, the knowledge of which may possibly bring about a truly integrated society where equality, on every level, is the norm rather than a tragic delusion.

What I see in the picture is a *loss* of dignity. To read dignity into these poor suffering people is to push aside the lives they lead. If you use the word "dignity" to describe the people in the picture, you're being racist. You don't talk about white people and *their* dignity. It reminds me of Hattie McDaniel in *Gone With the Wind.* They said she had "dignity," too. But in the long run, she was the slave who took care of Miss Scarlett. What you think of as dignity is passivity. But that passivity is wearing off. It's changing, particularly among young people. All it takes is a climactic event to remind black people of the neoslavery in

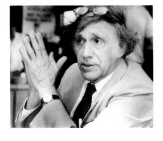

WILLIAM KUNSTLER (b. 1919), a lawyer, has defended civil rights leaders and activists including Lenny Bruce, Martin Luther King, Jr., the Chicago Seven, the Catonsville Nine, and the Black Panthers.

which they live. Lashing out is no longer standing on line. Lashing out is destroying black communities, because they know no one is going to stop them. It's the only community they can destroy. They can't go up into the rich people's places. The cops would shoot them dead, even if they had the transportation to get up there. So they destroy their own homes, their own businesses, and the system loves it in the long run.

There's nothing simplistic about this. It's a very hard thing to discuss, particularly with whites. It goes deep. The psychological layer that all whites— and I don't care who they are—are convinced of, subliminally, is that they are far superior to blacks. And all blacks—again I don't care where they come from—are convinced they are inferior to whites. This psychological ratio has been deliberately enforced for so many years to create a subservient class to do the work for the dominant class, that it has not gone away by legislation, or by going to a black church, or by speaking at a NAACP dinner. All politicians ever do is suck around for the vote. That's what black people mean to them—voters. If they didn't have the vote, nobody would pay the slightest attention to them.

As far as I can see, the problem between blacks and whites is virtually insoluble. But when I say insoluble, I don't mean in a thousand years from now. Third-world people already outnumber Caucasians, but even numbers won't do it, because whites will still be the so-called "aristocratic" class. Whites are not going to relinquish economic control, and everything is judged by whiteness. Look at ads. Even the blacks allowed in ads have Caucasian features.

Today the picture might be thought of as derogatory in that it

Louisville flood victims, 1937. Margaret Bourke-White

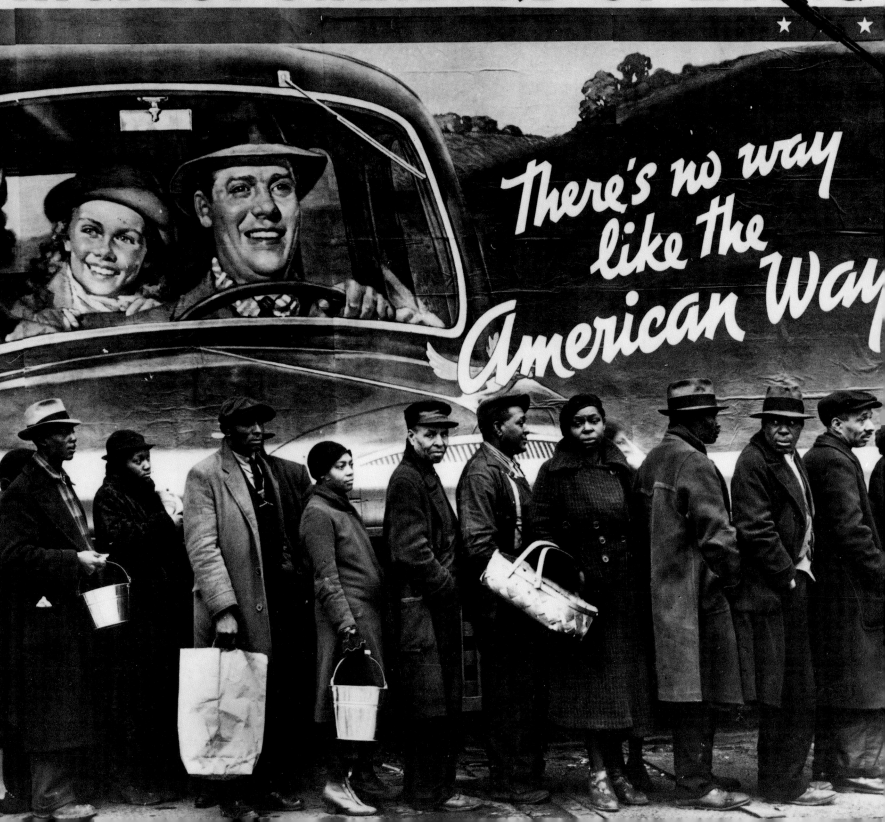

shows black people in an unflattering way. They're not at some college looking through a microscope. If you're going to show realistic photographs of black communities, and they are derogatory in nature because of the very life of the people they portray, you're going to get enormous opposition from the people who live that life. You'll be called a racist for portraying it. If Bourke-White were alive today, and went up to the South Bronx, and photographed derelicts and bums and drug addicts, and wanted to have an exhibition, people would object. Black people would say that's a terrible thing to show—that's not what *all* blacks are about. But if you took pictures of Harlem that were all rosy, you'd probably get little opposition from black people, even though they'd know they're not typical.

I had to work very hard to change my superior attitude. There are a lot of little tricks that after a while are no longer tricks, but attitudes that become part of your personality. The white man's or the white woman's superiority complex: knowing better, so you want to help "these people." It's "you people," and "these people." I think I've destroyed a lot of that mentality in myself over the years. But it's not all out.

For the first fifteen or twenty years of law practice, I was just another lawyer. I was on the West Coast publicizing a book, when I got a call from the American Civil Liberties Union that Freedom Riders were pouring into Jackson, Mississippi, and being arrested in droves. I didn't know what Freedom Riders were, but I agreed to stop in Jackson on my way back and give the ACLU's regards to a man named Jack Young, a black lawyer—one of four in Mississippi—who was handling the cases. I landed in Jackson on June 15, 1961. Sometimes you know exactly when your life changes. On June 16, I went over to Jack's office, and I said, "I bring you regards from the American Civil Liberties Union." And he said: "I don't want

regards. I need lawyers here. Regards are a dime a dozen." He said: "Go down to the Greyhound Bus Terminal. There's going to be an arrest when the bus comes in. Then come back and see me."

So I went down to the bus terminal. I saw five people, a couple of blacks and three whites, come into the bus terminal, and Captain Ray, who was in charge of what was called "Operation Mixer," arrested them all and took them away. I was so goddamn angry I couldn't sit still. I was determined to see whether I could do anything that made any sense. The die was cast. I said to myself, "I'm going back to Mr. Young's office, and I'm going to stay in Mississippi." And I didn't leave Mississippi. We moved everybody into the federal courts and got everybody out of jail.

My whole life changed. In the beginning, when I think of it, I could almost throw up. I was like Lord Bountiful. I was going to help poor black people. I went down with a holier-than-thou attitude to help these poor benighted people. I didn't really regard them as comrades, more like subjects. But that changed over the years, as I got deeper into the 1960s and 1970s with the Black Panthers, the Black Liberation Army, the SNCC—the Student Non-violent Coordinating Committee— and so on. I began to realize that I did not have a healthy attitude. I was paternalistic, to put it mildly.

I've looked up racism in the dictionary, just to make sure I was on the right track, and it's defined as a feeling of superiority of one race over another. The progress to be made is in the direction of acquainting white people with their own racism. Racism only works one way. There is no such thing as black racism. Blacks have no feeling of superiority over whites at all. I've been saying that for a long time, and everybody tells me

I'm crazy. If people understand the nature of their own racism, then some day they'll be able to make the necessary psychological adjustments. If people with enlightened self-interest educate themselves psychologically, and any other way, as to what white racism is, maybe we can begin to diminish it. Because the only notion that grabs people is their own self-interest. It's not the most noble of motives, but at least it's a workable one.

Back in the early 1950s I was in the Academia in Florence looking at the statue of David. Bernard Berenson was in the gallery, and I didn't know who he was. He came up to me and said, "Young man, what do you think of the statue?" I said, "Well, it's a very great statue, very beautiful, the musculature..." He interrupted me and said, "That isn't at all what Michelangelo was trying to do." He went on to describe how Michelangelo was trying to show a man at a moment of decision, how we all have these moments in our history. A time that comes when, if you don't do something, no one will be the wiser, so you won't be at risk. But if you act, you risk yourself. Berenson said, "That's what Michelangelo was trying to do." I never forgot it. So I brought back a small statue of David, and I set him up here in my office. Whenever there are moments in which I'm about to be held in contempt, I think of David, and I try to imagine his situation. He *did* put the rock in the sling, and he *did* hit Goliath, and it made him a hero for all time. But what if he had missed. He would have been one dead shepherd boy!

When I was in the University at Bucharest, we used to go to the movies once a month. We saw a lot of Western movies. Clint Eastwood. John Wayne. We saw *Lawrence of Arabia* and *Ship of Fools*. Unbelievable. What I liked very much, was that when the communists let good movies come through, they didn't really understand what effect the movies would have. They let *They Shoot Horses, Don't They?* in trying to say, "This is America, the America that kills you, that grinds you to the ground." I thought, "Stupid idiots. They are so communist stupid." They didn't see that the people in the movie were so *great*. What's the sense to live like a little worm in life, when one day you can be an eagle up on top of the sky with *everything* or at least try to dream. I said to myself, "I'm going for that day." So I escaped from Romania in 1972, and this movie had a lot to do with my decision to flee.

My dream, when I was young, was to become an actor, but I didn't pass the admission test. They drafted me into the Army/Air Force, and after the Army, I completed the physical education program at the University and became a teacher and a coach. I was good at sports: gymnastics, track, soccer, team handball, all of them. Sports were important in communist countries, because they could pave a road to a future that was a little smoother. In communist countries, people adulate a good athlete, they buy you a drink. The communist party gives you food and an apartment in the city, instead of sending you into some little village.

I have to give some credit to the communist philosophy. They believed strongly that the future of the country was in the health of the children, and children would only be healthy if they were physically fit. Physical education and sports were an integral part of communist culture. It was a *corpus sana* approach, not like in America where today nothing matters

except inches and looks and cosmetics. Other societies don't have this luxury. They have to perform and be efficient at work. In America, people's idea of what they should look like is so tied up in images. I'm sick and tired of people comparing themselves with pictures of people in magazines, then looking at themselves saying, "I look disgusting." To be *just* a body builder is ridiculous. Aerobics is nonsense, nonsocial, nonpsychological. Not a normal human activity. Exercising in America has become totally abstract for people. They treat it like bitter medicine they have to take. In a field where there should be joy, all the time you have anorexia, bulimia. Distortions. Bicycles, machines, they're all the same. They don't give anything. You are like Sisyphus, pushing the rock that never goes anywhere.

Over there, everything was integrated. Team work. Moral qualities of courage, honesty, admitting superiority, learning how to lose in competition. The joy of movement. There was a real physical education program that taught health, movement, basic motor skills like tumbling and climbing, and all the sports. I worked with hundreds and hundreds of children to find the elite people, and trained them for teams that would compete. All the time, you train and compete, train and compete, train and compete, permanently. It was constant conditioning and constant performance until you got too old and then you'd drink. Communism was basically a lot of drinking.

I wanted to be challenged. My mind was stale. I couldn't do what I wanted to do in the frame of communist machinery. So I escaped illegally. Lots of people were killed or jailed trying. I didn't tell anyone what I was going to do. My premonition was

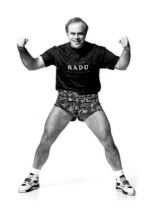

RADU TEODORESCU (b. 1944), a Romanian-born fitness trainer, immigrated to the United States in 1972 and opened his own gym five years later. His clientele includes John F. Kennedy, Jr., Candice Bergen, Calvin Klein, and Cindy Crawford.

Movie still from the film, *They Shoot Horses, Don't They?*, featuring Jane Fonda and Red Buttons, 1969. Palomar Pictures International

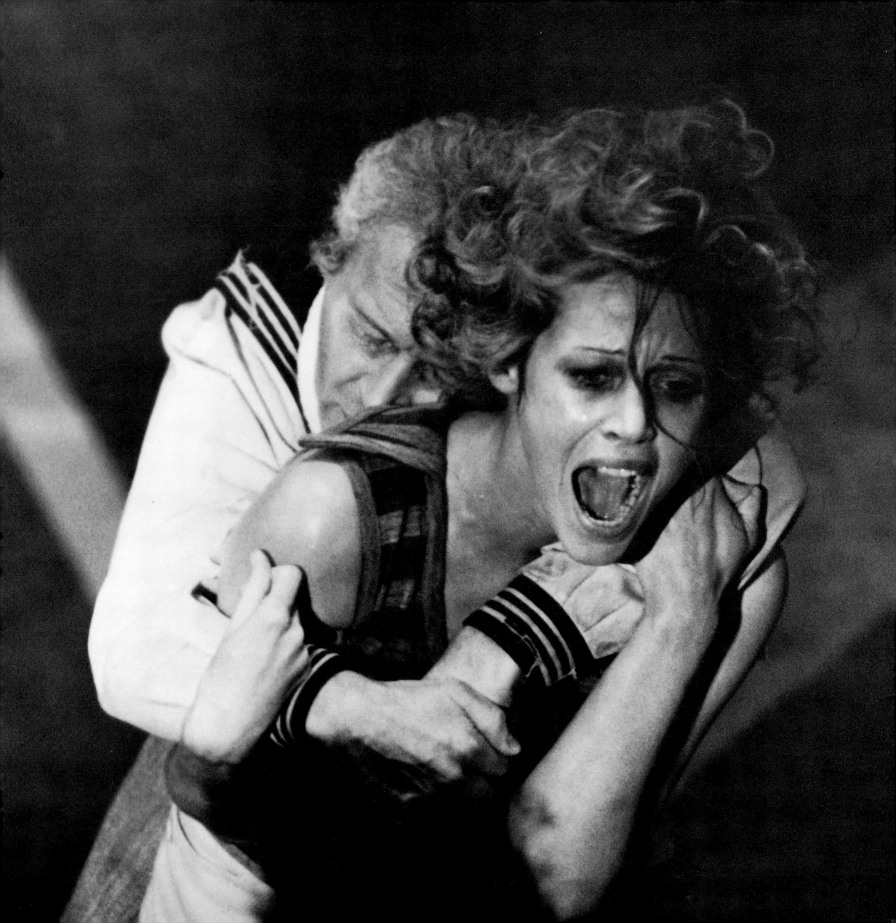

that things were going to change, and I was right to leave, because after 1972, things got worse and worse, until 1978, when everything went down.

This movie has a lot to do with my decision to flee. When I saw *They Shoot Horses*, I thought, "*This* is it. This is about *life.*" You start it, and you end it, and life is the marathon you go through. Look, these people are competing, sleeping, eating, making love. They go and go and never stop. They have one thing in their mind. They want to make it. Their *dream* is to make it, to bring what they are dreaming about into reality. That's why I really like this scene. It shows a person who doesn't want to lose and who doesn't want to leave anybody behind. She's giving this man her life to make him move. Just a little bit longer, even though at this point in the movie, he's dead. Dead! In the movie, I think he died of a heart attack while he was dancing. But she would lose the contest without a partner. She's willing to give him a leg, an arm, an eye, and a half of her heart, just to finish the contest. Here she's giving two-hundred percent of herself, one hundred for her and one hundred for him, too. "You cannot die on me. Come on," she's screaming. "Go bitch. Don't die. Come on move." It was unbelievable to me then, and even today it's amazing. "Don't let me down. Don't let yourself down. Don't do it. Don't do it. We are *here.*"

When Cernesceau came in, there was an unbelievable ascent in the standards of intellectual living in Romania. All of the sudden everybody was translated that we'd only heard about: Huxley, Camus, Sartre, Cesare Pavese. Unbelievable! We were reading, days and nights. It was not just political masturbation, we were talking about things. We were happy thinking about what was going on in France, what America was doing. We were identifying with their thinking. All of a sudden, from the

virile *body*, where you had to be solid, like a tree or mountain, all of a sudden, people started to have *heads*, and it didn't matter how you looked.

I was twenty-five or so when I was listening to Jimi Hendrix and Janis Joplin, thinking, "Oh, my God. What a wonderful country, America. America in the sixties and seventies was in transition. It was infested with drugs, Vietnam, intellectual controversies, political controversies, revolution. I knew I was not going to pick up money from the streets and have a villa. I knew it would be very hard work, so I said to myself, "I'm going to do everything in my power, and I'll train myself to be in the best condition—intellectual, mental, psychological, and physical readiness—to be ready for the marathon I'm getting in." I *knew* I had to go over there, where if you are good, you could make it up to the top. If not, you were dead. So when I saw this movie, *it* was a revelation.

I knew I would make it. From the beginning, I *never* ever had a doubt. I used to dream of walking on Fifth Avenue, in front of thousands and thousands of people, making them exercise on the street, making them healthy and happy, jumping and running and *laughing*. It was not because I wanted money, or because I wanted fame. It was because I had this *need* in me, a call to help people. "Come on. Come on. This way is much nicer. Let's go and kayak, cross the river, and do something together. Let's do it."

In the movie, Jane Fonda did not win. Unfortunately. That's the problem and the reason the movie is so important to me. In the beginning of the movie, there's a young man—Michael Sarrazin—on the prairie with his grandfather. They're riding horses, and all of a sudden, one of the horses is hurt, and the grandfather takes a gun and shoots it. The young man cries,

but he understands that a horse without legs is dead. After this scene, when she's lost the competition, there is nothing for her to do anymore. So she goes out on this little balcony, and Michael Sarrazin is there. It's quiet outside. She opens her purse and gives a gun to him. No talking, nothing. And he knows exactly what to do. She is broken. It is not fair for her to be alive. So he takes the gun and shoots her. Of course, he's arrested for homicide, because he cannot give any reason why he shot her. I mean how could he say, "They shoot horses, don't they?"

But I don't feel it's a sad ending. It's hard for me to believe in death, ultimate death. I believe in transformation. Nothing stays the same, it's transformed. So this character was meeting another challenge, going into another life. The movie is about survival, competition, equality, making it to the top. That is why this picture was America to me. You had to really prove yourself, and you might die doing it. Nothing's fair, but it is clean. The best wins.

When I fled Romania, I went into a political asylum program in Italy. I tried to escape from Italy, but I was jailed by the Austrian border police. Then I was moved to Vienna, where I was beaten up by drunks. I couldn't live there either. I needed to go to a country where I was respected like a human being. I knew America was made of all different kinds of people, so I went to the American ambassador and applied to get in. He said, "We need people like you." He made me put the hand on the flag, and I said the oath and sailed October 19, 1972, my birthday. When I came to America, I had no language. I didn't know anyone. I had a pair of sneakers, a pair of shoes, two pairs of pants, a jacket, and a T-shirt, and a lot of dreams. I opened my gym on October 19, 1977, five years later.

So far I am close to pulling through in *my* marathon race. To be honest, I'm in the middle, because now I'm a contender for the top. I am at the point where the cameras are paying attention to me, because they expect me to be the winner. But I'm not the winner yet, not by any stretch of the imagination.

My ultimate goal is still the one of Fifth Avenue. To be the leader. You know, Moses wanted to take the people to the water, to the other side, to the Promised Land. I don't know exactly what it is, but I feel I'm coming close to a point where I'll realize it myself *for* myself, and then I'll be able to describe it to others. That's my ultimate goal. If I can find it. It's unbelievable. I came to America because of Jane Fonda, and now I am her competitor. I'd like to meet her someday. I'd like to talk to her. She changed my life, and she doesn't even know it. And now, who knows, I maybe can help her change something here and there. I know there is room for improvement in anyone and in anything. That's progress and life. It cannot be denied or stopped.

In the winter of 1968, I was a freshman at Bennington, living in Manhattan for the first time. I lost my virginity. I went to J. D. Salinger's house. On Saturdays, I worked at the Riverside Museum in Manhattan where they had a group show with this photograph by André Kertész in it. There was something magical about this picture to me. I suppose it's what I wanted the future to be like, back then. I was incredibly romantic. I wanted to be a muse. Just like the woman in the picture.

Well, there I was in the museum, having just seen *Satiric Dancer* for the first time, when Cornell Capa, who organized the show, introduced me to Kertesz in the elevator. I didn't really get to know André until 1972 when I worked at Magnum Pictures, the photo agency. I was sent to his apartment on a little errand and was completely captivated by him. From Magnum I went to work at LIGHT Gallery which represented the sale of André's works. So André and this picture kept appearing in my life.

One day, I came to work completely distraught. My best friend, Callie, had suddenly died the night before, and I was vacuuming the gallery, waiting to go to the hospital for a memorial service. This picture was hanging on a wall, and I decided right then and there that I *had* to have it. Back then, one of the ways I dealt with pain was to look at beautiful things. The picture made me feel better, so I bought it.

I felt I had a relationship with this picture that nobody else could have. I *felt* like Magda. I had my Magda clothes and kind of tossed myself around. My grandmother and I both had those strappy little shoes. And I have always had pointy elbows. Ironically, André kept asking me to model for him, in front of his famous distortion mirror, but I wouldn't take my clothes off.

This is not strictly a picture of one woman. It's a moment of Shalimar perfume and champagne and Paris nights with no mornings. Henry Miller could be waiting downstairs. In that silky evening dress, with that funny, funny costume collar, like a dog's collar, she's completely angles, but also soft and pretty, with hair under her arms and lipstick. She's real. That's why I love this picture: it's guileless. Magda's kicking up her heels in joy, totally eccentric; a woman who likes her body and knows how to play. I think people from other cultures would recognize her as a love goddess because of the openness of her body, her curves, and her open mouth. It's amazing that a woman could be so happy and be art at the same time.

Magda's an Indian miniature, an odalisque. She's both sacred and profane. She appears juicily female and powerful at the same time, and there still aren't too many models around like that. That's why women love Marilyn Monroe, Judy Holliday, Tina Turner, and Bette Midler, but Magda didn't make a career out of starring in this picture. Nobody made a film from it. Nobody wrote her biography. André once showed me a picture he took of her when she was old and I was shocked. It was a completely different woman. She had cancer. But this picture keeps Magda and André alive, and *me* too, for a while. I had it up on the wall in a silver frame for years, but then I didn't need to look at it. It had become like the Mona Lisa, I just couldn't see it. So I put it away in a box.

For me this picture is about that period in my life when I wanted to become a man's muse. I still love the picture, but I don't have that same kind of attachment to it. I've become so much more aware of the impermanence of things since I started spending time with people who are dying. I've gone from

IRENE BORGER (b. 1949) is a dance ethnologist, radio show host, and writer. Her articles have appeared in the *Wall Street Journal*, *Los Angeles Times*, and *Architectural Digest*. She conducts writing workshops for AIDS Project Los Angeles.

Satiric Dancer, 1926. André Kertész

wanting to be an "Inspiration" with a capital "I" to *doing* something that has turned out to be truly inspiring to both me and the people I work with.

About five years ago, I sat my first Buddhist retreat. A week of silence in the mountains of New Mexico. I encountered enormous physical pain in those seven days of sitting. The Buddhists talk about life's ten thousand joys and sorrows, and when I was able to begin to really look at pain and sit through it, something got larger. On that retreat I heard a voice. It wasn't like I'd flipped out and had a psychotic break. The idea to do a writing workshop for people with AIDS *came through me.* When I got back to L.A. I applied for a grant I'd heard about, got the grant, and started the first group in the fall of 1990. A door had opened. I worked hard to plan the workshop, used every resource, every inch of myself. I found that I could teach in a way that touched people very much, that opened something deep inside them.

Twenty-six people have died since the project started. I teach three on-going groups, two for people who are HIV positive or have AIDS, one for caregivers, health professionals, and significant others. The workshop is a very passionate place for people to lie shamelessly, to tell truths they're afraid to tell, to become more and more articulate. A lot of autobiography gets written, dealing with everything from Eros and lime green high heels to death. The work is extraordinary. Most of the people I work with have a clock ticking in their heads, and it's important for them to find their voices, to write while they still can. We inspire one another. We are all Magda.

When I used to look at this picture I wanted joy to be perpetual. But I've learned that it's not a fixed state. It can't be possessed. I may delight in this picture now, but I don't need to

hang on to it. Still, I'm drawn to this picture's sweetness again. I don't think it's an accident that right now, five months after Philip, my companion, has died, I've just gotten the picture rematted in a beautiful Art Deco frame.

Now when I look at *Satiric Dancer*, I can't help but think about swan songs and people dying, about the writer's workshop, and some of the very funny and campy things that have happened there. Even in the midst of lesions and pneumonia and beautiful thirty-two-year-old men with canes, joy is still around. Maybe it lasts for as long as André's shutter was open, but it's there. And the best thing I can do is *really* pay attention. As much as André loved that moment, I love these moments that appear before me. "The glass is already broken so I enjoy it incredibly," one Buddhist teacher said.

This picture is what Magda left behind, and I love her for it. I don't think of Magda now as an object for the "gaze" or as a sacrificial muse for the Great Male Artist. Now I just want the channel to be open in myself and in everyone I encounter, and we each serve differently. This picture is one of the marvels of this evanescent life. But there are many.

Nothing I saw as a child was ugly. In the Arizona desert, where I grew up on a ranch, everything was spectacularly beautiful and idiosyncratic. The desert teams with poisonous snakes, scorpions, and tarantulas. You have to be aware of every step you take to make sure you are not going to step over a rock and find a rattlesnake on the other side. I learned very quickly to pay attention to everything visual, for self-preservation, if for no other reason. And it was my early exposure to the designs of Nature that helped me to appreciate what is extraordinary in man's interpretation of Nature.

The first time I was aware of photographs *seriously* was in 1955, when my mother took me to the Museum of Modern Art to see "The Family of Man." I was fifteen. I remember it, even though I didn't know what to make of it. Until that show, photographs were like journalism to me, like the newsreels at the movies, disposable information that went by you in a hurry. The photographs in the exhibit were pristine, beautiful prints. Suddenly you could see *photographs* for the first time, and everyone walked through the show as if they were having a religious experience. Remember, we were very prudish in 1955, and people were shocked or embarrassed by certain pictures. There was a photograph of a baby being born, a scandal to everybody. There were two soldiers holding each other in their arms, black and white people with their arms around each other. They didn't shock me. I was actually thrilled to see that all these human relationships could take place, relationships that seemed to be impossible or forbidden at home or at the Episcopalian prep school I was sent to, or later at Yale University, which I remember being a hotbed of bigotry.

It *is* interesting that I get to use the visual skills I learned as a child in my work today. The photographs in the picture books I do for Tiffany's of things like home interiors and table set-

tings represent the "It's fun to dream" theory. They're of objects and of situations that never exist quite in the same way in the three-dimensional world. In a photograph real time is suspended, therefore, you can study every tiny glint on a glass, and see things that in no way would catch your attention if you're living in real time. A photograph forces you—to use the obvious word—to focus. By focusing and by cropping out what you don't want by arranging everything in a photograph, you can close all the exits. In my books, I never allow the eye to pass under the subject. Let's take a photograph of a table, because that's the simplest situation where you can pass *under* something visually. It's the first thing your eye will try to do. If we're told to do something, the child in us will insist on doing exactly what we are being told *not* to do. So a photograph basically gives you the instruction, "Look at me!" But if there is something distracting in the picture, you're going to run away. And I try never to let that happen.

In this day and age, we are all so completely conditioned by photography that we've come to see the world in two dimensions, as a flat photograph, a flat TV screen, a flat movie screen, a flat page, a flat billboard. It's an entirely flat and imaginary world we inhabit. And the nature of photography proves to us that life totally changes from one instant to another. Whatever is going on in a photograph is *not* going on anymore and *will not* go on again. Photographs are instant history. But a photograph is also evidence and can tell you something or can be a springboard for the imagination. You can wander off into positive and useful mental explorations when provoked by a photograph.

Perhaps that's why photographs tend to make me uneasy. They provoke anxiety, raise questions about their inaccessibility. If you are looking at a good photograph, it's insistent. It tries to

JOHN LORING (b. 1938), senior vice president and design director of Tiffany & Company since 1979, is the author of several books, including *Tiffany Parties, The Tiffany Wedding, Tiffany Taste,* and *The New Tiffany Table Setting.*

pull you out of yourself, into *its* mythic world. It's like flinging off a cliff or trying to leap across a chasm, where you know you are not going to make it to the other side. A photograph beckons you, "Here I am, you *must* look at me. I am another form of reality, and you *must* focus on me. But you can never get here. I am on the *other* side. I'm not a mirror, where you adjust the image emotionally. I'm simply somewhere that you're allowed to glimpse in this one frozen image. And if you wish further information about this world, it will be denied."

Here I picked the earliest picture from my childhood, a picture of my mother that was always hanging in a hallway of our house. As a kid, I was a little ragamuffin, walking with my lunch pail to a one-room schoolhouse. All the little girls wore faded, patched gingham dresses with the bows untied at the back and with various kinds of dirt wiped on their skirts. But the image in our house of this perfect little girl in her white dress was something for me to dream about. She was cleaner and had prettier clothes and looked like she had more of a fantasy life than the little girls at school. This photograph let me dream about a mysterious, foreign place where people did things differently. In the desert of Arizona, *this* was glamour.

It was taken on July 14, 1905, my mother's fifth birthday. She's trying to look like a little sailor, or the photographer's trying to make her look like a little sailor boy. This photograph represented a world to which I had *no* access. I was fascinated by the idea, for instance, of the cut stone wall in the background with vines growing on it, even though it was painted. In the desert, there are no vines on anything. It's too dry, and nothing is made of stone. The idea that you could wear patent leather and not get it scratched and dirty, the idea you had perfectly pressed clothes, rather than patched gingham faded by the blazing Arizona sun, that a straw hat could be pretty, that it

wasn't a cowboy's sweaty straw hat was fascinating. And she was *beautiful.*

It's also a Renaissance portrait of a saint ready to be shot through with arrows, ready to be martyred. And there's that quality about children, they're about to be martyred. So the pose and the idea are a perfect representation of that innocence and yearning and wistfulness of the child who doesn't understand what's going to happen. And at the same time, there's a certain sexuality to it. My mother grew up to be married four times and had some pretty flaming love affairs. Maybe you can see that in this photograph, too.

In my grandmother's house, there was a single picture frame that had ten pictures of my mother in a row, from age one to ten. My grandmother had my mother photographed on every one of her birthdays. It was very impressive to me, because there was change, in front of my eyes. My mother went from this tiny little thing, the size of a cat in my grandmother's arms in 1900, to a pretty, grown-up, pulled-together, ten year old. This picture was in the middle, and one focused on the center picture. I think my mother put it up in our house, because she liked it the best. She thought it best represented the way she grew up to be. If you knew her in later life, and you saw this picture, you'd say, "Of course."

China Loring, Chicago, July 5, 1905. Photographer unknown

58

My whole professional life has been involved with the gradual expansion of the idea of what pediatrics and child care is. I got involved in pediatrics because I was the oldest of six children. I also identified with my mother and her intense delight with babies. By the time my brother was born, I was nine years of age, and I participated a good deal in raising this kid, giving him bottles, changing diapers, and rocking him to sleep. That was my first dim idea of what my career might be. That was the *emotional* basis for my career. Then, when I was an undergraduate, I worked in a home for crippled children in Connecticut, and watched an orthopedic surgeon perform an operation on a child crippled with polio to make it a bit easier for him to walk with crutches. I thought, "Well, it would be nice to be a children's doctor."

I had no idea of the difference between pediatrics and orthopedics. So, I went to the Yale Medical School and got some information. They told me about the chemistry, physics, and biology prerequisites I needed, and I said, "Well, I'll take those, just in case." But I majored in English and history, which I think was a wise thing to do. Nowadays, it's much harder to get into medical school, and too many people try to wedge their way in by taking only science in their undergraduate years, thereby losing their last opportunity to broaden their vision a little. It was so easy to get into medicine then. I had a C grade average and Yale Medical School said, "We're glad to have you!"

I became a pediatrician, and was still thinking of pediatrics as a medical, or surgical, health problem. There was no psychology taught in the study of pediatrics at the time. "Thumb sucking?" "It's a bad habit. Paint the thumb with some evil tasting stuff. Put aluminum mitts on the baby. Spread-eagle the baby and tie his wrists to the side of the crib," was the attitude. Well, I got

the idea, somewhere, that it would be good to train in psychology. In the medical tradition, I took a residency in psychiatry at the Payne-Whitney Clinic in New York, which consisted of the study of manic-depressive and schizophrenic adults. But it had nothing to do with helping mothers, who were asking specific, psychological questions like, "When do you start toilet training?" or, "How do I get this baby weaned from the bottle?" I decided that the next year, when I started pediatric practice, I would also take some psychoanalytical training, which I did, and that came closer to what I needed. At least there were concepts about stages of emotional development. That was the first big step in expanding my idea of pediatric practice. If I deserve any credit, it's for getting the idea that I should have some kind of psychological training.

I practiced pediatrics in New York for fourteen years all together, with two years out for the Navy. They were rather miserable years, in the sense that I was struggling to support my family and to reconcile Freudian concepts with what mothers told me about their babies' behavior and what mothers said were their problems. I never doubted that the mothers were right, or that Freud was right, but they didn't fit together. Ten years after I started pediatric practice, an editor from Pocket Books asked me to write a book for parents. Not because I was well known—I was utterly unknown—but because they had made inquiries and had found that I was the *only* doctor around who'd had any formal psychiatric, psychoanalytical training.

The editor was a sort of a jokester, though he was serious underneath, and he said, "It doesn't have to be a very good book. It will be a best-seller. We'll be able to sell it in the tens of thousands every year." That helped in two ways. One, I

BENJAMIN SPOCK, M.D. (b. 1903) is a pediatrician and the author of *Baby and Child Care*, which has sold over thirty million copies and has changed America's attitudes and practices toward child rearing. As a political activist, he spoke out against the Vietnam War, and advocates nuclear disarmament.

Children fleeing a napalm strike, Vietnam, 1972. Nick Ut

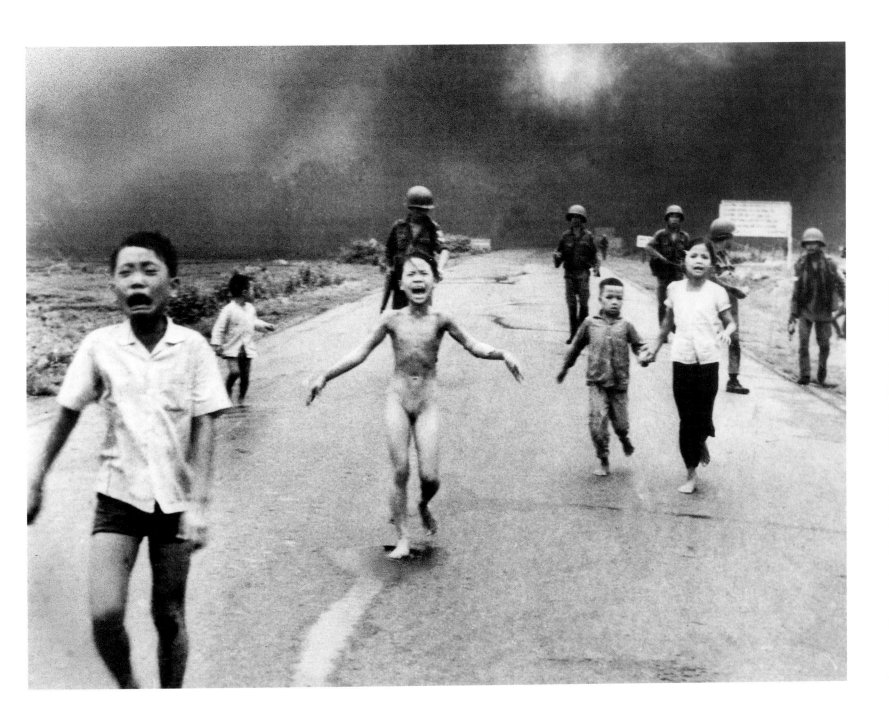

didn't have to claim that it *was* the best book ever written; and two, the idea of reaching ten thousand families a year appealed to the do-gooder in me. So I wrote the book, and it helped me to form my ideas. As often happens with me, I don't know what I believe until I try to write it down. It was out of that pediatric practice experience that I was able to reconcile the Freudian, the mother, and the baby data. I gave up being a practitioner and became a teacher as a result of writing *Baby and Child Care*.

I had never specifically followed the effects of nuclear bombs on the children in Japan after World War II, but being aware of the fact that children were killed was a step in my realization that pediatrics was even broader than psychology. In 1964, I was asked by Lyndon Johnson's campaign committee to support him. He said he would not send American boys to fight in an Asian war. So I said, "That's the candidate for me," because Barry Goldwater had said we should bomb the Vietnamese into submission. It was very easy for me to say, "Yes, not only will I, but I should, become an antinuclear and disarmament person." But when Johnson escalated the war just three months after he won the presidency on his promise not to send American boys. I was outraged and quadrupled my antiwar activities.

In 1967, when I had to retire from teaching because of my age, I became involved in politics as a further extension of my ideas that pediatrics is not just vaccines and wonder drugs. I was persuaded by the SANE people, the National Committee for a Sane Nuclear Policy, to become politically active, because as a pediatrician I would have an influence over parents. They were particularly interested in getting a test-ban treaty between the United States and the Soviet Union. Otherwise, as other countries developed nuclear arms and wanted to test them—just

from testing alone, not necessarily from war—more and more children would be born with mental and physical defects and would develop diseases like cancer and leukemia. In the next eight years I spoke against the war in Vietnam at hundreds of universities at the invitation of the students.

At the time, people thought I was counseling people in draft resistance. As a psychiatrically trained person, you have no business telling anybody what they should do. You only hear what their problems are and help them formulate their own solution. My job was to go to colleges, where there was already increasing resistance to being drafted, to tell them that an older person was against this war, too. My talks were about the history of Vietnam. We tried to present the facts. And, by implication, that it was all right to decline to be a part of the war. I never counseled anyone. I simply said, war is wrong. Let us get out of it just as fast as we can.

But let's get to this picture. It was taken a year before the American troops left Vietnam in 1973. Although it didn't give me my idea of becoming a disarmament and peace person, it confirmed my notion very, very strongly. We shouldn't have been in Vietnam. Intellectually and morally, we had no excuse for being there. We were killing lots of people, but they were just statistics, or body counts. When I saw this picture, it horrified me. Setting fire to children is absolutely horrible. We were hurting kids and civilians, not even drawing distinctions between soldiers and civilians. There's really no excuse for it.

I was never a television watcher, so I must have first seen this picture in a newspaper or in a weekly magazine. And my response was very strong. If you burn your finger with a match, you know how much it hurts. But how much must it hurt to

be covered with burning napalm? The agony must be horrible. I tend to be only a moderately feeling person. I've even been accused by wives of being relatively unfeeling. The whole male sex gets accused, because males are somewhat different than females. But it was easy for me to identify with the children in this picture. The boy in the picture is ten or eleven; he doesn't look as if he's gotten into puberty. And the girl is a year or two younger, nine or ten.

I became very indignant when Dow Chemical, who made the napalm, said, "Its not our business how it's used. The government orders it and we supply it." Well, I think that industry has to have a conscience. As organizations get bigger and bigger, each person has less and less responsibility and can say, "That's not my job." Kids should be brought up to question their government's policies. Young people should be educated, all the way through school, to come to independent judgments. In most schools, from kindergarten on, children are indoctrinated, taught to be compliant. I think they should be taught to question, to make up their own minds, to not be afraid to be creative or different than other people.

The Vietnam War was not the first instance of parents' antiwar sentiment, or of concerns about kids seeing violence or playing with guns. People were asking questions about that way back in the 1930s and 1940s. Conscientious and sensitive parents would come to my office and say that their boys were playing with war toys, asking how could they stop them. And I said, "That's a stage of development." My sons were fascinated with war games, with violent comic books and radio violence, and they turned into sensitive, thoughtful people. So I realized it was not just a stage of a child's development. It's giving them ideas. But it's not all right to allow the children to watch violence on television. Even if right triumphs in the end, neverthe-

less it gives children the idea that violence is one of the ways you solve human problems. We ought to be teaching alternative ways of solving problems.

It would seem to me, and I haven't spent hours studying this, that the influence of a picture like this is strongly antiwar. Warlike men can rationalize it away by saying, "Well, it's one of the inevitable, unintended results of war. It's too bad, but wars will always be wars." It gets discouraging because there are more wars now than when I became interested in disarmament and peace. Well, it would be a lot worse if there had not been an antiwar movement. We'd still be fighting in Vietnam. Pictures like this, which show the horror of suffering, must inspire us, must teach us something.

This picture is the most copied photograph I've ever published. I have seen variations of it in practically in every magazine since it appeared in *Vogue* in 1991. "Woman's Wear" did a story in which fashion photographs designers remembered that year, and something like nine out of twelve picked this picture. I've seen how *this* picture has influenced fashion, collections, and photography.

What Karl Lagerfeld, who designed these outfits, was trying to do with this particular collection, and what he continues to do, is to deconstruct fashion. The whole idea of just one look, top to toe design where everything is perfect, is very de mode, and Karl understands that. Taking a ball gown and putting a leather jacket over it was a great symbol of that attitude. I think Karl was very bored with the whole idea of the Chanel suit, which was the ladylike look of the eighties, and so he started to break with it.

At the same time, there were an awful lot of influences coming from rock and roll, since those guys get so much coverage because of the way they look and dress. What we were trying to do in this image was to pull fashion back into the street and add that Marlon Brando, *On the Waterfront*, feeling to symbolize what was happening in fashion today. It was a moment of change, and being *Vogue*, we have to symbolize change. If you just go on showing straightforward beige suits like I have on today, nothing is going to change. Fashion is a reflection of the times. It always has been, and it always will be.

When *Vogue* is going to pick up on a particular look, a fashion photograph extends those ideas. A *great* fashion photograph that makes people think about fashion in a different way,

ANNA WINTOUR (b. 1949), editor-in-chief of *Vogue* magazine since 1988, began her magazine career in 1970 at *Harper's* and *Queen* magazines in London. She was previously editor-in-chief of *House and Garden* and British *Vogue*.

Vogue magazine, September 1991. Peter Lindbergh

wild at heart

Lifted from the runway to strike a pose out of *On the Waterfront*: rough but romantic styles by Karl Lagerfeld for Chanel. Left to right: lace top, quilted leather jacket, and silk skirt; leather bomber and blue silk skirt; leather jacket and pink silk skirt; black leather bustier, leather jacket with white lining, and black silk skirt; leather bomber and pink bustier dress; leather jacket and burgundy bustier dress. Details, stores, see In This Issue.

490

makes them think, "Oh, my god, I've got to change the way I look." It has to have a real cutting edge to it, because there's an endless stream of pictures in the world, and we publish pictures of many really nice clothes on smiling pretty girls, which is fine, but they don't threaten anyone. For fashion to change, for everyone to start thinking differently, it often takes the most outrageous photograph, and often the most outrageous fashion, to get the trickle-down effect. So I, as a fashion journalist, respond to that.

A fashion photograph comes from the clothing, but it is up to us to generate the *feeling* of the clothes to the public. The reader might think, "What are all those girls doing in ball gowns in the middle of the street in Brooklyn?" That is the average person's point of departure, and then they start to think about it. Maybe they'll go back to the picture, or the next time they see a black leather jacket in the store, they'll try it on. So a good fashion picture makes people think, "I want. I want. I need something new." *You* may not go out and buy this ball gown, but a lot of people will go away thinking, "I need a leather jacket," or, "I think that's the sexiest look I've ever seen."

Of course, you have to balance provocative portfolios with much more conservative and straightforward ones, where you can see the clothes more clearly, because different things appeal to different people. When I've been on an airplane, I've seen women going through *Vogue* and ripping out pictures, but those pictures are about needing something specific like a pair of gray pants. This is a picture that changes fashion. Without sounding too egocentric, *Vogue* has the influence to change fashion as much as designers do, because of the way we present it. We know what the power of the magazine is. We hear it from the stores and from our readers.

At *Vogue*, we have a very talented group of production editors, and about five editors who work directly with designers. We'll say to a designer, "Well, we're thinking about this. How do you feel about it?" The designer will often make things for us, or he will say to us, "This is what I'm doing for my spring collection. What do you guys think? Do you think this is right? What do you think about skirts?" It's a continual exchange. It's not that we would ever tell a designer *what* to design, but we're certainly eager to tell them what we are thinking about. The same relationship exists between designers and store buyers. It's all a collaboration. If we work enough ahead of time, we can have clothes placed in stores before an issue comes out, or we can call Bloomingdale's or Bergdorf Goodman and say, "This is a new designer, and we think you should see the clothes because we believe in him or her."

We knew leather was going to be an important portfolio in the issue. The art director, the fashion director, and the editor were in on the sitting. The fashion editor looked at *On the Waterfront,* and we discussed it. We always knew that Peter Lindbergh would photograph it. Peter is a wonderful photographer. In this instance, the idea was given to him by the fashion editor, but then he took it and made it his own picture. It's very rare, in my experience, to find fashion photographers—and they are very special people—who can come up with ideas. That's why a good fashion editor is so incredibly valuable, especially someone with an interesting vision about what fashion photography should do.

Fashion is no longer the realm of the privileged person. It's more available now to everybody and it *should be.* We're all running and doing things. Life is full. The success of the Gap obviously stands for that. People don't want to be so uptight anymore. But I don't feel that because the world is in such

straits that women shouldn't feel good, or that they should go around with no makeup and looking horrible. Just because you look good and take care of the way you dress doesn't mean you don't care about what's happening in Somalia or Bosnia. Why does one negate the other? I think it's a ridiculous, old-fashioned way of thinking, and the worst of feminism, to say that fashion can't be taken seriously in today's world.

Some critics have commented that there isn't enough differentiation between editorial and advertising photographs, that they look too much the same. What's happened is that a lot of people enjoy the advertising in fashion magazines, too, since advertising has become so creative and people have become image conscious. Sometimes advertising is more about image than about clothing, therefore manufacturers and designers have gone after creative photographers like Bruce Weber to create a mood.

Because *Vogue* feels that its photographers are very, very key, I've made a big effort to keep certain photographers with Condé Nast. They give us a look that is vital. Obviously, Irving Penn's been key to *Vogue* for forty or fifty years. Of all the photographers, Arthur Elgort's pictures have a charm that's really unique. His relationship with a model catches something another photographer might make banal. He makes a picture look *real*. Helmut Newton stands alone. I think he's incredible, a very powerful force in this magazine. The sexiness of a Bruce Weber or a Herb Ritts is important, too. What is *most* important is to have a nucleus of photographers who are constantly in the magazine and who feel connected to the magazine, to my editors, and to my art department. Everyone working together produces a very strong magazine.

I saw this picture when it was first published in *Life* magazine in 1943. I kept the magazine and referred back to the picture from time to time. During World War II, it was controversial. People said one shouldn't show dead American bodies, because it would undermine morale. This photograph was taken after the Marines landed on Tarawa, an island in the South Pacific. There was a lot of criticism that a serious tactical mistake had been made. The Marine's timing of the tide was wrong. Although one can't see it in the picture, the Japanese had a dock there, and the Marines were swept under it. A lot of them drowned. They were not killed by enemy fire, they *drowned*. While it was controversial, what it did really—as, I expect, was understood by the people who decided to release this photograph and the story—was harden the resolve of the American people and made them realize what was going on in the Pacific.

You have to understand that I was eleven years old on December 7, 1941, when the Japanese bombed Pearl Harbor, so I have vivid memories of that attack. I know *exactly* where I was—in the home where I lived with my parents. We had an old radio, one of the big ones that was larger than a modern television set. We were listening to it when Gabriel Heater interrupted the program and said that we shouldn't get terribly excited or upset. He said, "You know the Japanese are a very volatile people. This may not mean war." My father said, "Oh, Mr. Heater doesn't understand. This *definitely* means war. We are at war."

I *absolutely* believed that I would be involved in the war, because I planned to lie about my age when I was sixteen in order to get in. Even if my parents didn't let me, then at seventeen I *knew* I could. There has never been an eleven-year-old like me, and there never will be again. I wasn't scared at all. As a matter of fact, I was eager to be in the Second World War.

Right through to the end, I continued believing that I would, because even after V-E Day, which was victory in Europe, the talk was, "Wow. We are all aware of how ferocious the Imperial Japanese Army and Marines are. Imagine how long it is going to take us and what casualties we're going to sustain having to take the home islands of Japan, island by island. We'll be in this thing until 1960."

Then, without consulting me, Harry Truman dropped the atomic bomb, first on Hiroshima and then on Nagasaki. The war was over, and I can well recall, I was fifteen then—a year to go—everybody was in the streets, weeping for joy, and laughing and carrying on. But I was weeping bitter tears because of my lost opportunity to fight in World War II. In this picture one could see what these men were doing for their country, and I had huge feelings of guilt, because I was safely back in the United States of America, while these guys, who were just a little bit older than I was, were dying.

I knew they needed replacements, and that's what I wanted to do, but nobody would listen to me. The ironic thing was that my father had gone through exactly the same thing. He had tried to volunteer for World War I when he was underage, and they'd said to him, "Go back home, sonny, and come back when you're shaving." Of course, by the time he could have gotten into World War I, that war was over. It seemed to be history repeating itself. He was too old for World War II.

One had to have lived during the time to understand why I wanted to be in the war so badly. The entire nation was focused on defeating Evil incarnate, the Nazis. Everyone hated

G. GORDON LIDDY (b. 1931), educated as a lawyer, was general counsel of the 1972 Republican presidential campaign, and served five years in jail for his role in Watergate. Author of three best sellers, he is a contributing editor to *Forbes* magazine and radio host of "The Gordon Liddy Show."

U.S. marines ambushed on Buna Beach, New Guinea, 1943. *Life* magazine, September 20, 1943. George Strock

S

ECT IT IN THEIR NAME

...ra doesn't show a road leading
...ood lot under the big harvest
...sn't reproduce the sound of a
...hen she told him, or the feel
...r the memory of her promise,
...sn't show the pool hall where
...y baseball scores, or the Com-
...g back in his law office with
...d his head, or the banker
... Sam Lawrence, or the min-
...t pointing upward to where

...doesn't show America, not
...ica, not even her mighty
... even the great gray cities
...ans tramping through the
... the paraphernalia of war.
...n it couldn't show any of

...the beach is America,
...dred and thirty million
...nts of that life we call
...nts of freedom.
...t these boys who have
...dom that has fallen: the
...und, the sight of free-
... realization, the mani-
...perience that freedom
... upon the white New

...of freedom.
... only here at Buna,
...alcanal, where the
...nd not only in half-
... only in trembling

...reedom all over the
...am of freedom, or

...ills of China, and
...Prague, and in the
...d along the jagged

..., now, there are
...mbol, and all over
... shot down, like

...g to understand
..., if freedom is to
... die.
...m is something
...t of principles.
... package. But

... of freedom are
...g them back to
...aning to their

...freedom falls,
...una, it is our
...not in living
...nd to which
...mighty sym-
...men, which
...to increase.

Three dead Americans
on the beach at Buna

35

what they were doing to the Jews, what they were doing by bombing and strafing the refugee columns, and all the rest of it. There were photographs published of Japanese officers decapitating prisoners with their samurai swords. I don't think people these days understand the depth of the resolve and the ferocity that seeing pictures like this one engendered in our troops and in our country.

The entire nation was focused. We plowed up our lawns, planted vegetables, and had "victory gardens." We went around collecting aluminum pots and pans with which to build aircraft. We all bought war bonds and stamps to support the troops. If you even looked as if you were of military age and you were a male walking down the street in civilian clothes, people would stop and say, "Why aren't you in the military? Why aren't you out there with our people?" Virtually every window had at least one or more blue stars in it, meaning, "We have a son in the armed forces." If you had a gold star, it meant you had a son who had been killed.

Then came the invasion of Tarawa. Even though there was an error—the tidal current was severe, and some Marines were slaughtered—they made it through. The angle of the camera was carefully chosen so you would not see any of the Marines' faces. There was a lot of blame going around about what had happened, but it was quickly dampened.

There was never anything in my life experience before, and never anything since, like this war. I, of course, from that experience, was particularly horrified, disgusted, and nauseated by the actions of Jane Fonda when she went over and sat on that North Vietnamese antiaircraft gun during wartime. Just imagine if you can, Betty Grable, Rita Hayworth, or someone like them, traveling to Berlin in 1944 to sit on a German gun, and

cheering and carrying on as the Germans fired on the Eighth Air Force, which was then in the skies of Europe bombing Nazi Germany. Imagine how someone like me feels—I subsequently did serve in the armed forces of the United States during the Korean War—to have a man who dodged the draft, and who ran away to another nation to avoid military service in time of war, as my president. I'd have done anything in my life to be able to serve. It is just mind-boggling.

Since 1941, when I was unable to fulfill my goal, I have always been trying to find something that approaches the moral equivalent of the Second World War. I finally found just a tiny portion of it in the challenge of resisting all three branches of the United States government who were seeking to coerce me to talk in Watergate. I said to myself, "Well, I didn't make World War II, but by God I'm going to fight and win this battle." And I did.

When photographs like this one were published, they showed the sacrifice. The government handled the news media correctly back then. They established an Office of War Information, which was headed by a very prominent newsman named Elmer Davis. The press people were put in uniform, taken over, and there was no way that the press was going to report what the OWI did not want it to report or send back stories that might damage morale on the home front. It was forbidden for damned good reasons. The idea that it would be all right to publish the sailing schedule of ships, when Nazi wolf pack submarines were out there waiting to intercept them, was thought of as absurd. They asked Admiral King, who was Chief of Naval Operations, "What shall we do with the press?" He said, "I'll tell you what to do with the press. Tell them when the war is over, and tell them who won."

In World War II, there was nothing like the treacherous activities of the American press during the Vietnamese War. This is why the press was thoroughly controlled at Grenada and Panama. The military had learned its lesson. They understood from the Vietnamese war that the press was enlisted in the cause of the enemy. In World War II, we'd have shot them.

Eventually I went to college and got my commission through the ROTC. I graduated during the Korean War, and I was immediately put on active duty. After I went to artillery school at Fort Bliss, I was all set. I had my Preparation Overseas Replacement qualification to go to Korea and was virtually en route. I had one more test to take, the "Night Combat Infiltration" course. The night before the test we had a contest in the Bachelors' Officers Quarters as to who had the strongest stomach, and I won by doing repetitive sit-ups. I did hundreds and hundreds of sit-ups, not knowing that I had appendicitis. I blew my appendix, had to be operated on, and was declared unfit for any duty and sent home for ten days. When I came back, I took four belts and cinched them across my wound, which was six inches long, all the way up the abdomen. I went through the course successfully, crawling over logs, and dodging high explosives. I was on my way to Korea when another officer, who knew what I had done, ratted me out. He said, "You can't send him, because the only thing that's holding his guts in are these belts." Even though he had been a friend, I didn't talk to that guy for years. When I was ready medically, the war had ended. Eisenhower had ended the war without consulting me, and there we were again.

When I look at this picture now, I *still* see World War II. I see I should have been there. We all think we're immortal at that age: I would have charged the Japanese line, and so on. That's the kind of person I am, always charging lines, which gets me in a lot of trouble. I was virtually that way at eleven. It was just a matter of time before I could do what I wanted to do. I have always suffered from a shy, retiring personality, as we know. I'm always giving vague, ambivalent statements.

The Marines in World War II epitomized the highest degree of American virtue: courage, perseverance, dedication, and intrepidity. We were on the right track, and then after the war, we started to lose our way. One of the reasons we did so well in the Second World War is that the generation that fought came from the severe hardship of the Great Depression, and they didn't feel sorry for themselves. "Hey there's yet another tough job to do. By God, we can do it. Let me at 'em. Praise the Lord and pass the ammunition."

In a sense, the prosperity that came after the war started to undermine that determination. Over the next few years, the core of the United States is going to be tested and challenged. We will either resist and become stronger, putting into practice Nietzsche's adage: "What does not destroy me makes me stronger" or follow our wartime, draft-dodging President and falter. I hope the country may become stronger, and may reflect upon where we came from, what it is that made us great, and how we have to behave to become great once again.

I saw this picture once, in *Life* magazine in 1950. Back then, I was studying at the American Theater Wing under the GI Bill, and working at Associated Press as a runner. Even though I never forgot this picture, it is different than I remember. All I remember is that the picture was black, and that Picasso did this fantastic drawing. But the reason I've always been affected by it is because everyone puts down modern art. They say, "These guys can't paint." But if you'd show them this picture, they'd see Picasso did this wonderful sketch of a bull in a second. That quick. They couldn't stop him. Picasso's kind of energy comes from passion. If you're blessed with it, you're driven. How many educated people have I met, how many college graduates with great marks and everything, who are frustrated because they don't know what they want to do? Imagine.

We live in a capitalist society, where we have to make a living and we're forced to be specialists. Everybody does his job. I always had a passion to paint and sing. And singing came first, it's my circumstance. But I've been painting my whole life. I went to The High School of Industrial Art, up near the Metropolitan Museum of Art. I paint every day. I still study.

Actually painting and singing are very similar. You're thinking of line, form, color, balance. You learn what makes something work, makes something miss. The rudiments are the same. How much do you put in? How much do you leave out? If either one is too white or too black, something's wrong. It's the middle values that harmonize singing and painting. Art and music really feed each other. If I were just a singer, I'd get burned out doing the same things over and over again. But when I'm singing, I'm thinking painting. And when I'm painting, I'm thinking singing. What would I do if I had to pick between being a singer or a painter? I'd say what Jack Benny

said when someone asked him, "Your money or your life?" "I'm thinking, I'm thinking."

The one thing I notice about the difference between photography and painting is people look at photographs fast. David Hockney taught me a complex answer to the differences between photography and painting, and it's fantastic. The camera, with just one eye, sees everything. So when you see a photograph, you just see a cut-out, kind of flat. It's not really truth or fidelity. It's just a picture. And you don't see everything that's in front of you at the same time. What I do see, when I look at you, is your left eye first. Then I see your watch. Then I see your hair. There's an eeriness about it that's hard to define. Our minds are like computers, and they go bup, bup, bup, bup, bum. It all registers, and I see who you are.

But when you look at a painting, all these questions start hitting you. Watch people in museums. They'll stand for a half hour sometimes, looking at just one painting. It's magical. An artist takes a two-dimensional thing, his painting, and tries to make it look three-dimensional. If it's successful, like Rembrandt, you look at it and think: "How did he get that to look like a piece of metal? You can actually hear the clang of it." Painting's very entertaining. You look at it. You study it. You think about it. I don't distrust photography. It's fascinating. But isn't it better, when you see an early Flemish painting, or a Michelangelo, or a Leonardo da Vinci, or a Raphael, and you wonder, "How did they do it?"

TONY BENNETT (b. 1926), one of the most popular vocalists of his generation, has won two Grammys, one in 1962 for "I Left My Heart in San Francisco," and another in 1993 for Best Traditional Pop Vocalist. His other hits include "Stranger in Paradise," "Rags to Riches," and "Because of You."

Picasso paints a centaur with light, 1950. Gjon Mili

This photograph *changed* my life. Through it, I found a window to the truth in history. I have always been a collector of many different kinds of things. Years ago at an antique firearms show, a dealer and friend of mine said, "You're a doctor. You should be collecting things that are medically related." My friend showed me this photograph and said, "This is a daguerreotype." He explained it came from South America and was taken by a famous doctor. He also said that daguerreotypes were really something I should look into.

It was *beautiful!* And, it was around three thousand dollars, expensive. We're talking about 1975! Never having seen a daguerreotype before, and knowing how collecting goes, the only way I can describe my reaction was, "Well if he has one, I can go out and get another 50,000, just like it." So I didn't buy it. But I thought, "Wow, this is exciting. I'm going to look into this." A month later, I had to go to a tennis match. On the way there, I stopped at the first photo show I'd ever gone to. I walked into a room and was surrounded by pictures. There I was in Tutankhamen's tomb, heaven. And my hunch was right. You could get all the medical pictures you wanted. The first one I picked up was three dollars, a picture of a doctor with a Laennec stethoscope. I picked one of this, one of that. Whatever I could carry. It was instinctive. I figured I'd learn about them later. After a half an hour there, I'd spent every dollar I had on me, but I couldn't find any daguerreotype like the one the guy had shown me.

Within a week, I'd read every book on the history of photography. They didn't include too many medical photographs. Then I took the key step in serious collecting. I got a list of the major collectors and called them up, one by one, to find out what they had. And they said, "Sure I've got a couple of those, but I was thinking of throwing them out. I can't look at them, and

they scare the neighbors. You can have it." And that's how I really started. Within several years, I had bought up most of the available medical daguerreotypes in the United States. Two or three years later, I finally got this picture by trading guns for it. Today I have over 30,000 vintage medical photographs dating from 1840 to 1920.

It was easy to collect what no one else wanted. To most people, medical pictures aren't pretty. They present the dark side of life. But being a physician, I know what goes wrong with us, and I know death. The images I was seeing were different than the medical photographs I had seen in textbooks. These were *old*, the *first* images in all of medical photography. Since they weren't popular when they were made, in many cases, they were literally discarded. So it was the garbage or me. From the beginning I recognized these pictures as the gems of medical and photographic history. And I loved the pictures, the beauty of them that other people couldn't see.

Most people cringe when they see pictures like this one. They are terrified and fascinated because of magical substitution, one of the properties of photography. When you look at a photograph, you magically substitute yourself in it. You put *yourself* in the picture. For instance, many people looking at Eddie Adams's picture of the American colonel shooting a suspected Vietcong lieutenant, instinctively turn their heads, as if the gun were pointing at their heads. Sometimes you don't want to look at what's in the picture, for fear it will happen to you.

We all start out thinking and integrating knowledge and understanding the world *visually*. As children, we get impacted

STANLEY B. BURNS, M.D. (b. 1938) is the creator, curator, and proprietor of The Burns Archive, a collection of over 200,000 vintage photographs. He has authored five publications, including *Photography in America 1839–1883* and *Sleeping Beauties*.

A daguerreotype of a South American Indian with a tumor of the jaw, Caracas, Venezuela, 1848. Dr. Eliseo Acosta

with lots of pictures in life. We learn to pay attention to certain ones and learn what they mean. When a child sees a dog, he understands it visually. He doesn't have the word "dog" in his brain. When we go to school, written words supplement visual impressions. At some point, most of us lose the ability to integrate the purely visual imagery our brain receives, to analyze it visually, because words are coming in.

I can still perform, to a great degree, at that pure visual level. I can "see" visual relationships, unprejudiced by word meaning. I still have that childhood visual ability, where I put meaning together without words, like grabbing pieces of the world—not by going from the big to the little picture, but from the little to the big one. I not only grasp the understanding of the picture, but I have the understanding of what it means in the context of the time it was taken.

A person looking at this picture might think, "How did he get that tumor? What can you do about it?" When I looked at the picture, I thought, "Wow. It's an African-American. He's got a tumor. The picture's early." I also realized it was unique. There weren't *any* other tumors of the jaw daguerreotypes in the world. Survivorship had gone down to zero. As it turned out, it is probably the *only* surviving clinical daguerreotype from South America. It was taken by Dr. Eliseo Acosta, who was the partner of Dr. Jose Vargas, the president of Venezuela, where this picture was taken.

Here's where my window to the truth in history comes in. The books about the history of Venezuela describe the first operation on the carotid, done by Dr. Acosta in 1848, on a South American Indian. But, what's written *wasn't* true. It wasn't the *carotid*. It was the *parotid*, a gland. I *had* the photograph that proved it. Their interpretations were *wrong*. It was then that I

realized that if I found the *right* photographs, I could rewrite the inaccuracies of medical history. And I could write a *new* history of photography, a history not based on paintings and masterpieces, but a history based on the work of innovative pioneers, who used photography as a new medium to document and preserve life in a way not previously possible. I focused on ideas erased by standard photographic histories and breathed renewed life in new topical issues, like death, lynching, and ethnicity. In photography, it is the collector who defines the art. So here I am changing both the history of medicine and the history of photography.

This picture is beautiful, because *daguerreotypes* are beautiful. If you have a clear daguerreotype, I don't care what it's a picture of, it's got a three dimensionality that suggests a reality of being in the picture. Other photographs are *like* windows, but a daguerreotype is *truly* a window. Look at the way this picture is framed. I get the feeling of being in the room with the subject, looking around in 1848. You get lost in its immediacy. It's clarity is due to the fact that the image is laid on top of silver, and you get a reflection from the silver. Look at the man's hair. Every strand glistens, as if he has just combed it. I can go over and touch him. I like his chest, I like his shirt open like that. I like that he is a South American Indian. This photograph is also beautiful because it defines this disease to me, and it defines the era in which it was taken. I can deal with this information lovingly. I empathize with this man, and I even know, as a surgeon, what he's going to have to go through. And I know as a historian what he *did* go through. No anesthesia. Primitive techniques. The chance of infection. I know the terrible choices he had to make.

As a physician, I've seen a lot of horrific stuff, but I see beyond it. Most people in our culture can't. The fact is, we *do* die. We

do get sick, and we *don't* want to know about it. Remember, at one time we lived with death in this country. In the nineteenth century, children were prepared for death. Look at Abraham Lincoln. Two of his children died, one son when he was in office. Lincoln had him dug up twice just so he could look at him. Today there is a fear of looking at death and disease. You don't want to own disease or death, but you do want to find out more about it. In America we want to know about perpetual life and perpetual beauty. We always want to look our best. And *this* picture is the worst.

Look, it's trite to say that people are fascinated by seeing things they're not supposed to look at. You want to stare at someone who looks unusual, but it's not polite. Not socially correct. However, with a photograph, you can do just that. Photographs free you to explore your fears. They allow you to think about things and deal with things at your own pace, on your own level.

Why was this picture taken? Why did an ophthalmologist, who is a surgeon, call in a photographer? The science of the nineteenth century was recording, measuring, looking. They didn't know what was going on and thought that by measuring things they could begin to understand what was happening. So the doctor was recording, for the rest of the world, *and* for the first time, this extremely unusual case that he was going to operate on. Pictures like this were used for consultations. If you couldn't travel to a specialist, you could send your photograph to one. And photographs could be used as teaching tools. You could even do engravings based upon photographs and print them in medical texts.

This picture is beautiful to me for another important reason. In art, we're used to the conventional ways that lines describe how a person looks. But this image throws some modern art curves into my aesthetic eyes, because of the deformity of the disease. The man's a real, live person, not an African mask that Picasso copied from. But when I look at this man, I see a face as Picasso or nature would draw it. *That's* the beauty I see. I'm not revolted by the lines that reflect the change in his body, because the impact of modern art has changed the way a body can look. This distortion has become integrated into my concept of beauty, because of Picasso. Blame it on him.

ANITA RODDICK

ANITA RODDICK (b. 1942) founded

The Body Shop, an international

chain of environmentally conscious

stores selling natural skin and hair

care products in 1976. She has

been active in Greenpeace, and

received the United Nations "Global

500" Environment Award in 1989.

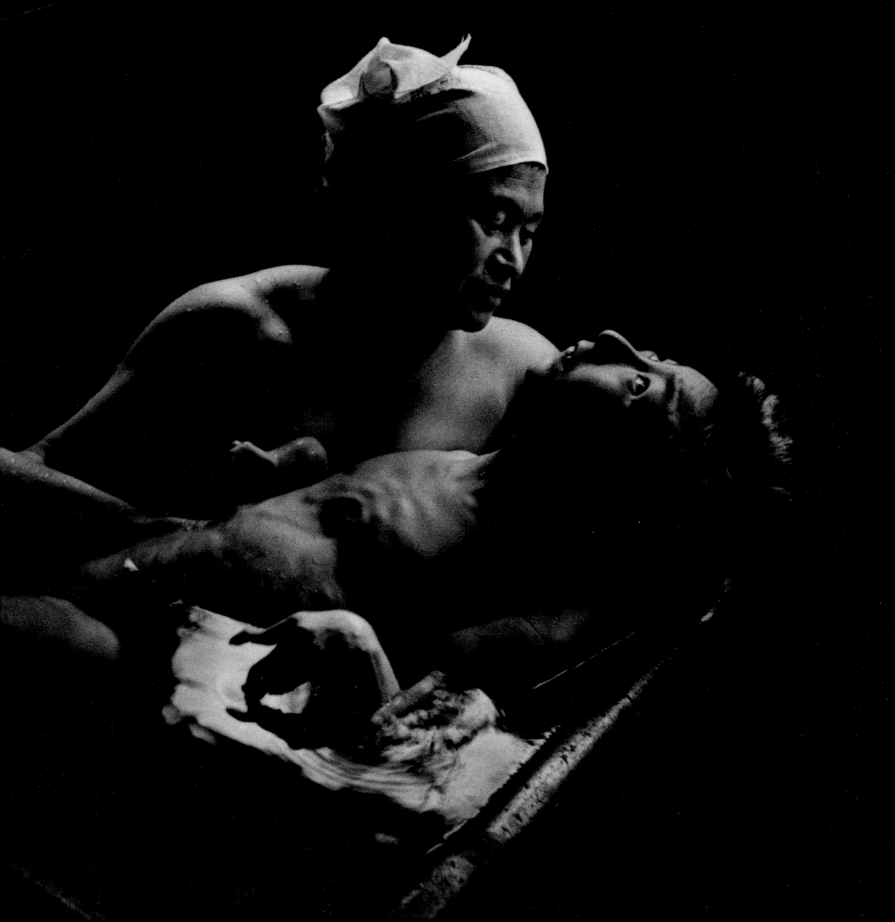

I have always thought that this photograph would be a wonderful counterbalance to the corny Revlon advertising feature, called "The Most Unforgettable Women in the World." I've always wanted to juxtapose this picture against the Revlon series of traditionally beautiful women to say, "*No!* There is another group of women out there who are faceless and beautiful. *This* is a truly remarkable woman." But we get lost, because generally remarkable women are seen by what they *look* like, by what they *possess*, and not by what they do. So this picture moves me, and its ability to do that is constant. I bring it out constantly to reflect on. It's a benchmark for me. It stills me. It pauses me.

This picture brings things down for me into one act, one relationship, between this woman and her child. It's there. The choreography of the photograph is the choreography of love. Here is a totally warped individual. Take away the face. It doesn't even look like a child. You've got hoof-like hands and hoof-like feet, and the pain is extreme. *This* is unconditional love. How is it possible, from an aesthetic view, that just because something comes out of your womb, you can love it, when you can't physically relate to it? Love is often about reflecting yourself and getting something back. That's the extraordinary thing about this photograph. If you take away all of the social things about love—such as that children are going to look like you and they're going to reflect your life and become an appendage to you—in the end, no reflection comes back. In this picture, this woman is taking in frailty and measuring herself by it, by how she treats this weak thing. To me it's a lesson, an absolute lesson, that true love is when *nothing* is given back.

Previous pages: *A mother bathes her daughter, who was born blind and maimed as a result of mercury poisoning. Kyushu, Japan, December 1971. W. Eugene Smith*

If I had looked at this picture when I was twenty, I would have given you a whole list of other reasons for being so attached to it. In my early thirties, I was birthing my children and feathering the nest, and I would have reacted as a young mother. In my forties, I can remember I only wanted to be surrounded by people I loved. I didn't want to be with fucking shits. Now that I'm in my fifties, I think, "*Now*, what are you going to do? *What's* your thumbprint? What are you going to leave behind?" I'm harder now in a way, because I measure love by service. I am constantly saying to people, "Just what do you do beyond your own self-gratification, beyond your own career? What do *you* give back?" It is the only question that matters.

Everything you are is the sum total of so much that happened in your early life. I think people like myself have common denominators. One is that at an early age things were taken away from us. And there is a sense of the work ethic. Another thing that's important is to be told that you're special, as I was, constantly, by my mother. I remember being ten years old, my father died, and that same week I picked up the very, very first book on the Holocaust. I opened this little book up, and there were photographs of the lamp shades, and of the bones piled up outside the furnaces. Well, those two incidents blended and gave me a kick start into social action. I know it was that, because Mom said to me, "Every goddamn cause that was there, you were running it." Whether it was for hunger relief or nuclear disarmament, from the time I was ten on, I was demonstrating, knocking on MP's doors. So I think that the pain of losing my father, plus seeing those photographs, developed me.

The most important thing that came through in my life was photography. The bench mark for me was *The Family of Man*, where the power of words and emotions were attached to still

photographs. Even to this day, I run my company by drawing on what I learned from *The Family of Man*. The Body Shop uses photographs and quotes on billboards and around our offices. We used to use them in campaigns on human rights. There was one photograph by Don McCullin of a Kurdish woman screaming, which we made a poster of with the words: "I will no longer allow this to happen." We got in *immense* trouble in malls in America. They said, "You can't put these in malls." So, of course, we said, "Up yours," and did. Trees are sexy, and animals are sexy, but human rights are not sexy. If I could find a way of developing as much outrage for human rights abuses in our customers as I have for the testing of cosmetics on animals, I could finally say a silent "Yeah!"

I am taught by my job. My job is my life. At The Body Shop we don't have a marketing department; we have a department of anthropology. We constantly look for tribal rituals of the body. We set up trade initiatives in small communities or indigenous groups. It is all very well planned. We've turned our shops into arenas of education. I can put up an image of a tree when we want to save the rain forest, and we'll get one and a half million letters. No political group can do that.

One has a responsibility for the humanness of the world and for the future. I have a gut feeling we've all lost a sense of community and the ability to connect. It's hard even now to dig into the recesses of your spirit to get a sense of outrage. How long did it take us to have a sense of outrage about Somalia? Years. We are burned out. Maybe it comes back to education, where there is no sense of spiritual outrage about injustice. None at all.

I don't remember if I knew about the situation behind the picture, which I saw in *Life* magazine in the 1970s: the mercury poisoning of the water by a big company in Minimata in Japan. Business certainly doesn't seem to have changed. The corporate crimes committed in business are so extraordinary, and yet still there's no one addressing the grievances. But you can't change *anything* until you have the language of *change*. With that language comes action. The revolutionary thing The Body Shop has done is to talk in poetic and spiritual tones about the responsibility of businesses, because that's the second bottom line. We talk about keeping the bottom line where it should be, at the bottom, and everything that makes a company's spirit and values—like its care for its stockholders, its education in the workplace, its empowering of its employees—should be at the top. I often think The Body Shop is an experiment. If we ever become like those giant corporations, this extraordinary experiment will have failed. Then I think, "Nada, no chance, never."

Mardi Gras is all about the people of New Orleans. It's a great, fun-loving bash, a parade through the streets. It's the last hurrah before you get on your ashes and start atoning for all the sins you committed during the year.

Every Mardi Gras, crewes parade. Usually a crewe is made up of people with common interests—social and professional—that bring them together. By 1974 my kids, a group of their friends and I had become a closely knit crewe. That year it was late, and I was getting tired of standing at the parade, even though I was much younger and less heavy than I am now. A kid came by with a grocery cart. I looked at it and said, "Oh God, I wish I *had* that to sit in." And the little boy said, "You want it lady?" I said, "Yeah, darlin', I do." So I called to my crewe, "Help put me in this thing."

All of a sudden this wonderful jazz band came marching through the crowds. I said, "Oh my God, let's go with that band! Just push the damn grocery cart." And then one of my girls, she started calling out, "Make way for the Queen of Mardi Gras!" And honey, it was like Moses and the Red Sea. "Here comes the Queen! Here comes the Queen." And the next thing you know the band is following us, and I'm sitting in a grocery cart in just a regular old street dress, no costume.

Everybody thought the Queen just had to have a beer or a drink out of their wine bag, and the Queen got so drunk sitting in the grocery cart that the kids ended up taking care of me. I thought, "I like this." Instead of me worrying, "Where are the kids?" they have got to take care of me. So the next year I just started off in the grocery cart. That way they couldn't desert me, and they could always find me. By the time my kids were in college, their friends started coming down. They represent the best in young people. They're generous of spirit. We have

such a good time. But everyone's growing up except me. I feel like Peter Pan. The guy behind me, dressed as a clown, is from Brooklyn, New York. His mama made that costume and he wears it every year. The other boy was from Austria. His hairdo was purple. You can see how tacky it is. The young woman is from Arkansas.

People started taking pictures of me. There must be a million copies of this kind of picture around the United States, because the parade is so tacky that everyone who sees it wants a picture. A local newsman interviewed me one year. He loved the idea that I was a librarian who got in a grocery cart and paraded on Mardi Gras. I think our parade helps do away with the old stereotypes. Now I've got a cult following. We're on the television and radio every year. People actually set out to find me— like a little treasure hunt. Through the years we got T-shirts reading, "Crewe of Coleen." I even have a band from Florida that marches with me. Now it isn't Mardi Gras unless you've toasted "Queen Coleen."

To me, Mardi Gras is fun and innocence, and this picture symbolizes that. People who ordinarily don't do things like this, get out there, start hummin', put on their beads, and feel part of our group. It's amazing how many odd people we pick up through the day. People who have nowhere to go.

To me this picture represents not only my ability to enjoy life but shows that *anybody* can. You don't need money. You don't need permission. Anybody can have fun. That's what life is all about. It's about free spirit. You have to take what's dealt to you and build from it. You can't sit around waiting for fun things to happen. You have to *make* them happen.

Coleen Salley, Mardi Gras, New Orleans, 1988. Linwood Albarado

COLEEN SALLEY (b. 1923) is a storyteller and librarian who has taught at the University of New Orleans since the 1960s.

LUCILLE BURRASCANO

When I became a police officer and started working with children who were being abused, this picture haunted me. I kept going back to it. I had seen W. Eugene Smith's picture, years before, in a gallery. I fell in love with it because of its power, its impact, its tenderness. There was something so emotive, right on the face of it. I found out the father of the children in the picture took the picture. I also understood that Smith worked in his darkroom for hours on the print, creating something absolutely wonderful. He took these children out of a tunnel-effect into the light, two children walking together down the road of life. This is his beautiful wish for joy and lightness and happiness.

It's about the future. They're in motion, and they're hand in hand. When I was working with abused children, this image became even more profound to me, because abused children aren't allowed to be like this. *This* picture became my goal. In it I see promise and hope for abused children. It's like coming out of the womb. When you know about how children grow up, you understand they come *alone* out of the womb, into the light. In this picture they're doing it *together,* they're bonded. I want every child, and every parent, to allow a child to have this experience, because you kill a child's future when you abuse them. You rob them of their childhood. You kill their spirit. I want children to have a tomorrow.

You see, when I was growing up you beat the hell out of a kid and threw him across the room. It was normal. You got a bad report card, and the nun and priest slapped you. You took a beating. This was family structure! When *they* cared, *you* had to care. But you had a sense of responsibility. Today kids have nothing. They run wild. I'm not saying beating on a child is acceptable, because it's not.

People are ignorant about child abuse, and know even less about sexual abuse. I've gotten into *some* fights with lawyers. Oh my God! The outrageous things they say, like, "Well, children fantasize sex." And I'd have to say, "Sir, they don't fantasize fellatio and cunnilingus. They don't insert objects like broomsticks into their rectums and into their vaginas. That's not part of a child's fantasy."

What kids *do* have today is a great sense of gloom and doom. They think they're going to die, to get killed. Well, I see the stuff they watch on television and on video. What do we value? We want everyone to be perfect, gorgeous. We can't have headaches. We can't have bellyaches. If we do, we take a pill. Everything has to be hunky-dory, and if not, we'll sue, because everybody feels they're entitled, and everybody is angry. Our anger comes partly from the fact that we can't have sex freely anymore, because we have a killer disease out there. This is an instant gratification society, where everybody is singing and laughing and washing their floors. There is *no* reality.

It's unfair, because we really are powerless. I mean, when you look at our society, do Americans *really* have freedom? *You're* not free. *I'm* not free. *We* don't have control over our lives. *Everybody* else does, and to be successful or accepted in our society, you have to be powerful. Power is money, success in business, success in your love life, success in how things look. And wait! We live in a society that doesn't see sin as sin any more. So it's a very scary thing for people like me. I wonder, "Where do the children fit in? What kind of a future is this?"

For the kids at the end of Smith's dark tunnel to come out into a world that lets them be who they are, creatively, emotionally,

LUCILLE BURRASCANO (b. 1943), an expert on sex crimes against women and children, is a private security consultant and lecturer. From 1969 to 1991, she worked for the New York City Police Department, and she was one of the first women on street patrol in the city's history.

The Walk To Paradise Garden, c. 1948. W. Eugene Smith

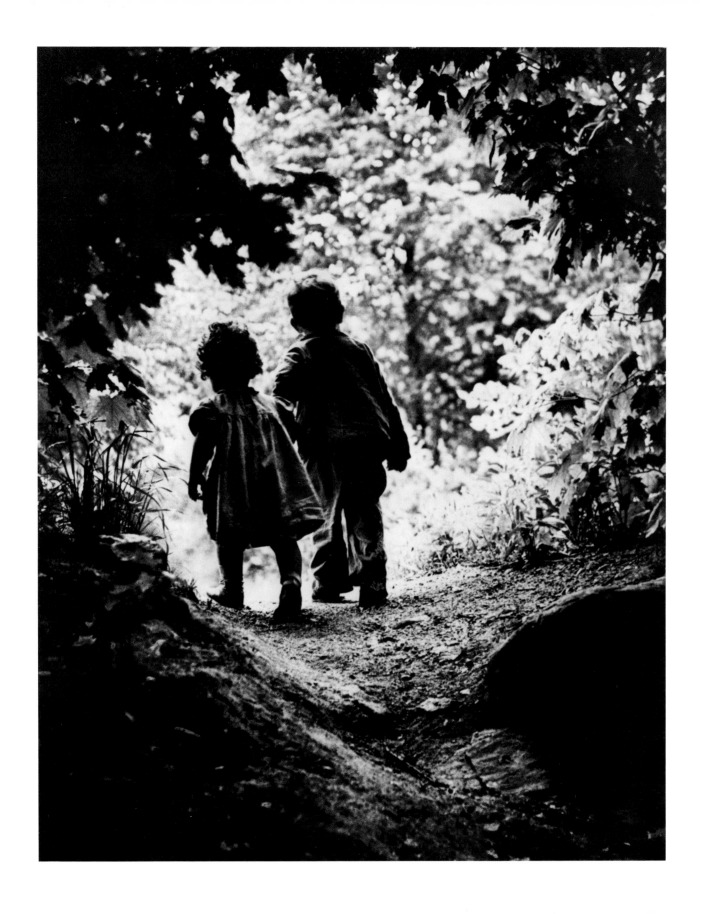

we would have to understand from the day that child was born that our number-one responsibility and priority is the health and welfare, the mental being of that child. You cannot give excuses and say, "Well, I can't afford any better," and, "I can't do this because it puts me out."

I always knew I had to be somebody, to do something. But people weren't letting me. My own father was a raging sexist. Typical Italian, you know. I left the house at twenty-two, got my own apartment, and had my own career in the insurance business. But there was raging sexism there! I knew the only way I was going to get some kind of power and respect was to be a cop. Acch! The world is a cruel place for women. So I took the test to be a cop in 1964, but I didn't join the force until 1969, because they had women on a list separate from men. It took four years of waiting. Ironically, when I was promoted to detective, my dad called his friends all over the country to boast of my new status, but, of course, he never told me.

I never liked the subtle pressure men put on you—especially being a cop. They were intimidated that I had a gun, that I had this power. And I'm intimidating *without* a gun. With a gun I was awesome! Men can't deal with a woman who knows what's up from down. Men want bimbos. Shoot! Remember the television show "Honey West"? Honey West was a private detective, and she had a pet ocelot. Anne Francis played her. Whoa, slinky! She was *my* image of being a cop. I was gonna be super-chic and sleek and smart and have my gorgeous cat, Mush. We've got to restrain the imagination. My early days on the force turned out to be something else.

I started out doing matron work in Chinatown. We searched dead bodies, live bodies. I ID'd the body of a woman who had been hit by a truck that just squashed her. I went to Bellevue

morgue. She was on a gurney, covered with a sheet, and blood was literally dripping off her body. She had no face! And I thought, "This is the dregs. This is not Honey West." My second precinct was the Silk Stocking District. I had to pose as a hooker! I hated it. Then I was in a precinct for three-and-a-half years on prison duty, until I got a phone call from a woman captain downtown who said, "Lucille, how would you like to go out on patrol in uniform?" I said, "Yes." She said, "You've got to do what the men do." I was *ready*. So in 1972, I became part of the original fifteen women on patrol in New York City. I went out in a patrol car with another woman. It stunned the world. We did television documentaries. We gave lectures. We were stars.

When the Crime Prevention Division was looking for a woman, it turned out to be my hero niche, where I really could shine. I went into a unit that was all men. The men got to pick their assignments first: crimes against banks, schools, hospitals—institutional-type crimes—or airport security. The only thing left was crimes against women and children, and I created my own little empire, my own little research project. I started studying on my own time and went to seminars with my own money. I wanted to understand. Who is the rapist? Why does he rape? Who does he rape? When? Where? I went out and interviewed rapists, and I began to wonder, "How come all these rapists are from dysfunctional, chaotic, horrendous families?" I mean, we didn't have one boy who grew up in a nice little out-of-town setting. I thought, "Maybe I'd better start studying about their childhood." That is how I focused on child abuse.

I wanted to save people by working in child abuse, not by leaping off tall buildings. So I became an expert, doing what I did the best: talking, lecturing, teaching. I have hundreds and hun-

dreds of letters from people: "You saved my life. . . ." I can't tell you how much incest I've stopped, how much almost-incest I've stopped. Tremendously gratifying. My message was that you cannot necessarily depend on the police or on the politicians to take care of you. Many studies have shown that people don't want to take care of themselves. They'd rather *you* do it for them. Why? Because once you assume responsibility for yourself, you can't blame anybody else!

When I lecture, I have all these eager parents who love their children. The first thing I ask them is, "Do you respect your child?" Let's think about it. This is an individual, an inarticulate adult, tiny, helpless, who lives in the land of the legs, and can't do too much. But that head and that body are like a computer making imprints and getting impressions. What is happening will be remembered forever. "Do you respect your child? Yes, they drive you crazy. Yes, they are going to disobey you, but the fact is, you made this creature, and this child is going to grow up and pay you back. One way or the other, it's going to pay you or society back if you screw up. Do the *best* you can."

Look at this picture again. For abused children, life is always a tunnel. There's never any light. Abuse stagnates children. It's like a record that never leaves the groove. They are locked into anger and bitterness and fear, and can't go forward. What I love about this picture is that these two children, these two inarticulate adults, these midgets, have taken that step and come *out* of this darkness. There's real movement and hope. They are not standing there posing. They're walking together. Their garments are flowing, moving.

Make this picture a goal, I say. Let your child go forward unscattered, unfettered, unscathed. There's going to be enough chaos in their lives. There's going to be enough tragedy. God knows, it's out there. I tell the mothers, "Now go home and kiss your babies good night. Go out and save some children. They're not going to be babies forever. They're going to be grateful for the hugs and kisses. Listen to your children. Believe your children, and believe *in* your children."

CHARLES SCHULZ

Her children all called her Ma. I called her Gramma. She had nine children and outlived six of them. To me, she was always old, and now I am older than she was when I thought she was old. For the last half of her life she depended completely on her children for support. While she lived mainly with us in Minnesota, she occasionally would take the train out to California and live for several months with another daughter until she missed my mother and returned to us.

Her photograph represents to me a portion of my life that was so significant it colored all the years that followed, and, yet, is now so far in the past it seems almost to have happened to someone else. All the people are gone. Parents, aunts, uncles, and cousins are all dead. Even the uncle by marriage to my Aunt Marion, who took the photo, has died. He had been a trumpet player in a dance band and an avid amateur photographer. Soon after I first met him, he had a photo printed in a national magazine. This photo of Gramma may have won a local prize, I don't remember.

The lines in her face represent all the tragedies in her life. She lost her husband when she was in her early thirties, and saw six of her children grow to adulthood, then die of diseases that could probably be cured easily today. Her photo casts images for me of the many hours she spent entertaining me by playing school. I was the teacher and she was the pupil. I gave her spelling tests and, because she had gone no further than third grade, she always misspelled at least a few of the words. She would go down into our basement with me and be the hockey goalie armed with a broom, while I shot tennis balls at her.

Now she is gone. My father and mother are gone. My father's barber shop is now someone's bar and grill, and my uncle who took the photograph and shared Army talk with me—we were

both machine gunners—is gone. Most of my family photographs lie jumbled in a couple of boxes. Pictures of my own children are mixed in with pictures of my parents when they were young, but this photo of Gramma was placed in a small frame by my wife and hangs in a hallway leading to our bedroom. I don't know when Gramma died, or where in California she was living when she died, and I don't know where she is buried, but my memory of her and that period of our lives is as vivid as this photo.

CHARLES SCHULZ's (b. 1922) comic strip "Peanuts" first appeared in newspapers during the 1950s. Gaining popularity, the characters from "Peanuts," including Snoopy, Charlie Brown, and Lucy, have become beloved American cultural icons.

Grandmother, 1947. Wesley Ried

I went to the Corcoran Gallery in Washington, D.C., to see the show "I Dream a World" in 1989, because I wanted to see which black women were being singled out because of what they'd done. I had *my* list. Well, it was one of the greatest experiences I've ever had. Psychologists have a term they call "peak experience," where certain things happen in your life, that may never happen to you, ever again, so you got to savor the moment. Let me tell you, that exhibit of photographs was absolutely one of *my* peak experiences. Just to see the exhibit and the women.

I felt a lot of pride as I walked through it, but it was this picture of Shirley Chisholm that meant the most to me. Shirley is pretty remarkable. She was before her time, really and truly, and she was very outspoken, no question. I saw in her much of what I felt about myself growing up. Secondly, I saw her as a person totally dedicated to service. She said, "Service is the rent you pay for room on this earth." I also identify with that part of Shirley Chisholm that is a little rebellious. I was not a bad kid, but I *was* mischievous. I was just discovering and seeing how far could I go before someone would say, "No, enough of that." Luckily, my mother, the person who was mostly there, because my dad spent a lot of time in the fields on our farm, gave me a lot of latitude.

I grew up in North Carolina on a farm. I had the duty of being with the cow. In the summertime, of course, we planted vegetables in the garden, and since I come from a family of ten kids, we consumed part of them. We also planted enough to sell as an extra source of income. I was also charged with the task of managing the okra patch and picking watermelons. I had my fill of watermelons, but I still love okra.

Education was always very important to my family. My father

had gone to the third grade, and my mother had gone as high as the sixth grade. I can remember from the beginning of my childhood, them saying, "When you grow up you have to get an education, because if you have an education, nobody can take that from you." They made sure that there were books and that we made good grades eligible to go on to college.

I could read when I was four, and decided I wanted to be lawyer after reading a book about a black, female lawyer, Cora Brown. I also remember a picture of her in an article in *Ebony* magazine, which came to our house. She was in her judicial robe. I thought that was cool. I said, "This is what I want to be." That caused my first argument with my father. He said, "No. No. No." My dad didn't think that being a lawyer was a nice thing for a lady to do. He wanted me to be a nurse. He said, "Do something safe. Lawyers are liars." But it was the rest of what he said that got me. He said, "That's all right for men, but women ought not to be bothering in this." So I said, "I'll show him. I'll go, and I'll do this nursing stuff for a time, because it can't be all bad." It was *his* money and *my* ambition. Well, I got hooked.

I was in my last two years of basic nursing, when the Army offered me a scholarship in exchange for three years of active service. I've been in ever since. While it was a practical turn of events that got me started, I think in the back of my head, I saw the Army as a way to get some traveling done. I didn't intend to stay more than three years. I went to Korea. I was about twenty-three and a lieutenant with a lot of energy. I had my idealism, and it was right after the war, in the early sixties. We helped a lot of kids in orphanages. I did all sorts of goodwill projects because I was an interested and caring person.

Shirley Chisholm, 1988. Brian Lanker

BRIGADIER GENERAL CLARA L. ADAMS-ENDER (b. 1939) is the highest ranking female officer in the U.S. Army. A veteran of thirty-two years' service, she is now Deputy Commanding General, Military District of Washington, D. C., and Commanding General, Fort Belvoir, Virginia.

Much of what kept me in the Army was what they promised me. When I found my time ending in Korea, one day a letter came: "Hello. Guess what? Have we a deal for you! If you want to travel, you can do that. We'll send you to another position. And after you finish that assignment, guess what? We'll send you to get your master's degree." I always wanted to do that. Remember, education. Big thing!

I knew I liked this outfit pretty well, because they paid me my own money, and I was getting very good experience as a nurse. The thing about being an Army officer is that you must assume responsibility for someone other than yourself. It's built into things. If you do that, and do that well, you can move along in the system without too much difficulty, even if you're a woman and in nursing. It wasn't necessarily *easier* if you were a woman. Remember, there were a lot of women deciding if I was supposed to be moving along in the system, and sometimes we women can be tougher on ourselves than other people can be. Shirley Chisholm said, about twenty years ago, that she'd experienced more discrimination as a *woman* than as a *black* person. Black was something that put my whole situation into perspective. I suppose there were things that were happening to me because I was black, but I saw that the *real* division in the work world depended on what your gender was, especially in the military.

When I look at this picture of Shirley Chisholm, I see a very determined person. There is no doubt that she's got pride of self, something I consider to be a positive quality. I also see her anger. She has a side of her that is really quite angry, which you see in her writings. She has resolved much of it over time, but she hasn't forgotten. That's her one drawback. She internalizes a lot of things, and that's where she and I differ. I smile a lot more than she does. I've always been concerned for her,

because people who really are serious about life, hold it in, and it really does wear on you. Really! It eats you up. Look at the manner in which she holds her mouth. It says, "Come hell or high water I'm going through here." Sometimes she should back off a little bit and go where those eyes lead her. The look in her eyes is what I believe to be a very soft, genuine, caring person. Cover the mouth, and *look* at the eyes. Focused.

In the exhibition there were photographs with the peoples' words next to them. I trusted my own sense of letting the pictures tell me whatever it was they could tell me. Then I filled in the gaps with what I read, and it made quite an impact on me. As I read their stories, I identified with their struggles, sacrifices, and triumphs. What had the *most* impact on me though was that I *could* identify with them. Once I'd done that, I made a resolution for myself as to where I was going from there. I got the idea that I wasn't quite finished with what I was doing, and I needed to establish more goals. Lined up with these women, you *do* decide. Right? What do you do *after* this?

So that the show helped me to define things, to say, "This is my goal, and here I go." I always try to look for a challenge that is greater than the last one I had, but at that point, I had run out of goals. To go from second Lieutenant to Chief of the Army Nurse Corps was all I thought I was ever going to get done. You see? So now, it seems as if opportunities are unlimited. Whatever I see out there that I want, I just head in that direction.

There's a funny story behind this picture. When I first saw it, I said, "God, that's Donatello, my wife, before we were married." Seeing a photograph that has nothing to do with your life become so highly personalized is a jolt. It was really weird knowing that a picture of a little plastic doll had this voluptuous resemblance to my wife. I see all of Donatello's attributes in this picture. She's kind, loving, sexy, and a good cook! Everything reminded me of her. I couldn't walk away from this photograph. I wanted it immediately. So I bought it, and every time I see it I get a romantic glow.

The picture might be about seduction, but I wonder if the photographer was thinking about that or was more interested in taking a twenty-five-cent figurine and turning fiction into real life. Or turning fiction into fantasy is probably more accurate. When you actually see the cheesy, white, three-inch high plastic doll with a blonde painted wig, which we did—the photographer gave it to us as a present—there's something eerie about it. And then, when your wife agrees that looks like her, you're really in deep trouble. *My* reality matching someone's fantasy? It's a double fantasy, actually.

The figure in the picture is posing, is having her picture taken, so there's a certain sensuality in what she's doing. If you compare it to skin magazine photographs of models, this has so much more mystery and intimacy and sexual magnetism than those pictures do, because they're retouched and unreal. They try to build an ideal woman, and this picture is not an ideal woman. This picture reaches more of your fantasy sense, because it's so imprecise. I find it incredibly intimate, maybe because it tugs at a certain, secret place in my head.

I grew up in the Bronx and New Jersey without any books, music, or art in the house. I was more oriented towards reading

than looking. I went to Rutgers and then Columbia's School of Broadcasting. In those days—it was the fifties—you didn't go out and say, "This is my career." You went out and asked, "Do you have a job?" My first job was taking tours around NBC, the closest thing to show business I could find. When I went into the Air Force, I ran the base newspaper, the radio station, and produced two television shows. Once I got out, a guy I knew said, "I know a guy, who's looking for a guy." So I started working at a very small advertising agency as a copywriter.

At that time, the creative marriage between the writer and the art director in the advertising business wasn't quite consummated. The writer wrote the copy which was handed to an art director, who would read the copy and do whatever he felt was supposed to be done. The agency that really put the collaborative process together was Doyle, Dane, Bernbach. They did most of the late fifties-sixties ads we remember—Volkswagen, Avis, Alka Seltzer. Bill Bernbach believed that a writer and an art director should work together as one unit. It really didn't matter who wrote the headline and who decided on the visuals. He understood words and pictures had become equally important. The job was getting the *client* to understand that a visual image could motivate as much as a "Buy my product" pitch.

The great advertising—and I'm not saying that advertising is important—is the most effective advertising. Take Marlboro. It's certainly evocative. People want to be Clint Eastwood, or whoever that cowboy is. It's been the same campaign for forty years. When *you* buy Guess jeans, you're not buying the jeans. The jeans aren't any better than Gap jeans or a pair of Levis. What you're buying is whatever imagery makes you feel better about yourself by having those jeans on your butt. So advertising is all about imagery. Is it reaching me? Do I want to identify with it? Will I think of myself with more self-esteem? Will I

JAY CHIAT (b. 1931) is the chairman/chief executive officer of Chiat-Day, Inc., one of the leading advertising agencies in the world. He and his company have created market identities for companies such as Nissan Motor Corporation, Reebok International, and Everready Batteries.

be seen to be a person of taste? It's no different for any kind of ad. It's just more or less subtle.

In the last ten years, MTV has turned advertising upside down, because the kids who have grown up on it are able to consume messages in micro-time. They're almost able to comprehend subliminal imagery. Images are flashed at them. They get the message. MTV has increased *everybody's* visual acuity like World War II airplane spotters. However, even though the messages are traveling so fast, they still seem to be understood. How serious is the information is that's being transmitted? If it's "Buy this record," it's not very serious information. No one is flashing *War and Peace* to you on MTV, or anything to which you'd have to pay careful attention to understand. Just as I don't think a Velázquez can be appreciated by simply breezing past it in a museum.

With most people having sixty channels to choose from today, a lot of people are watching nothing. Most people don't even see the barrage. Look at any witness identification program. "What color hair did the suspect have?" "I don't know." "What happened?" "I don't know." Nobody watches anything in depth. We're not drowning in an image world as much as we're drowning in a *media* image world, which means that if you choose to drown yourself in that ocean, it's there. But if you choose not to, you can pick up a book and go in the corner and read, or pick up a book of photographs and see.

If 1,600 advertising images flash at you each day, you block out 1,550 of them. Most of them don't mean anything to you. People are not consciously looking for advertising. They respond to ads if the imagery is provocative, or if the message is provocative, or if they're in the market for whatever it is you're selling them. You never look at refrigerator ads until the moment when your refrigerator breaks. What you try to do in advertising is sell a product or service. First you have to decide who's the target you're trying to reach. If it's an MTV viewer, you say, "OK what's going to interest *this* person?" In many cases, it can be an image as blurry as a Barbara Ess photograph, something that demands you become involved if only to identify it, then complete it yourself. Or it could be as blatantly sexual as a Guess Jeans ad. There's range. People want illusion in certain things and not in others.

Untitled, from the series "Desire," 1990. David Levinthal

I do remember going to this photography show at the Museum of Modern Art in 1970. I must have seen the poster at the museum, but I didn't buy it until I was in graduate school at the Yale Drama School in New Haven. I have a wistful quality to me, and I identified with the melancholia of this picture. I was very depressed, and when I saw this poster, I thought, *"Fabulous! Me!"* I got it framed, which for a graduate student was a big deal, and I was going to give it as a gift to my friend Christopher Durang, the playwright. I took it backstage where they were doing a play called *The Final Analysis* by Saul Bellow at the Yale Rep. Chris was doing props, and I brought it to him as a gift. But I could see that he was *completely* uninterested in it, so I decided I would take it home.

I put it up in my dreary New Haven apartment right where I worked, so I could look at it. I was very attached to it. I *felt* like this picture, hazy and a little bit sad. There's a wistful quality of time passing. It's either late fall or early spring. I guess those are buds; something's coming. It isn't your usual, "Oh, but it's *spring*" kind of picture. There's a bit of loneliness in it, and it's a bit comforting, too. It's that moment when a sadness passes or when a decision is made. You wouldn't end your marriage on a day like this, but you *could* realize that you had fallen out of love. This photograph is very precipitous of something, and there's that tug between nature and civilization. You wouldn't find *peace* here. This is not peace to me at all.

When I was working, I would look at this poster. I liked the orderliness of it. As someone who writes plays, structure is very important to me. I had started reading Chekhov, and the tone of this poster was *so* Chekhovian. All his plays, like *The Three Sisters,* are about time and how, "We have to get to Moscow! We have to get to Moscow!" What's interesting is the play I wrote under this poster was *Uncommon Women and Others.*

WENDY WASSERSTEIN (b. 1951) was awarded the Pulitzer Prize in drama for her play *The Heidi Chronicles.* Her plays, which focus on the loves and careers of women in a feminist age, include *Uncommon Women and Others, Isn't It Romantic,* and *The Sisters Rosensweig.*

That's a play in which these girls say, "When we're thirty, we'll be amazing!" And later, "When we're thirty-five, we'll be amazing!!" And by the end they say, "When we're forty-five, we'll be amazing!!!" That's exactly what this image represents to me, that idea of time passing.

Looking at this picture, I would think, "I *understand* this. This is visually how I feel." At the time, I wanted to, and I still want to, somehow combine *this* feeling with humor. Put *this* mood together with something that's a much brighter color. And that's very hard to do, because when you write with a much brighter color, you often don't realize that underneath is this somber feeling. I can't tell what that statue is. It seems sort of humorous, like a Scapin or some sort of clown. You could give it a red hat or a little beard and have it pull at it. But this picture doesn't really have *any* comedic potential. It does have music though, a Rodgers and Hart song, like "Nobody's Heart Belongs to Me," or "Who Cares?" Very sad, very melancholic.

I grew up in New York. I went to high school from 1963 to 1967, and I used to go to the Museum of Modern Art a lot, because I thought I was very *sensitive.* To cut high school to go to the museum, how *cool* could you be? Even *more* sensitive than the kids who went down to the Village, because I went to the *museum.* Even when I was in college, the people in the museum were the sort of people I wanted to grow up to be. You wished you knew them. All the people looked like the cover of *Freewheeling,* the Bob Dylan look, blue jeans with the jacket and those boots, and that was *fantastic!*

I've always been a very urban person, and when I was younger, I used to like those horrible photographs in books about

Exhibition poster, *St. Cloud, outside Paris, 9 am,* March 1926. Eugene Atget

Atget

The Museum of Modern Art, New York

December 1, 1969–March 22, 1970

Atget

The Museum of Modern Art, New York
December 1, 1969–March 22, 1970

Central Park. I'm attracted to city parks. To me, as a city kid, *this* is a landscape. I remember when I went to Mount Holyoke to college, which is in Hadley, Massachusetts, in the middle of nowhere. I would walk from the library to the dorm, it was so quiet, and I found it very unnerving. It didn't feel "at one" to me. This picture *does*. Actually, I look out on a park now, and I've always had a room with a view. I spend hours staring out my windows.

I always have a milieu in mind when I'm writing, but not an image. The people who interest me most in the theater are the set designers, because I don't have a great visual sense. If you were talking to a playwright like James Lapine, who is also a director and was trained as a graphic designer, he would tell you he knows *exactly* what a play is going to look like. My latest play, *The Sisters Rosensweig,* takes place in England, and I wanted an upscale drawing room as the setting, only—and here I get very specific—as an American living in England, trying to be English, would decorate it. So I knew that there would be *too* much chintz in the room and that there would be a lot of attention to window treatment. *Those* details went into the script. But where the couch and the chairs should be? How do the characters get up and down? I have no idea!

This poster lived with me in my first New York apartment for around ten years. I've always written on the same table, and this poster was close to the window, to one side of that table. But then I moved around to a lot of sublets, and it went into storage. When I moved to the apartment I'm in now, it disappeared. I'd left a whole bunch of clothing and stuff in the front hall for the Salvation Army, and nearby were three framed posters that were very important to me. I *assumed* they wouldn't take them. Well, they came by, and I'd left a friend in charge, and she gave them *everything.* She said, "I really didn't

know *what* you wanted them to take." I suppose I could have called, but I'm not the type to follow-up and say, "Where is it?" I thought, "I hope whoever gets it likes it." It was time for it to pass on.

If you showed this poster and said, "Whose play is this a set for?" *Nobody* would say it was for a play of mine. No way! This picture may be where my writing comes from, but it's not where it goes. Maybe this is what is in my heart and soul, but I wouldn't think of putting *this* on a stage. Also, when one is younger, before you really know the sadness of time passing, it looks like this is a very sensitive setting, and "Oh, I'd love to feel this way... my lover has left, and I'll wear a black dress and a shawl and feel *these* things." Once you've been there, you think, "Thanks a lot, I *don't* really want to be here." This feeling is still there, underneath what I write, but it's gotten more complicated. Maybe knowing the reality of this feeling, I know it *too* well.

But I will always find great *connection* to this image, *always!* When I was younger, it was the stillness that struck me. Now that I'm twenty years older, I can't cope with it. I know I couldn't live with this poster now. I see the anxiety of it, and while that interests me, I don't *need* it now in my house!

When I was a kid, pictures of the moon's craters turned me on a lot. When you look at a world that's so different, yet in some ways similar to our own, you ask yourself, "Isn't it possible that people have been there before and have lived there?" So I'd look for signs of people in pictures of the moon and other planets. With a little six-inch telescope that I built as a ninth-grader, I tried to see as much I could see.

By the time I was in ninth grade, Sputnik had gone up and the space program was just getting going. The idea of going into space and observing things was powerful. My teacher introduced me to a professor at Macalester College who was a telescope builder, and he showed me how he built them. Then my parents bought me a little book called *The Fascinating World of Astronomy* that tells what it's like to be an astronomer. That's where I first saw this picture of the Mount Palomar telescope in the moonlight.

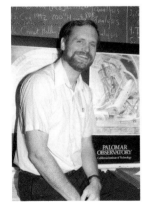

ROBERT D. GEHRZ (b. 1944), professor of physics and astronomy at the University of Minnesota, is a leading observational infrared astronomer who specializes in instrument development and observations of comets and novae.

The picture is schematic, very mysterious looking, ethereal. The dome is illuminated from everywhere, it's as if it were lit by the light of the universe itself. There are no people, nothing but this giant mechanical beast, which they called "The Glass Giant of Palomar." Palomar looks like a Trojan helmet, and the scientist is the warrior inside, peering out, ready to do battle with the mysteries of the universe. It's interesting to think about the impact this photograph has had on my career. The little doorway in this picture fascinated me. It seemed like the doorway to the universe, the doorway the astronomer goes in. Somehow, I realized that someday I could walk through this little doorway and unlock the mysteries of the universe. I used to think, "There's no one else in it, so I will be in this picture and have the power of this telescope at *my* command."

In school they showed us lots of images of nebulae and outer galaxies and planets. It fascinated me that you could see *details* on other planets, and maybe you could learn whether there was life out there. I had a lot of fantasies about what I'd see, about whether I could find out where we came from. As a kid, I was intrigued with the idea of going back in time. I was also fascinated by Superman and DC Comics, and I wondered whether there could really be people from other planets. What kind of a world would they come from? Would they be very different?

At the time I guess I thought I would be become an astronomer in the classical sense, a cataloger of the heavens. It took me a while to get from there to where I am. As an astrophysicist, I'm concerned with taking the data I get from telescopes and understanding what it tells me about the laws of physics throughout the universe. It took me a while to get from this picture to Mount Palomar itself. I'd never been there until 1992 when I was a guest observer on this very telescope.

Nothing in this picture could have possibly prepared me for what I saw and for how big the thing actually is. Mount Palomar is in a very beautiful setting. It's an Art Deco building, a classic, beautiful shape covered with stucco. The dome is silver in the picture, and apparently it was at one time, but now it's all white. It is massive, 130 or 140 feet high. When you stand in the structure it's so big that you feel swallowed up.

Palomar was designed in the thirties, and the metal structure that holds the mirror was completed by about 1938. But the glass and the polishing of the mirror were put off during World War II, and the glass wasn't put in until around 1948. No one built a bigger optical telescope afterwards, because this one was extremely costly, and because it was so much bigger than anything else, astronomers needed to skim the cream of discoveries with *this* one. Palomar is still the biggest operating optical

telescope in the world that is used on a regular basis. And although they're building bigger mirrors—three- and four-hundred inches diameter—the telescopes aren't collecting data yet.

The way we worked at Palomar, a typical day when I was there, sounds like a paragraph out of my astronomy book. We'd stayed in a building called "The Monastery," where the astronomers sleep and eat. An hour before sunset, we'd go up into the dome, get our observing program for the night ready, and open up the dome so the air inside could equilibrate to the air outside. As the sun set we'd begin pointing at objects, and work all the way through the night until sunrise. Then we'd close the doors up and go to bed. In the five days we were on this telescope, we made a discovery a night about the astrophysical world that hadn't been understood before.

Astronomy has changed. Nowadays, we use telescopes to make electronic images that you can interpret in photographs. While there's still some photographic work being done, we use digital detectors, like the ones in modern television systems. We look at wavelengths that photographic film can't even record. Incoming data is fed into computers and then reconstructed into images representing the data in a way the human mind can comprehend. But we still can't fly a spacecraft out to even the nearest star. It's frustrating. We take all this data, we have an understanding of the physics that goes on, but we can never go out there and grab a piece of the action by putting our hands on it. But that's what makes for interesting research.

Being an astrophysicist is like playing detective all the time. Even if you spend a lot of time looking through telescopes, the universe is still very difficult to understand. We talk about the Big Bang, but even the laws of physics we do understand are

almost inconceivable. People who come closest to understanding it, like Stephen Hawking, still can't really convey to you where it all came from. What makes astronomy unique is that there is no way to see the end of it. I think my son expresses it best. He asks me if I can conceive of what's it like for there to be *nothing*. He says, "Dad, think about it. Nothing." How would it feel? What would it look like? What color would it be? Do all astronomers feel like it's them alone trying to make sense out of things?

As a young person interested in astronomy, I used to go out and look at things at night. It's hard to describe the feeling of awe, the compelling feeling you get when you're far away from the city under the dome of the night sky, all alone in the dark. You're drawn to the stars in a way that nothing else can attract you. It's a universal feeling. It makes you almost religious.

I still do a lot of fantasizing about what I do at work and about what the images I make mean. I flip back and forth between what's happening down here and what's happening in the sky all the time. It's part of the creative process. I may fantasize about the last baseball game I saw, or what the Vikings are going to do, but it's just as likely that I'll think about the images I'm making with telescopes. If I'm driving the car and it happens, I try not to have an accident.

Something about *this* picture conveyed to me that doing research as a life's work would be satisfying. Why? That's the mystery of this photograph. It's beyond me. Except looking at that little door led me to understand that it was *my* door to the universe. And whatever was conveyed to me by this photograph turned out to be reality, the truth. I'm a very lucky guy.

Page from the textbook *The Fascinating World of Astronomy*, 1960.

are required to keep an observatory running. The astronomer and his assistant close the dome and go to bed at dawn, about the time other people are thinking of getting up. They sleep till noon—or try to sleep, since it is not always possible to change your sleeping habits abruptly. They get up about noon and have breakfast when most other people are eating lunch.

At some observatories—such as Lick near San Jose, California—the astronomers and their families have homes on the mountain top from which they observe. At others—such as Mount Wilson and Palomar Mountain—the astronomers live in nearby Pasadena, and travel to the mountain only when they wish to observe. At Mount Wilson and Palomar Mountain the astronomers and other people connected with the observatory eat and sleep while they are "on duty" in quarters specially provided for them and called "the Monastery." This name was first applied to the Mount Wilson living quarters; later, when the 200-inch telescope was erected on Palomar, the name was borrowed for staff quarters there. According to one story, the name originated in the fact that three of the

men who worked on Mount Wilson in the early days were called Abbot, Monk, and St. John.

A schedule, made out about three weeks in advance, assigns astronomers to the telescope according to their particular observing programs. For example, at Mount Wilson a man may have five nights at the 60-inch telescope, after which he transfers to the 100-inch telescope for another five nights. Then he goes down the mountain as someone else comes up from town to take his place.

After lunch the astronomer will probably return to the dome to look over the results of the previous night's observation. Perhaps he still has some photographic plates to develop. Or maybe something had gone wrong with his apparatus so that practically the whole night was wasted; if so, he will be busy inside the dome

1. *Left:* The dome of the 100-inch telescope of the Mount Wilson Observatory.

2. *Below:* The dome of the 200-inch telescope on Palomar Mountain seen by moonlight.

ALICE O. HOWELL

Astrologically, photography is ruled by Neptune, which is the ruler of Pisces. Neptune deals with realities that border between one level of reality and another. Neptune rules dreams, every kind of emotion that dissolves boundaries or difficulties. It's also mystical, but in its negative aspect rules alcohol, drugs, delusions, illusions. On the physical level it rules things like gas, film, smoke, or perfume.

I'm an analytical astrologer, which means that Jungian analysts and psychiatrists send me their patients to have their horoscopes done with the idea of looking at their astrological charts from a psychological point of view. I've been doing this for almost fifty years, and when I do a chart, I see it as an in-depth description of the way a person is likely to process experience unconsciously. And you might just as well be conscious of it. We are each born with a pattern, "a negative"—if you want a photographic metaphor. What I do works, as opposed to what some people do who call themselves astrologers. You know, predictions and that kind of thing.

Hans Jenny's picture is a proof that invisible energy is at work. Jenny, a Swiss, experimented with sound. Working off a late eighteenth-century discovery, he found that if you take sand or powder, and put it on a drumhead or inside a tambourine, and make a sound, the particles form a geometric pattern. Jenny found that as you went up the scale, the patterns evolved and changed to form patterns you'd find in nature—in tortoise shells, in animals, in plants. What is so extraordinary is that although he was using inorganic material, sound would lift that material to form the designs of organic life. The organic particles are in the inner section, but the life or energy is visible in the blanks, in the empty spaces.

Where does this energy come from? It just is. The Chinese call

energy chi. The Hindus call it prana. Energy, no matter what you call it, takes different frequencies. It goes by octaves up and down, we know that scientifically. You can hear it, and you can see it. For me, this picture is proof of a sort of invisible sacred energy at work in the manifest world. It's something some people accept on faith, but keep looking for confirmation of. Then there's a wonderful coincidence, that the pattern in this photograph looks like a natural expression of the sections of the astrological chart. Well, that means a lot to me. You can walk around the earth finding many, many proofs, but this struck me particularly. We're between two worlds: the world of sound and the world of matter. It's a blessing to begin to see the hidden, invisible process that is at work.

Every photograph, just like the one I've chosen, works as a symbol to people. If we each look at this photograph, not a single one of us will see the same picture. You bring everything you are to the pictures you look at. Looking at this picture, you can see a flower, a snowflake. I see energy, an astrological chart, the mathematics of beauty, the harmonic proportions of it.

I believe that Sophia, a figure of feminine wisdom in the Old Testament, is an archetype who has something to do with the way we look at the world. This way of seeing is a true gift. Sophia's gift of vision is intuition, which means "inward." It means to teach yourself to see. It's an inner gift of innocence and seeing things in *other* things. I try to describe the gift of Sophia as that of a loving eye, the third eye. When you begin to look at the world with a loving eye, you see beauty in pathetic things; you see the sacred in nature, and in the last place you'd ever think to look for it, right under your nose, in the commonplace, in daily life.

ALICE O. HOWELL (b. 1922), an astrologer and student of Carl Jung's work, has pioneered studies linking depth psychology and astrology. Her books include *Jungian Symbolism in Astrology,* **Jungian** *Synchronicity in Astrological Signs and Ages,* **and** *The Web in the Sea: Jung, Sophia and the Geometry of Soul.*

A visual sequence of sound waves, from the book *Cymatics,* **1972. Hans Jenny**

There's my sister Abby, up there on the right, and if you notice, she has a little skirt with big quilted checks. When I was a baby we had a dog, little Trixie, who lived under our house. And some way or the other, my sister Abby got bit by the dog, and so did one or two other members of the family. They had to take the dog's head off and send it off to Montgomery, and they found out it had rabies. My Daddy had to take all of them and catch a train Montgomery to get shots for rabies. That's when this picture was taken. A man came with a big camera and set it up and put a cloth over it. And then he lit a fuse or something, and it made a bunch of smoke.

Abby wasn't supposed to eat nor sleep while she was taking them shots. But she slept and ate sweets anyway and had an abscess from where the needles went in. Abby died, and a year after she passed away, my mother had her picture put on her tombstone, this same picture. Everytime I would go to the cemetery, there was Abby up on the tombstone.

So this is Abby, a picture of her on earth. But my first picture of her, from the dead, is the one I remember more than any. It was a beautiful morning, I was three years old, and I was on the mill road looking for my mother. I was scared because I didn't see her nowhere. While I was hollering for momma, I turned round and looked up. And there was my sister, coming down from the sky on a set of steps about fifty yards away, out of the clouds, from the north. Abby had been dead, oh, probably several months. And I didn't even know she was dead 'cause at three years old, I didn't know you died. As she walked on each step, that step would go away behind her. Abby came down those steps at a forty-five degree angle, made a turn, and she started right back up at that same angle.

I recognized who she was. When she got back up, I hollered out. And when I called her name, she stopped and turned her head over her right shoulder and looked back at me. This white gown she had on opened sideways, and under there she had on that skirt with them big checks on it. I was sure then it was her because I knew them checks. Then, she disappeared. There I was alone, and I was scared, and I run and told my mother about it. And that tore her all up.

When that happened, it made a print on my brain cell. I'm seventy-six years old now and that was seventy-three years ago. It's just as fresh right now as the day I'd seen it. I've never been able to forget nothing about that. When I seen Abby, that's when God called me. I understood it later, when God called upon me to do sacred art. He said: "Howard, that was your first vision. Hers will be your basic vision for all the other visions you have. And if you believe in that vision at three years old, then you can believe in all the other visions you will have."

When I'm gonna make things, the picture comes from God to my brain cells. And I can see it. My brain photographs things. Like that vision I had of my sister, that's recorded. It's in the warehouse. All of the pictures I've ever seen in my lifetime are somewhere in the files in my brains.

And every picture is a story, and everything you read is a picture. Everything you look at is pictures. When you write, it's a picture. Your eyes take words to your brain, and that's where the pictures are developed. My whole life is a picture. And you're a picture yourself. Your pictures come from your mother's womb. God put it there. And you're gonna be a picture after you're dead and gone. You're gonna be a picture in heaven, or you're gonna be a picture in hell.

Page from Howard Finster's scrapbook, 1920s. Photographer unknown

REVEREND HOWARD FINSTER

(b. 1916), America's best-known folk artist, began making art after God appeared to him in a vision. His work has been exhibited in numerous museums, and his work has been commissioned by Coca-Cola, MTV, Swatch, and Absolut Vodka.

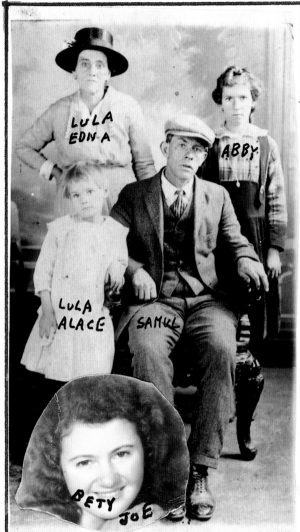

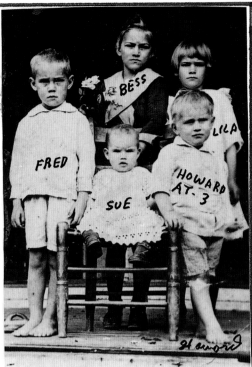

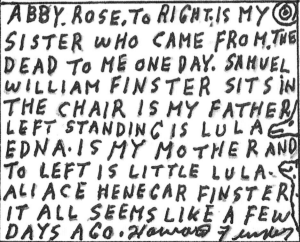

Within images (labels): LULA EDNA, ABBY, LULA ALACE, SAMUL, BETY, JOE

FRED, BESS, SUE, HOWARD AT. 3, LILA

ABBY. ROSE, TO RIGHT, IS MY
SISTER WHO CAME FROM. THE
DEAD TO ME ONE DAY. SAMUEL
WILLIAM FINSTER SITS IN
THE CHAIR IS MY FATHER.
LEFT STANDING IS LULA
EDNA. IS MY MOTHER AND
TO LEFT IS LITTLE LULA.
ALIACE HENECAR FINSTER.
IT ALL SEEMS LIKE A FEW
DAYS AGO. Howard 7 inches

THIS IS HOWARD AT
THREE YEARS OLD TO
BEFGT. THE YEAR I HAD
MY FIRST VISION MY
SISTER ABBIE COMES
FROM THE DEAD DOWN
TO ME ONE BEAUTIFUL
SUN SHINING DAY. MY
SISTER LILA STANDS JUST
BEHIND ME. THEN MY
SISTER BESS. BEHIND
THE CHAIR. AND MY
SISTER SUE. IS IN THE
CHAIR AND MY BROTHER
FRED LAST. TO LEFT
1919. THERE WERE
FINALLY. 13. OF US KIDS
OUR TABLE WAS. 9. FEET

These photographs just break my heart. It's an exact moment that happened every Sunday afternoon in my grandmother's little yard in McKeesport, Pennsylvania, when everybody popped in. Today a lot of these people are dead. This is my uncle Steve, in the last picture on the right, who died of Alzheimer's. It was a very sad, terrible death. This is my father, in the center of the last picture, between my grandmother and grandfather. He's gone, so there is this a sense of déjà vu. If I spend any time looking at these photographs, they really get to me.

It's probably about three or three-thirty in the afternoon in the summertime. We would always go to nine o'clock mass and then come home. We lived next door to my grandmother, so we'd have a big mid-Sunday lunch, and then little by little, the uncles would pop in with the kids. My uncle Andy took these pictures. He just sort of stood back and photographed everybody as they were interacting. In the next to last picture, my uncle's with my grandmother. He spots Andy taking the photograph, and points to the camera as if he's saying, "Look, Andy's taking your picture." I would have photographed this exactly this way. It's quite stunning to see it.

My aunt had these pictures. I saw them a couple of years ago, and my response was immediate. "Oh, look at this. Oh, here's another. My God, I remember that. And that." You can see they're creased. I like all that. I like their awkwardness. You know, you go to a museum, and you look at photographs, and say, "Oh, how lovely." But these photographs, which will never be in a museum, are *so* powerful to me. Private photographs have infinitely more meaning for people, especially as time goes on and our memories dim. This sequence is my "madeleine."

When I saw them, I just fell over, because it's such a flood of real memories of that afternoon. The fact that they're out of

focus is OK, too. I wish they weren't, but to my mind it's what a memory looks like. You see the outlines, but they're never as crisp as they were when the actual event occurred. Memories are also very selective. As you get older you tend to remember the good things. These pictures reconfirm my memory. They say, "*This* is what did happen." I might vaguely remember this kind of afternoon occurring, but *this* is the fact, the only evidence I have that this afternoon *existed*.

I can hear my grandfather talking to my uncle about the Pirates. They were all baseball nuts. My father would talk to my grandpa about drinking. They would slip into the kitchen and throw down a shot when nobody was looking. And the women would be talking about who got married, who's getting divorced, who's pregnant. I didn't know that my Uncle Steve was that bald. I guess we have a bald heritage in my family, which is nice. I'm not the first. It wasn't God's punishment.

Look at the picture where we're all posing. This was my best friend Art, in the center, at the back. This is my brother Tim, kneeling, on the left, in front. And Tommy in the shorts, and this is Kenny next to him. Look at all the little details, like my grandmother's cherry tree in the garden. I used to build little model cities out of stone up here. And my father was *such* a dandy. You see? He's got his suspenders on. That's when he took care of himself, when he loved to wear expensive clothes. He was still skinny then.

My grandmother would refuse to let anybody take her picture. "Why do you want to photograph me? I'm so old. Why don't you photograph some pretty young girl?" she would ask me. She never valued the beauty of her age. You couldn't say to her,

DUANE MICHALS (b. 1932) is a photographer who pioneered the use of narrative text and sequential imagery. His books include *The Journey of the Spirit After Death*, *Sequences*, *Things Are Queer*, *A Visit With Magritte*, and *The Nature of Desire*.

Grandmother Anna Matik's backyard, McKeesport, Pennsylvania, 1951. Andy Vanyo

"Well, I want to take your picture, 'cause you're going to die, you know." She was vain. I'm amazed she even sat for this picture, but here she is in the middle. Little Anna Matik. She always said, "Duane, you've got to be a toughy tough." That was her phrase. I remember walking up these steps, and she was standing at the top, and she saw me and said, "Walk like you have life in you! Don't walk like a wimp! You're alive. Let's see you walk!"

I was about nineteen in these pictures. I didn't mind being photographed. First of all I didn't know what I really looked like. I was home from school for the summer, and looking at everything from a distance. I was in major transition, beginning to come into my gay consciousness. I was becoming aware of my difference. I was always different. I had this fancy name, Duane Michals. I was always the highbred, compared to the rest of the kids. Here I am on the edge of the third picture, coming up the steps. My mother had given me the identification bracelet. In those days it was very cool to have one.

Because I was so overwhelmed, so moved by the pictures, I decided to write a poem and send it to my relatives for Christmas. My aunt called me in tears when she got the poem. She said that I was the last person capable of writing down what it felt like to be at my grandmother's. So this sequence became a catalyst; it provoked me to write.

Words do plenty that pictures can't. Pictures collapse constantly. They're like balloons, they very seldom transcend description. Writing picks up where the photograph fails. What I want to write is what you cannot see in the photograph. If I see a woman crying in a photograph, I want to know *why* she's crying. I don't care what she looks like crying. That's why portraits are silly. They don't tell you anything about anybody.

A photograph doesn't have its own inherent meaning. Very few things do. But I don't want people to have ten interpretations about a picture of mine. I want them to be moved on cue, because I'm saying something very intimate to them. The more intimate a picture is, the more manipulative it is, the more power there is, the more I like it. I want people to respond to my pictures on *my* terms, to be carefully manipulated. They forget it's total fiction and identify with it. That's the power of art, and art is in nuance. It's like somebody's repeating your secrets out loud, and you think, "My god, *he* felt that, too."

You know how we look at daguerreotypes? In the next century when we have laser-motivated, digital, projected images, these snapshots will be the equivalent of daguerreotypes. These kinds of pictures will become rare and very valuable. With the gum-chewing, instant gratification kids we have nowadays, photographs are all about sensation. The ones who shout the loudest get the most attention. There's no room for the kind of feeling I get looking at this sequence. People don't value these kinds of feelings today, because we're all too hip and too cool. I make a point of saying, "I'm not hip, and I'm not cool." I have nothing to do with that. *This* kind of intimate, private knowledge, which would be considered sentimental and nostalgic, is definitely uncool. Luckily, I don't care.

I took this photograph of my father just before he failed to complete a six-week cycle of radiation at UCLA's Medical Center. He died three months later from a brain tumor. Almost unrecognizable, except for those indelible eyes ricocheting an unfathomable truth, Dad's picture makes me think of his suffering from cancer and the so-called therapies developed to prolong life—the cumbersome machine baking two hundred rads twice a day into his head for five weeks—and his courage while living under the reign of a tumor rapidly enveloping his frontal lobe.

I remember the day he and I walked up Conte Street, past the Plum West restaurant and Bullocks parking lot, to UCLA Medical Center for his treatment. It was slow going because Dad wasn't in a hurry anymore. Holding my hand in the midday heat, he stopped unexpectedly, and looked at the ground for an unusually long time before he picked up a smashed metal ring and handed it to me. Dad's new rituals of exploration led him to contemplate the design of broken pencils, dents on tables, and even the configuration drops of water made in a filled bathtub. The boundaries of what was considered worthy of his curiosity had definitely expanded. As I put the crackerjack prize on my little finger, I didn't notice Dad had ambled off to become friends with a giant sycamore and its temporary tenant. Even though I succeeded in pulling him away, he couldn't take his eyes off the little sparrow singing its song long after we entered the hospital's glass doorway.

Inside UCLA's massive complex, we drifted through endless hallways until we reached the waiting room. "Well, I guess it's time for the guy who does the camera work down in the dungeon to take the big picture. If he keeps zapping me in the head, I'm going to look like Yul Brynner," he said. He already did. The cheerful room was jammed with hairless men and

gaunt women sitting passively under fluorescent lights. To see my father sharing the look of the disease, which had succeeded in erasing the spark his beautiful light blue eyes used to have, replacing them with cancer's famous hollow look, was heartbreaking. When the nurse called his name, he got up like a good dog.

Dad's attendant marked his head with green X's, designating the areas to be radiated. The machine, looking pretty tired after battling cancer for seventeen years, was the size of an average living room. It seemed harmless enough, sort of like a giant, beige kitchen appliance. After Dad was strapped to a gurney, his moving shadow on the wall passed a huge color photograph of a soothing forest scene. As the rays invisibly entered one side of his head and then the other, I couldn't help but think of the machine as a vicious toaster, grill, and steam box rolled into one. We used to laugh at the story about how Dad, when he was a child, would pass out cold at the sight of blood. Now, with his head in the grill and the men in white frying his skin off, he took it without a word.

And he kept taking it, until June fifth when he prematurely flunked the program, and was driven home in an ambulance to be more comfortable. "It's the quality of life, not the quantity," Dr. Black had said. For my family, an air of disbelief about Dad's future filled our lives with a depressing kind of hope, a stagnant hope, a hope of no hopes. My sisters, Robin and Dorrie, and my mother and I ritualistically watched for any improvement. He might get better. That was what we were sort of, kind of, told by doctors. But at the same time, Dad was looking more wounded, more broken, more like the dozens of dazed birds who, over the years, had flown into Mom's plate glass window never knowing what hit them. My father's failure to live up to the "program's" requirements was obvious. His

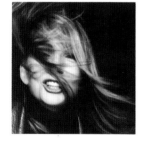

DIANE KEATON (b. 1946) is an actress known for her roles in *The Godfather, Baby Boom, The Good Mother,* and *Annie Hall,* for which she won an Academy Award. She is the author of *Reservations,* a book of her photographs, and has edited two collections of photographs, *Still Life* and *Mr. Salesman.*

six-foot frame barely held up on the uneasy steps his skinny
legs took him. He didn't stop to look at sparrows in sycamores
anymore. In fact, he stopped walking altogether.

Those days were very sad, and this picture reminds me of
them. Some people say photographs lie, they don't tell the
truth. I believe that, but some photographs do tell the truth.
My father's eyes gazing out through prolonged suffering is a
reminder of his disappearance and my family's loss. That's the
truth, isn't it? It is to me, his daughter. Those same eyes also
provide a certain kind of inspiration, which doesn't lessen the
unbearable fact that my father is gone, and I will never see him
again. He was always an honest man. He never chose to lie to
himself, or embellish his existence. He didn't mince his words.
If bad news was forthcoming, the blow wasn't softened. I'm
aware that it might seem peculiar to have picked this murky,
ill-defined photograph over others, including those taken when
he was a boy or a handsome young man; but this is the one
that means the most to me. I can't pass it without being struck
by his unflinching look into the face of death. All I know is I
miss him, and I only hope I can engage life like he engaged
death, directly, with no lies, no hiding, no special touches
added in order to appear to be more than what I am; if I could
face the future like that, I, too, might have the grace my father
had on his last journey.

Jack Hall, summer 1990. Diane Keaton

I buy a lot of pictures nobody wants, odd movie publicity stills that used to be ten cents a piece, and are now up to twenty-five cents each. I started looking at these kinds of pictures *not* because they were from movies, but because early on, I was looking for photographs to incorporate into my own work that didn't involve my own sensibility.

I went to places that sold movie stills every few weeks, and I would spend hours and hours looking through disorganized cardboard boxes of photographs until my eyes started to go out. I liked the randomness of going through these pictures. I pulled photos intuitively, things I thought I could use in making my own pieces. I have to use pictures that are banal, so banal that they are not very interesting by themselves, but have some charge that begins to work when I shove one of them up against another. They're pictures that have some hold on me.

There are some pictures I've bought but have *never* been able to use. Like *this* one, which is so charged in subject matter that all I can do is just show it to people. In all my searching, I've *never* found anything like this picture. There's something very troubling and sad about it. It speaks about sexuality in some way as death and dirt. There's also something very judgmental about it, something bipolar. This picture seems like it's about strange and overlapping sensibilities.

Why would anybody make a picture like this? I cannot figure it out. It's so enigmatic. There are really weird overtones in it: beauty, birth and death, pain, decay. It's very open. You can read so much into it. What's out the window? Could be clouds. You can look at this picture from now until doomsday, and still have no idea about what is going on. I know why I like all of the other pictures I have. There's not another one that eludes me, like this one does. I've had this picture around

for a *long* time. And although I've always loved it, it's just too good to use in my own work.

When I used to categorize the pictures I bought, this one got placed in the folder called "art," because it's so perfectly composed. In some way, it seems to comment on art. It's got the quality of being both here *and* there. The backs of movie stills usually have captions printed on them, and this one does, too. It says, "Assembly Line of Beauty—3. Emerging from the 'Bubble Bath,' Dolores Casey will halt behind the flimsy screen for a rubdown, after which she dons a negligee, also the creation of one of the famed Parisian designers." It was number three of a sequence, but I can't imagine what the other pictures might have been like. The caption implies that she's going to come out of this bubble bath, go behind this screen, go to get a massage—no a "rubdown."

It's mysterious. There's something on the left, behind what I guess is a curtain, which looks like a figure out of a Masaccio painting. A figure going to hell. It's wearing a towel. Maybe it's being transformed. And *this* figure, on the right, covered in suds, is very sensual. The idea of soap or suds, cleansing like fire. The picture has a lot of religious overtones to it, I suppose. But then when you look at *this* part in the center, suddenly the picture moves off into another area. Once I was going to use this photo to make a reference to Barnett Newman's paintings or to Jackson Pollock's *Blue Poles*. But it was just *too* good.

This picture became important to me because it's a reminder of what happens when art becomes too beautiful. I admire it, but on the other hand, it provokes me, and maybe I'm resentful about that. I would like to make something so perfect, but on

An untitled movie production still, 1960s. C. Kenneth Lobben

JOHN BALDESSARI (b. 1931) is an artist whose works have been exhibited in museums and galleries worldwide. His teaching career at California Institute of the Arts has influenced generations of experimental artists.

my terms. I mean this is *brilliant*. Look at the divisions. The negative space is very important, as important as anything else. Compositionally, why would anybody put what looks like artificial fingers in front of the rope on those poles? That idea wouldn't come to you in a million years. It drives me *mad* trying to figure that out. That hand, it's gorgeous. How the fingers repeat the poles. How the poles are bound. Those decisions have to figure into the story the photographer was trying to tell. It was a brilliant move. This picture is almost Cocteau-like, dreamy, and the longer I look at it, the weirder it gets.

In fact, this picture has a lot to do with an artist's dream of becoming artless. What is great about this picture is that it is *stupid*. Artists all want to be stupid, in a *good* way, and artless. It gets to the root of a fundamental question for artists. When does something flip? At what point does something become art? When is something *not* art? It happens on a sliding scale, and I'm always interested in finding the point when a picture all of the sudden goes over the edge, in one way or another. All it would take to make this picture *not* art is just a slight shift in its arrangement. As it is, this picture smacks of art, because it's so composed and such a *beautiful* image. This picture does just what an artist does. Takes a piece of dirt and keeps doing something with it, until it's still a piece of dirt *and* it's art. But how do you keep its "dirtness?" It's a pretty hard line to walk. It's either *dirt*, or it's *art*. Just where do you stop? When do you push it too far? At what point do you kill it? It takes a lifetime to learn how to do that. You never want to make something so totally beautiful that it doesn't leave any room for a person to enter it. *That* would be boring.

Usually, when you say something can be art, it's because you've found a precedent for it in art that already exists. You say to yourself, "It looks like *that*." The things that are resistant, you might say, "Why not? Why *couldn't* it be art? What can I do to it to push it over the edge?" But this picture starts and ends at the absolute ground zero level of what art is. It's enough to make me catatonic.

It would kill me if this picture looked anything like the art I make. I don't want to give people something comfortable to look at. I want to upset people. *This* is too beautiful, too comfortable. I *always* distrust beauty. I'm very jittery about it. There is no way that this is *not* a beautiful picture. No way.

I love photography. And I love to take pictures and have ever since I was ten or twelve, about the age you see me in this picture. With me is my grandfather McFeely, my mother's father, who I named the speedy delivery person after on my television show. When this photo was taken, he would have been retired. He was always starting companies, and then selling them so he could start up something else. Once, he started a company called The McFeely Brick Company. I think he had all of $25,000 when he died, but he had created so many companies and had given so many people jobs. My sister and I always called him Ding Dong, because he taught us that nursery rhyme, "Ding, dong, bell. Pussy in the well," which didn't have the connotation it has now. He seemed to have liked it.

The picture was taken in what was then called the music room of my mother and dad's house in Latrobe, Pennsylvania, about 1938 or 1939. The organ you see in the picture was mine; I had started to play the piano when I was five. I used to go to the movies or listen to the radio, and then go pick out the tunes that I heard. Grandfather McFeely's wife, my grandmother McFeely, always supported me in my endeavors to play instruments. When I was determined to get a Hammond organ, my grandmother said, "All right, I will match you everything that you earn." Somehow I earned fifty cents, took it to her, and she gave me fifty cents. The next day I went back to her with the dollar, and she said, "You know there are those who have said that you're not that good at mathematics, but I think you're very good." But she bought me the organ.

I don't know why this picture was taken this way. It looks very formal, and I look kind of serious. My mother and grandmother were exceedingly protective of me. I grew up in the era when the Lindbergh baby had been kidnapped, and they always kept me in where they could keep a careful eye on me. It was

because they loved me, I know that. But it was my grandfather McFeely who...well, it's better to tell a story to illustrate why he was one of the most important people in my life. I was at his farm in the country one time—he had a lot of stone walls around his farm—and I was climbing on one of the higher walls. Either my grandmother or my mother said, "You'd better come down or you'll get hurt." And he said, "Let the kid walk on the wall; he's got to learn to do things for himself." He really supported my own ego growth.

I'm sure my grandfather was talking to me when this picture was taken. He might have been telling me about the next time that we'd get together. His being at our house was fairly rare. We went every Sunday to visit him out in the country. It was a special time. I loved to go out to his place. I often say on my program, "You've made this day a special day." My grandfather could very easily be saying that to me in this picture, as a matter of fact. "You make this day a special day, just by being yourself, Fred." Every kid needs to hear that message.

As I look at this picture now, I think about a day, oh, six or seven years hence, when I could be grandfather McFeely and Alexander, *my* grandson, could be me, because he's four-and-a-half now. Of course, I would not have a cigarette in my hand. But I notice that cigarette now, and I notice that watch of his, which he always wore. From my vantage point now, I look at my grandfather's glasses and think about the people who were killed in the Holocaust, because those glasses remind me of certain glasses I have seen in pictures of the Holocaust. I also focus on how fat I was. As soon as I got to be an adolescent, I got taller and much thinner. To this day, I weigh 143 pounds. I didn't like being fat. In fact, as I look at this photograph, I think of some of my cousins who didn't lose that chunkiness.

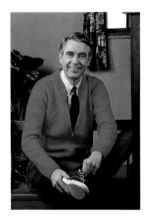

Fred Rogers (b. 1928) is the host and creator of "Mr. Rogers' Neighborhood," a television show that has influenced children's television programming since its inception in 1966. He has won every major award in children's television, including two Emmy Awards.

This picture is ingrained in my mind. The other day, I had blown-up a Xerox of it to see if I could decipher what that music was on the organ. At first I thought it must be Chopin; it has a lot of sixteen notes. The bass looks like Gershwin. But now I'm convinced that it's Beethoven. And it is not a piece for organ; an organ piece would have three staffs. So the photographer must have taken this sheet music from the piano in the living room, just across the hall.

It's almost prophetic that this room, which they called the Music Room, became the television room after I left home and took my organ with me. You see that window behind my grandfather? Well, to the right of it is where the television set was. It was in this room that I saw my first television program in which people were throwing pies at each other. Early TV. It's what made me decide to go into television, not because it looked like fun, but because I thought it could be a wonderful instrument for education. I had a feeling that I could do something with that. I first saw the program when I came home for Easter vacation from college in 1951. I had been accepted at the seminary, and, of course, my parents thought I was on my way there. But when I saw this program, I said, "You know, I think maybe I'll try my hand in television." My parents said, "Well, you haven't even *seen* it." And I said, "I've seen enough to know that I'd like to try it."

I knew that I loved music and writing and drama, and I knew that I loved things of the spirit. I felt that I could use all the talents that had been given to me in that little box. My parents were just astounded when I wrote to NBC, and told them I'd be graduating with a degree in music, and asked if they had any room for a gopher. They hired me right out of college.

I never planned anything, and I still don't. I always just present myself, and the truth seems to come forward. I'm convinced that the space between the television set and the viewer or listener is holy ground. That space can be used particularly for people in need in ways that we can never begin to understand. That space is also an important space for photographs.

If I have a message for children, it's about the importance of childhood and the sanctity of honesty. I don't mean to wax poetic; I'm just trying to explain what we help kids to see and hear from the Neighborhood on my show. I think people long to be in the presence of honesty, and for the sharing of very human, personal things that stems from trust. That is the most basic growth task in anybody's life. It's what this picture is about as well, the development of trust. Even though there might have been somebody with a big camera standing under a black cloth on the other side of the room—the picture is kind of spiritual also—it's just two people being together, talking to each other, listening to each other. This picture just makes me think of great times in childhood, and that's a gift in itself. Thank you for reminding me of it.

Fred Rogers with grandfather McFeely, c. 1938. Photographer unknown

My field, called forensic science or criminalistics, covers any activity where there is physical evidence to analyze scientifically, in order to interpret what's gone on. Whether it's looking at hairs and fibers and paint smears, or simply matching bullets, or reconstructing a crime scene, you try to apply science to physical evidence. You get to a crime scene and should, in a sense, have your hands in your pockets. You do nothing, touch nothing, just try to observe things.

You try to think about what you're observing *really* means, how it fits in. You sit at one vantage point for a while, and after you've documented certain things, move along. Finally you reflect on it all, and it begins to fit together. Now, as in any good science, you have to try to trash your hypothesis. Sometimes it's difficult because a hypothesis might be a beautiful creation, but only when it survives testing, or is replaced entirely, does it become a working framework for your investigation. Then you can take the relevant photographs you need, the details you want to document at the scene.

Both the crime scene and the laboratory have important needs for photography. Photographs are important because they are probably the single most detailed record you can make. Sketches can handle things that photographs can't. You can record things in notes. A videotape is good to get an overview of the scene, panning around and facilitating measurements, documenting where a photograph was taken from. But the video never, ever supplants still photography. It's got nowhere near the resolution you need for detail.

A lot of times, I'll handle a case from some remote area in which people send me photographs of crime scenes and cases. Bizarre is the wrong word, but the photographs often come in those little drugstore folders that say, "Save your important

memories." Or, "Your treasured moments." That's one of my favorites. I'll get a sheaf of color photographs and go through all of them. But without having been to the scene and without having a videotape, it's very hard to get an objective, three-dimensional image in your mind. It takes a long time.

Somebody gave me this picture years ago, in the mid-1960s. It's from a cereal box or something, I'm not sure. I've used it in lectures for over twenty years as an analogy for recognizing evidence at the crime scene. I use it to indicate that the pattern you recognize may be more than visual. It may be a pattern of data, of ideas, or of items. You must realize that most of what is at the crime scene is irrelevant to the investigation, has not been affected by the event that has taken place. You've got to be able to extract the relevant stuff from the irrelevant stuff, separate the signal from the noise, make order out of chaos.

This image must have been photographed on some surface, on the side of a building or something. It's got cracks in it. It's got dust on the negative. There are all kinds of dots, extraneous to the image. There's a lot of information that detracts from recognizing the underlying pattern of what it's a picture of. People often look at this picture and see footprints or fingerprints, because they're in the mind-set to look for physical evidence.

Give up? It's a picture of a cow. There's a wire fence on the left. There's the cow's face—nose, nostrils, eyes, ear. The cow's head, in the center, is turned towards you, and its body, parallel to the picture plane, is on the right. For most people, the idea of a cow doesn't occur to them, so they're often thrown for a loop. But once you see it, *boom,* it's really there.

PETER R. DE FOREST (b. 1941) has been a professor of criminalistics at John Jay College of Criminal Justice, City University of New York, since 1969. He is a private consultant in criminalistics and works with police departments, prosecutor's offices, public defender's offices, and private attorneys.

A premium picture from a cereal box, 1949. L. L. Tillery

MYSTERY PICTURE
Ⓒ L. L. TILLERY
J.3433 · 1949

In 1979 Pope John Paul II visited America, and Philadelphia was one of the planned cities of visitation. The city was ecstatic. There was a big mass scheduled at Logan Circle, and in the evening there was a scheduled stop at Saint Charles Seminary. The Pope had a fondness for speaking to people who will be the up-and-coming servants in the church. I entered the seminary in 1975, and at the time this picture was taken, I was in my fourth year.

In September 1979, when the word came out that the Pope was coming, everyone was buzzing. While everybody was speculating about his visit, I did some research on the papacies. In the course of going through all this material, I turned up a tradition, an intriguing custom. If you knew you were going to be in a papal audience, or cross the Pope's path in Rome, you could go in and buy a *zucchetto* from the Papal tailor in Rome. A *zucchetto* is the white scull cap that the Pope wears. Obviously, *you're* not going to wear it, but if the opportunity arises, you'd present the Pope with it. Then *he* would remove the one on his head and exchange it for yours. This old custom was a gesture of respect, but it was also about receiving a souvenir. In Catholic tradition there's a reverence for relics. There are first-class relics, like a piece of the bone of someone who's been canonized. Second class is a piece of a saint's garment. Third class is something they've touched.

I had a friend from the seminary, who had been sent to Rome for higher studies. I thought "Ooooo, the Pope's coming *here*, and I've got a contact over *there*." I told him to go in to the Pope's tailor, buy a *zucchetto* in the Pope's size, and ship it to me as fast as he could. I didn't tell anyone at the seminary about this. I wasn't going to be aced out of this opportunity. When I got it, I kept it under wraps, waiting for the day. My level of excitement grew. My biggest concern was whether I

could get close enough to the Pope. Security was going to be tight. So the day grew closer, and I kept wondering, "Where am I going to do this?" The most logical place to attempt it would be at the seminary, that was the time I'd be closest to him. And indeed it was.

The Pope spoke to us in Saint Martin's Chapel, the building in the background of this picture. After his address, he began to walk down the long aisle. A *zucchetto's* very flexible, it's made of white moiré and lined with lambskin, and it folds and rolls very easily. So I had the *zucchetto* tucked into the sleeve of my cassock. Then there was a rush to get up front, but I was no where near him. Although my rightful seat *was* up front, there were guests there that evening. Prior to the visit, they had eaten in our dining room, and we had to wait the tables. So I was stuck on late busboy service thinking, "I'm not going to get my seat," and sure enough, I didn't. "Well," I thought, "I lost the battle." So I thought, "I'll go outside and catch him in the vestibule. All I've got to do is catch his eye." But as he moved out through the crowd, I got pushed further and further outside the chapel, down the steps. It was nighttime by then, and there was a sea of people and guys with television cameras.

The big steps were lined with hundreds of bishops, who wore purple and looked nice against the granite. But I couldn't get anywhere near the Pope. The secret service kept pushing us further back, but one bishop, I don't know who he was, looked at me. He obviously knew, or guessed, what I was up to, and he said, "Come here." He put his arm around me, and got me up to the very front by telling a friend, "Move aside a second, John," as he steered me out. Of course, a secret serviceman came right over and put out his hand. But the bishop said,

BOBBY CUNNINGHAM (b. 1951), who has worked as a mortician and an FBI agent, has attended seminary and has been the captain of the Woodland Mummers String Band, is studying to become a medical assistant.

Bobby Cunningham with friends, Philadelphia, 1979. Robert S. Halvey

"Oh, come on, let him go, he lives here." "I'm sorry, that's my orders," the agent said, and he turned his back to walk away. The bishop pushed me out into the aisle, and there was the Pope at the top of the steps. They were putting on his cassock, this beautiful full-length, white cashmere coat. The Pope's got great clothes! I turned around, looked up, and there he was, looking down at me. And there I was, with the *zucchetto*.

Now, as two secret service agents came to get me, the Pope motioned me up the steps, and I thought "*Yes!*" So I walked up the steps, and the Pope looked at me, smiling. Standing immediately next to him was Bishop Marcinkus, formerly of Chicago, and most recently of the Vatican Bank scandal fame. He was the head of security on the North American tour, a gruff character, and not necessarily polite. I got the icy glare. He motioned to the security people, "Get him out of there." But then, the Pope stopped, waved him off with his hand, and said, "Come."

I had the *zucchetto* in my hand. I looked at him. He looked at me. And I said, "This is for you." So he took it. He looked at it. He looked at me. He didn't say a word, almost teasing me like, "Do I know what it's for, or don't I?" That was the feeling I got from him. Then he took off his *zucchetto*, put the new one on, and pushed it down. He looked at me, then looked at the people around him, and said in broken English, "It fits, it fits." In the back of my mind, I thought, "Of course it does, your tailor made it." He looked at his *zucchetto* and said, "What do I do?" I thought, "Don't tell me I'm not going to get this thing, don't tell me he doesn't *know*?" I looked at him, and he looked at it again, and handed it over to me and said, "For you," And I said, "Thank you very much, Holy Father. Thank you, Holy Father." And he said, "No, thank you." And I said, "We love you here." He put his hand on top of my

head. His hands are very large. And he said, "We love you, too." Then he gave me a blessing.

There was a distant, not too faint burst of cheers from my classmates, who had only learned about my plan that day. Once I had realized that no one else had time to get a *zucchetto* from Rome, it was OK to tell them. I made my way over to them, and they were thrilled, because I got so close to the Pope, and he spoke to me. After the Pope left, I went to my room to hold court and receive visitors. It took thirty seconds for the word to get around. They all said, "Let me see it, let me touch it."

By the next day, I was getting phone calls from the local media. A lot of them couldn't get close to the event, so they wanted to come out and get a picture, do a story about me. The photographer who took this picture asked me to meet him in front of the chapel. My friends were happening by and came over to talk to me. As they were taking pictures, I said, "What do you want me to do?" The photographer said, "We're done."

The photo was probably taken for the *Catholic Standard and Times*. It may have also been in the *Philadelphia Inquirer*. I don't remember. Oddly enough, it made wider press circles than I thought it would. The story must have hit the wire services, because people began to write to me and send clippings from newspapers I'd never heard of, some as far as the Midwest. Two of my former teachers from grade school, nuns, quickly took to their Palmer-method penmanship and wrote how proud they were to have taught me. It was getting to the point of, "Don't deify me, I just outfoxed a few people."

The picture amazed me when I saw it. I guess what I felt about that moment is reflected in my gaze upon the *zucchetto*. But

the curious part of the picture is my friends' gaze upon me. It's like a chain reaction. The Pope looking at me had made me feel a certain way. And looking upon that *zucchetto*, I could feel his gaze, and relive that. It's as if the effect he had on me, represented by that *zucchetto*, filtered through me. My classmates are looking at me the way I looked at the Pope. Something cyclical comes through in the photograph.

It's a black-and-white photo, and the whitest thing in it is the *zucchetto*. This next thing is going to sound crazy, but I'm used to being called crazy. I still have the *zucchetto* in a plastic case on a bookshelf in my study, but this picture recalls that incident for me even *more* than the object itself. Although the event made me feel a certain way, the object itself, while it means a lot to me and brings that moment back to a degree, doesn't describe that feeling I had then, as much as my own face and my friends' faces in this photograph do. This photograph does more in terms of recalling the feeling of that moment, a moment I'll never forget. In a sense, it's the closest I'll get to God until the time I close my eyes and open them to eternity, in that the Pope is the Vicar of Jesus Christ on earth. When I look at this picture, it all comes back. It's like it just happened again.

Seminary was a very intense experience, like living in a fishbowl, twenty-four hours a day. It had a drab wardrobe, and I got sick of black and buttons. The whole experience has advantages and disadvantages. When I left the seminary, I kiddingly told my friend, who'd bought a funeral home, "If you ever need help, I've got a closet full of black suits that I'm not going to be wearing out for cocktails." Not long after that, he called me. He needed help in removing bodies from where they die, bringing them to the funeral parlor, helping in the preservation

and embalming, making them up, setting up the viewing, and working the funeral. I signed on.

We use photographs when we're making up the bodies, almost always with women, because their hairstyles are so diverse. If someone's undergone facial changes due to illness, we can restore their face, but we have to have a reference. Working in a funeral home is not creepy. I know people think it is. Since I was one of seven children, we had a credit card account at the accident ward, so the sight of blood never bothered me. Illness never bothered me. Some people say: "You had to go pick up a body in your station wagon? You drove all the way from New York with that? Doesn't that bother you?" I tell them: "It's the ones walking around you have to look over your shoulder at. The ones lying down can't hurt you."

The hardest thing for me in this business is not the physical part, it's the emotional part. Being Irish Catholic, I tend to get a little emotional and melancholy. There are sad situations, you know, especially when a younger person dies and leaves kids behind. That's when I think I'm probably more of a detriment, so I'll leave the room, because I'll be standing there, filling up with tears, and I don't want to get people started. I'm supposed to be there to *help* them through this.

My religion does help me. I'm not afraid of death, I love life. I'm pleased with everything I have, but I know that what I'm going to have after my death is more. Although I'm not in a hurry to cross the line, I'm not going to be disappointed or afraid when it happens either.

This is my family on the event of my parent's fiftieth wedding anniversary and my father's eightieth birthday in 1990. It's not that this picture of my family is, above all else, so important to me. *All* of them are important to me. They are symbolic of my family, which is, other than my work and my husband, the most important thing in my life. It's *who* I am. It's *what* made me who I am.

My sister Jill is in the flowered dress on the right and Amy is in the spangled dress. I didn't always gets along with my sisters, but we are all *very, very*, close now. You must admit, my father doesn't look eighty, and my mother doesn't look seventy-four. My father is a concert violinist who still plays and teaches seven days a week. He revels in having three daughters. In his profession there were women, not a lot, but some. People were judged to a large extent on merit. There was always some sort of *idea* from him that if you set yourself a task and do it well, you could be recognized. Being a woman didn't make a difference. My mother was a much more traditional person. I remember her saying to me at some point that I didn't have to let boys know I was as smart as they were. I thought, "Why shouldn't I?" It really made me mad. But now she is a real estate agent who also works seven days a week, and she looks back on that period and doesn't understand how she ever thought that.

When this picture was taken, the photographer came over and said, "Now this is a good chance to get a shot of you all." My mother is horrible in front of the camera. She's a pretty woman, but when the camera comes out, a barrier goes up. There is this *horrible* social smile, which comes across as *asocial*. In this picture we're teasing her, trying to get her to act "normal" in front of the camera, and we're all giggling.

We all have enormous self-confidence, even though we don't feel that way very often. We were very secure in how we grew up. During the Anita Hill, Clarence Thomas affair, when I broke the story, my parents didn't say anything to me—I was too busy. But when it was all over, my father called me up and said, "I want you to know that I've been very proud of you."

While I was growing up we didn't get a television until I was seven or eight. Then my father used to go on rampages about us watching too much. He would feel the television set, and *know* if we'd been watching. He thought we should have been doing something better. I used to listen to a lot of radio. I had one in my room. Last thing at night I would listen to "The Cisco Kid," with the sound at almost nothing. When I heard my mother come clicking down the hall, "click, click, click," I would turn it off. I'd like to tell you that my interest in radio as a kid has something to do with my ending up in radio, but I don't think it does. It was just a very good journalism job.

Certainly there are advantages and disadvantages to radio over television. There are stories that are *television* stories, stories with very vivid, visual images that are *told* by television. I'm thinking about Ethiopia or Somalia. The main difference between television and radio is that you can tell much more on television quickly, because a lot is told by a picture, information you don't have to *say*. On the other hand, complicated ideas don't work very well on television. I've done some pieces where the ideas are at war with the pictures, and the pictures always win out or confuse people. So you have to drop all the ideas, all the language. The pictures tell the story. And if there aren't good pictures, people get *bored*. They stop thinking.

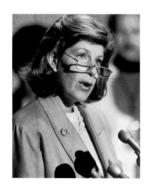

NINA TOTENBERG (b. 1944), National Public Radio's award-winning legal affairs correspondent, is heard on NPR's "All Things Considered," "Morning Edition," and "Weekend Edition."

The Totenberg family: mother Melanie, father Roman, sisters Amy, Nina, and Jill, 1991. Photographer unknown

If a photograph can be charismatic, this is it. When I saw it about ten years ago, it gave me a physical shock, and the shock has endured. It's not something that gets used up or that I can walk away from. The shock is located somewhere behind the stomach, and it moves up. It happens in the face of greatness or sublimity, because something is so perfect that it doesn't need us in any way.

I first experienced such a shock when I was sixteen years old. I'd gone to the Whitney Museum to see the 1950 Arshile Gorky retrospective. I looked at the show, and then I went home, threw up, and slept for eighteen hours. The following weekend I went again, and the same thing happened. Since then, it's happened three or four more times. It's a process is called the Stendahl Syndrome, a condition in which art can make you literally ill. William Burroughs told me about it a few years ago. We spend all our life looking at things that have one-point perspective, that are flat. But all of a sudden, with the Gorky paintings, I was floating in the picture and there was no floor, no ceiling, and no side. I think I became literally sick.

My reaction to this picture was different, but similar. It was a milder reaction. This picture constantly forces me to think. Reflect on how few things force you to think. When you feel something, you ask yourself, "What the hell is going on here?" You deconstruct it. That's what this picture forces you to do. That's the great beauty of something like this photograph. It's not all sold, sealed, and delivered the moment you see it. There's a relationship within it that struggles to express itself.

This picture is from 1930, but it could have been taken in 1994. I would say, art historically, it's "aware" of Alfred Stieglitz, Paul Strand, and Georgia O'Keeffe, in the sense of a close-up of a detail that fills a plane. This picture could be a

wonderful flag for a South African country or a paradigm for everything that Nadine Gordimer writes about. It has a movie screen feeling and scale as if the size of those two hands could be projected as large as Cinerama. It's also so American. It redresses the cliché of white fear of black aggression. This photograph is exactly the opposite. It shows the kindness and caring of an older and wiser culture for a culture that's naive, that's not strong enough yet, and that needs support. I don't think this picture isn't about miscegenation, but all of that hovers at the edge of it, because that's only one way to talk about it.

Look at the composition of this photograph. Suspended in the air two-thirds from the top is a huge oval, which is connected by two cords, like two alleys to the sides of the image. You can read it forward and backward because of the sleeves on each side. The black hand can be read as a bowl with the white hand lying in it. The composition is very pacific. There's a visual weight, a substantiality about this picture that has to do with the enormous physicality of the black hand and the way it's cupping the fragile white hand. It all connects like loops of metal, so it can be read like a linked chain. There's a lightness to her hand, a tentativeness. It's a terrifically magisterial and calming image.

This little hand will be surprised if it gets slapped. The other hand will just keep going. Americans wake up every morning and have to learn things all over again. Americans are amazed all day, whereas the ancientness and rootedness of the African culture, as transferred to America, is something that wakes up and expects what the day will bring. All of this, of course, is happening in one's head, but it's there. In the picture the idea

Hands, 1930. Consuelo Kanaga

HENRY GELDZAHLER (b. 1935), former curator of twentieth century art at the Metropolitan Museum of Art, New York, was the commissioner of cultural affairs for the City of New York from 1978 to 1983. He is the curator of the DIA Art Foundation in Bridgehampton, New York, and writes and curates for magazines and museums internationally.

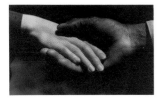

of an ancient culture versus a newer culture is pure projection. But the wood, maybe ebony or some very, very fine hard wood, is holding something that is not exactly dull, but that doesn't have much of a history. The feeling of ancientness is reinforced by the wonderful lines on the black hand, which go up the wrist and disappear. Here I go, talking like an art historian again. I feel crazy, talking like this.

A photograph makes you nervous because there's less room to shrink from it. A painting gives you a wobble somehow, a tiny bit of space to move around in. It's less exact, mechanically less enhanced. With a photograph, you feel it incumbent upon you to have an opinion. If you don't give one, it may appear as if you don't have one.

I was so interested in this photograph that I got a print of it from the Brooklyn Museum and put it in a $1.98 plastic frame. I kept it on my desk, and I looked at it all the time. Everything in my house gets judged every day. If it's not up to snuff, it goes in storage and something else comes up. When I moved from an apartment to my house a few years ago, it was put away. Recently I was flipping through some stuff downstairs, saw it, and it came right back up again. And it's stayed up. I've been traveling with this picture for the past six months. I bring it with me to make myself feel comfortable.

When I travel with it, I put it up in my hotel room. Very often, if you see something that you know very well out of the corner of your eye, you suddenly see it differently. When I visited friends in Saint Martin, I put it up in a place where I would see it as I went to the pool and back. But it was only in looking at it very closely with Ellsworth Kelly, that we noticed the manicured nails and realized that this was a small woman in relation to a man. I had always thought—and this was my

fantasy, because I always think I'm six years old—that this was an older person taking a child to school. But the immaculate novelty of the small hand does have a trace of a history. Look at the one callous, which might have to do with working.

When I was a child, eight or ten years old, we had a maid, called Ann, who was black, a college graduate, and in her twenties. I adored her. I would come home from school every day and sit in the kitchen with her. She would be doing the *New York Times* crossword puzzle. I thought it was ridiculous. She was in this subordinate position, and yet better educated than some other people I could mention.

Like this picture, I was sheltered. That adds another layer of emotion and sentiment to my response. When I see this picture, I think about being protected. It's about the specifics of the fact that I'm being sheltered, and yet society tells me that I'm being menaced. The ingrained idea is that blacks commit crimes against you. This picture is exactly the opposite. It's about somebody who makes sure that I'm safe.

This is definitely the picture I think about the most, but, of course, there are other photographs that interest me. Like a lot of people, I rip out pictures from newspapers and magazines all the time, and what I rip out is pretty personal. They're pictures that could clearly be passed by as nothing by someone else, but seen from a certain point of view, they're absolutely loaded. There's one place where I hide pictures like that. I have a huge Dale Chihuly blown-glass clam shell, in which I keep my hats, and I keep my ripped-out pictures under the hats. Isn't that terrible? If someone looked at them, they wouldn't see what I see, but they would know what I'm ashamed of—no, not ashamed of—excited by.

Photographs have always been a potent stimulus during my research for a stage project. It was Eliot Elisofon's 1960 photo of Gloria Swanson, standing in the rubble of what had been the Roxy Theater, that influenced Boris Aronson's designs for *Follies* in 1971 and dictated the structure of the libretto, the atmosphere of the musical numbers, and the direction and staging of that show. Another photo—a centerfold from *Life* magazine of a group of young boys, naked to the waist, wearing crosses, and snarling at a black child on her way to her first day of school in Little Rock, Arkansas—gave the original cast of *Cabaret* a sense of the relevancy of the material beyond its obvious context. It can happen anywhere!

But when asked to choose a photographic image that affected me, I instantly flashed back a few years to a visit my wife and I took to Poland. Included in our itinerary was a pilgrimage to Auschwitz and Birkenau. I have visited a number of concentration camps. Why? Well, I believe if you are in the vicinity of one, you damned well had better. In 1969, the first one I visited was Dachau. Dachau is like a museum, pristine and clean, in a hamlet outside of Munich. When I asked where the camp was, the people refused to direct me there. Some denied knowing of its existence.

Auschwitz has been arranged as respectfully and eloquently as any memorial can to anything so ghastly. Aside from thousands of people who were herded into airless boxcars and shuttled into the camp, I'm told that between 1937 and 1945, entire families from the "privileged" class, under the delusion that they were to be resettled, packed picnic baskets, got onto trains, and journeyed first-class right into the eye of the Holocaust. While Dachau is painted white like an exhibit at a world's fair, Auschwitz is more immediate. It contains one room, possibly one hundred feet long and sixteen feet high,

with a glass wall behind which there are nothing but shoes. Another room is piled high with overnight bags on which people have painted their names and addresses and, in some instances, where they were born. Since 1945 millions of people have read those names and read beyond them.

There is another room filled with children's clothes, many of them homemade, such as pretty smocks and crocheted baby's clothes and decorated infants bibs. And another, floor to ceiling, packed with human hair shorn from the men, women, and children of Auschwitz. When they were gassed, their hair turned yellowy orange, so all the hair in this room is the same color and presumably was used to stuff mattresses and pillows. Yet another room is filled with brushes: tooth brushes, hair brushes, clothes brushes. Just brushes.

Which brings me to the photographs. In the corridors linking each of these rooms are hundreds, possibly thousands, of photographs of inmates, which were taken on arrival in the camp. Each is a composite: a view from the front and a side view. They range from infancy to old age. There is a thin metal bar over their head, under which they were told to stand for the camera. Some wear small caps, most are shorn. Some appear frightened. Most numb. A surprising few are smiling.

What none of them knew at the time their pictures were being taken was that on average they had four more days to live. The phrase "talking pictures" is astonishing apt, for what most affected me walking those corridors is that these people still live. A current behind their eyes spans fifty years with the energy of their life force. They are immortal.

Following pages: Identification photographs, Auschwitz concentration camp, 1940s. Photographers unknown

HAROLD PRINCE (b. 1928), winner of more Tony Awards than any other person on Broadway, directs and produces musical theater. His Broadway hits include *Pajama Game*, *West Side Story*, *Fiddler On the Roof*, *Cabaret*, *Sweeny Todd*, *Phantom of the Opera*, and *Kiss Of The Spiderwoman*.

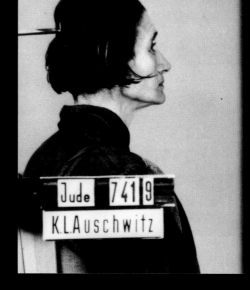
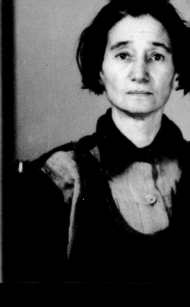

Jude 7419
K.L.Auschwitz

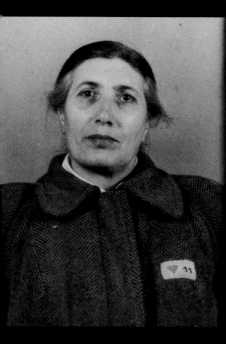
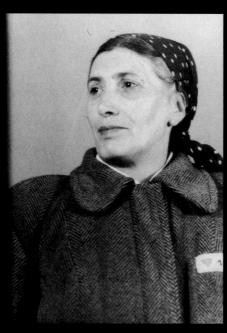

Pole 21669J
K.L.Auschwitz

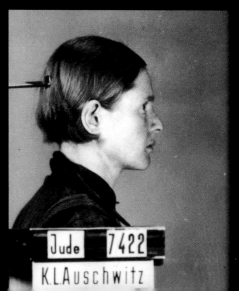
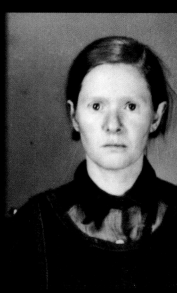

Jude 7422
K.L.Auschwitz

I was living on Gilcrest Drive in Beverly Hills when I saw this picture in 1945. Someone sent it to me and said, "You're married to a Marine, you really have to see this." I thought, "Look what our boys are doing. This is a marvelous picture." I put it up by a mirror that I used a lot. You know ladies like to look in mirrors. It stayed up there until after the war, I'm sure. It is a sensational picture of victory. I could appreciate what these boys were going through to raise that flag. They were real targets. They made themselves targets. Marines always do. I've heard they made millions of copies of it as a poster and a car sticker. Not to mention a postage stamp! It doesn't surprise me that it's probably the most reproduced picture of all times.

During the war I visited Army camps and hospitals for the USO in the United States. Everyone in Hollywood was involved in the war effort. We were proud to do our work. In September 1942, I traveled to Texas, New Mexico, Arizona, and then back to California, visiting Army camps. My mother had been a Marine in the First World War, and she was lobbying for me to visit Marine Corps bases. The first one I went to was Camp Elliott in San Diego.

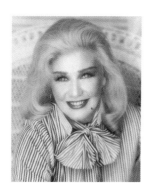

GINGER ROGERS (b. 1911) made her stage debut in vaudeville at the age of fourteen. Although best known for the musicals in which she danced with Fred Astaire, *The Gay Divorcee*, *Top Hat*, and *Swing Time*, she starred in seventy-three films, hundreds of stage shows, and won an Academy Award for her dramatic performance in *Kitty Foyle* in 1940.

It was there that I met Jack Briggs. This darling young man was assigned to escort me around the camp. At the end of the tour he said, "Is there anything else I can show you?" I said, "You're kinda cute." I told him that if he was ever in Los Angeles on a pass, he should give me a call. The invitation was extended as a courtesy, and I didn't really expect to hear from him. Two weeks later, he landed. We married after about three months. A few weeks before Christmas in 1943, Jack was sent to the Pacific. I wrote him every day and sent him homemade chocolate chip cookies, cakes, and salami, every fifteen days or so. You can imagine when I saw this picture the meaning it had for me.

It is a work of art. Look at the composition. You can't walk away from it. If you're a painter, as I am, you certainly can't walk away. The angle of the flag is very beautiful. The sky is very still, conducive to the action to come. The young man leaning on the right-hand side is a beautiful figure. The battle was raging and those hands are struggling to get that flag up there. It was very patriotic. I looked at it and just loved every one of those precious guys. You can't see their faces in the picture. They stand for anybody and everybody, but I thought of it as being my husband. Today, people burn flags like this one. Kids have no idea of the meaning of this picture.

I think it is spirit that gives a picture life. As the Bible says, it's the spirit that creeps in. "The flesh profited nothing." It is the spirit of your performance as an actor that comes through, not because your hair's parted in the middle. You have to know something about what spirit really is. God. Is there God in your thoughts? I could not attest to the fact that God was in the minds of these Marines when this picture was taken. But they were doing something that in their minds was victorious and wonderful. They were winning the war this way. I know that God was the motivating force. The intensity of feeling and togetherness is brotherly love to me. It is one of the most smashing pictures I've ever seen.

Marines raising the American flag on Mount Suribachi, 1945. Joe Rosenthal

This is a Polaroid that the photographer Bernard Plossu made of me. A picture of my back: my short hair and neck. But when the Polaroid came out, there was a small red line across my neck, like a razor mark, like blood. I got extremely scared. I took the Polaroid home, and for eight days, I didn't go out. I've always had some problems with my neck. I was strangled twice. The first time in Guatemala by a man who attempted to rape me. I simulated I was dead to get out of it, and he reacted by running away. Again, in Paris a man attacked me in the street by grabbing me around the neck. After that I have become completely allergic to being touched on the neck. I would wear nothing around my neck for several years, even a scarf. But later I had this lover who enjoyed strangulation. It became a challenge to like it, to distinguish between someone who strangles you to rape you, and someone who does it for other reasons. Eventually I liked it a lot. I keep this picture in an envelope of things that have meaning. I look at it often.

SOPHIE CALLE (b. 1953) is a conceptual artist whose work has been exhibited at international institutions including the Museum of Modern Art, New York, and the Centre Georges Pompidou, Paris.

Polaroid SX-70 of Sophie Calle, early 1980s. Bernard Plossu

This is the first picture I made that made me feel I'd really made a *photograph*. I remember the day exactly. It was in 1966. I had a Fulbright Scholarship, and I had been traveling all over Turkey. I spent a few days photographing a family in Trabzon, and on this day one of the daughters posed for me in the back of the house. I couldn't speak Turkish, so there was no way I could give her any instructions. She just stood there. She is at that wonderful age, a time of life we all recognize. For me, this picture says all those things that come into our minds when we think about a young girl becoming a woman. The child looks so seductive, and at the same time her face is beautifully innocent. Her clothes contradict her attitude. Her face and body don't belong together.

When I took this photograph, I knew I had taken an intellectual step as a photographer. I was in this picturesque, exotic country, but I understood I was photographing something that went beyond that. I was crossing cultural boundaries. This picture is also about *my* transformation from being a young woman just learning to use her camera to really becoming a photographer. While it's one of my earliest pictures, it's one that I feel is still very commanding. It has a life of its own.

It's very difficult to make unique pictures. But, of course, that's what you strive for. When people ask me to photograph poverty it's difficult, because I want to move *beyond* the cliché of all those images of the poor we've seen so many times. I also want to make a *strong* picture, so I look for less obvious symbols, for qualities like vulnerability, for irony, for that edge, and even for humor. What amazes me is that when you photograph tough "reality," you're always asked about exploitation. Photographing someone who is disadvantaged makes people question if mutual consent exists between the photographer and the subject. The truth is people who are not famous or

who are poor also want to be recognized and granted that sense of immortality a photograph gives you.

Throughout my life, of course, I remember and think about many of the people in my photographs. The child from Turkey in this picture was about twelve years old in 1966, fourteen years younger than me. I was twenty-six. She'd be thirty-eight now, twelve years older than I was when I took her picture. Isn't that amazing? I wonder if she remembers me. Probably not. I chose never to have children, but there's a series of these "children" from my pictures that have come into my life. The children I've always connected with are preteens or teens. Like this girl in Turkey or Tiny, a teenage prostitute from Seattle, who was in my movie *Streetwise*. I guess, in a way, they're a substitution, the children I never had. I think about them then and now with a lot of the people in my images. I think about what they're doing and where they might be. With some of my images, like my pictures from Mother Teresa's Missions of Charity in Calcutta, I wonder if the people are still alive.

I've chosen to photograph the people I photograph because I care about them, their lives interest me. I decided from the very beginning to be mainly a photographer of the nonfamous and sometimes less fortunate people, because I wanted to be a voice for them. Even though they were less advantaged, I thought them to be more worthy, more deserving to be photographed. To me they *needed* to be photographed.

MARY ELLEN MARK (b. 1940) has photographed subjects as diverse as the Indian circus, runaway teens, the mentally ill, and Mother Teresa's Missions of Charity. She has been awarded the Robert F. Kennedy Journalism Award and the George W. Polk Award for Photojournalism.

Young Turkish girl, 1965. Mary Ellen Mark

This photograph was taken at 95-36 150th Street, Jamaica, Queens. Judging by my size, I had to be three-and-a-half to four. It's 1935 or 1936, and my parents had come to America about six years prior to this. The gentleman behind them was probably a customer. The man next to my father is our landlord, Mr. Kessler, who taught my father how to speak English and run the store. He has an apron on, but he never worked in the store. We could never have afforded him.

My father and mother came from Nocera and Tramonti in Italy. My mother's father owned a mountain, where they cut down trees and made barrels. My father was a laborer on the mountain. My mother had only seen him working and had never spoken to him alone until he proposed to her. They got married, stayed in Italy long enough for her to become pregnant, and then my father went to Jersey City where a cousin had a job for him as a ditch digger. Another cousin, Rosario, had a fish store in Queens. He had come over before my father and was sophisticated compared to him. Rosario spoke English very well. Although he could not read or write, he had done well. He said to my father, "You can't work as a ditch digger, you'll kill yourself. You're too small!"—my father was lame as well—"You'll never make enough money to take care of your family. You need to be in business."

It was the Depression, 1932, and people were leaving stores empty everywhere, including Mr. Kessler's grocery store. Rosario heard about it, went to see it, and told my father, "Mr. Kessler says that it will cost you six hundred bucks for everything—the key, the stuff on the shelves." And when my father said, "I don't have six hundred bucks," Rosario said. "Maybe Kessler would let you pay over time." Which Mr. Kessler did. Who knows why? I have come to believe he is one of the great men. A saint. Even if he was just protecting his rent money,

what's the difference? He taught my father to run a successful grocery store. And the store stayed open twenty-four hours a day, seven days a week. My father took care of the customers, because he could count. My mother could count a little, but he would never trust her. When you're young, you're stupid. I remember being a little ashamed of my parents. Now that I'm older, I think of the shame that they must have been feeling.

I remember being in the back of the store most of the time. There was a room, a giant room, where we all lived. After a while, we got one bedroom upstairs. The other people in the building were mostly Jewish—the Kayes, the Rubins, and the Kesslers. Down the block was where the O'Rourkes and the Kellys lived. There was a Portuguese bar and grill across the street on one corner, an Italian bar and grill on the corner across from that, a Black bar and grill on the third corner, and on the far corner, there was an Orthodox synagogue. Everybody lived civilly with one another.

My brother and sister did most of the work. I was spoiled compared to them. But as soon as you could push a broom, you had to go downstairs to the basement and clean forever. All winter long, you had to shovel coal into the furnace. As soon as you were big enough, you'd be sent down to get a twenty-pound box of spaghetti, or when you got a little bit older, a case of tomato paste, which was really heavy. Milk was very heavy. It came in bottles in wooden crates, and it went very fast. No customer would leave without milk and bread. I still have the muscles from it.

A whole new life opened up to me through school and church.

MARIO M. CUOMO (b. 1932) is New York State's fifty-second governor. He has worked to create programs relating to environmental protection, energy conservation, and drug education and prevention, as well as assistance programs for children, the elderly, and the homeless.

Mr. Kessler (in apron) with Mario Cuomo and his parents Andrea and Immaculata at the family store, Queens, New York, c. 1936. Photographer unknown

School made the big difference. I went to P.S. 15 because public school was free. And then, I became an altar boy, which also made a difference. I stopped hanging around the store. I went to Sunday school, where I was forced to learn the catechism. And I began to read a lot. I'd come home and read in the back of the store. Even when I was older, there wasn't much to do in the neighborhood. We didn't have team sports; we didn't have money for them. I didn't know how to play ball until I was fourteen or fifteen. I didn't know how to swim. I never had a bike. I never had roller skates.

I got my books from the Queens Borough Public Library on the other side of Kings Park. For some reason I'd run there as fast as I could. I'd go to the periodical room. I went to the career planning section to get books on the law, engineering, how to be a policeman. That's how I got my idea of the outside world. Reading and the radio. And I was constantly using that part of my brain that drew pictures—the imagination. I loved picture magazines, too, but nobody bought them. You'd have to find them on the streets or in junk piles or at the library. Picture magazines were for people with money, middle-class people who lived in houses. We were the tenant people.

It's interesting to consider how important this picture is to me and then to understand that the importance of photography in politics is something I don't really think too much about. The best political advice I ever got—which I never followed—was from my son, Andrew, when I first became Governor. He said, "You ought to pick one thing and become associated with it. Get identified with something people can keep in their mind, so when they think of you they automatically think of that. If you want to build roads and bridges, be the builder. If you want to do education, be the educator, and make all the pictures education pictures and all the speeches education speech-

es." I've never been good at that, because I have dealt more with ideas. We've never worked at any particular image, and the result is that I have no image. And that hurts, politically. People are always saying, "What has he ever done?" The truth is nobody has ever done what we've done. As Governor, nobody. Not Rockefeller, not Dewey, not Harriman, certainly not Roosevelt.

I'm not a person you see in a lot of pictures. I duck them as much as possible. It never fails, even after all these years, that people, usually women, say, "You're not as ugly in person, as you are on television. You look better in person than you do in your photographs." I hear it all the time. I'm not a good-looking person, but I look better in person, I think, than I do in almost all my photographs. And television is a horror, but I laugh and make jokes about it. Television makes me look fleshy and baggy and lined, with shadows everywhere.

There's another thing that is interesting about this picture. It makes me think that the American Dream still lives. The rags to riches, log cabin to White House, coal mine to Park Avenue story, will not be as prevalent in the future, because so many of the immigrants that come here are already reasonably advantaged. The trip to affluence and success will be shorter for them, not quite as dramatic as it was in the past. But the chance to go all the way to the top, however you define that, is greater than it ever was. There's more opportunity now, because the world is so different. We're still the most powerful country in the world. The American Dream is still alive. That's why people keep coming, as my parents did. People don't come for nightmares.

This is a picture of the Cruz family—Maria and her three daughters, Cookie, Deborah, and Lucy—in front of Mount Sinai Hospital in New York City. They were part of the strike that took place in 1959 for union recognition. I identify with the picture completely. Whenever someone comes to take a photograph of me, I stand in front of this one. I have it on the wall in my office because it symbolizes not only our union, but what we are here for. It's the largest image of maybe forty or so posters, paintings, and other photographs I have around me, believing as I do in the propagandistic power of images. What really dramatized this picture for me is here you have a Hispanic family that is closely linked together, all involved in the struggle. For me, being from Hispanic heritage, this picture makes me feel very, very proud. When I see people from other ethnic origins who identify and recognize this picture as a symbol of what they are, too, that makes me even prouder.

Maria Cruz earned thirty-six dollars for working a six-day week, and she took home less than thirty dollars. The picture basically talks about how a family cannot live on thirty-two dollars a week. As a matter of fact, in 1959 it was possible for you to work full-time in the hospital health care system in New York City, and qualify for welfare at the same time. The income was poverty level.

I first saw this photograph when I came to the United States in 1977 from Puerto Rico. It was on the cover of one of Local 1199's union magazine issues. I had been hired to work as an organizer for the union, so after work I would go to the magazine department of the union, and I would start with the first issue of the magazine, and read issue after issue to get a sense of the union's history. The strike was about the hospital worker's right to have a union, and it went on for forty-nine days. This is the strike that really did it, that made Local 1199 the hospi-

tal worker's union. In fact, more than 20,000 people joined the union in that one year. We went from 5,000 members to close to 25,000 people. Now we are 117,000.

There is a sense of determination in the eyes of everybody in the picture. The third woman back is the mother. Look, anybody who's been in a strike knows it's probably one of the most vulnerable moments of your life. You feel like you don't know what's going to happen. It seems that you're putting your whole life on the line. It's a period of great anxiety, and I've always thought that the look in the mother's eyes is a reflection of her state of mind. There's a sense of identification between the children and the mother about what's happening. I've always assumed that the children are sharing the anguish and the anxiety and the problems that their mother is facing. They *know* what is going on is important. Clearly, it's a working-class, struggling family. The kids are not sheltered from reality, but on the other hand, while it's clear to them that life is very rough, they're fighting to get ahead in our society.

It is harder now to organize people than it was in 1977, particularly after years of Reagan and Bush. The labor movement in America is in the biggest crisis since its inception. Right now, legally we've lost the right to organize, the right to strike, the right to collective bargaining. Even more seriously, the values of what the union stands for, what it is about, what role it plays in American life, has been completely deformed. So the labor movement is completely paralyzed and doesn't know how to counter this moment.

In the past, people used to say that labor unions were bad for the economy, that they prevented employers from really letting society function. The objective reality in the countries that are overrunning America now as economic powers, such as Japan

DENNIS RIVERA (b. 1950) is president of Local 1199 of the Drug, Hospital and Health Care Employees, the largest health care workers union in the United States. Born in Puerto Rico, he moved to New York City in 1977 and has become a significant force in New York politics.

and Germany, is that they have double the percentage of unionized workers and their economies are *flourishing*. On the contrary, union workers have a greater sense of control over their lives and a greater sense of participation in society. Because of the lack of trade unions in our country right now, we have a horrendous gap between rich and poor, and we don't have any mediating forces that help us to have a better society.

When the Second World War ended, Japan, Germany, and all of Europe were completely decimated. The United States was pretty much intact, so we proceeded to become suppliers to the world of primarily manufacturing goods, and that's how the middle class was born in this country. They were basically high-school students who worked in factories, and through the unions were able to get decent wages. Now we have an economy that has been completely transformed. The countries that the United States decimated in the war have rebuilt themselves, and now *compete* with us.

In the United States, the working class was comfortable and was not having major crises compared to other societies, so we did not take issue with the shortsighted vision that managers had. We went along with the idea that we could get good short-term returns on our investment, forgetting long-term investment and what was going to happen with us. Further-more, we bought into the false notion that our sense of pros-perity was going to be permanent and stable. At this moment, my sense is that our society is at a crossroads, and we have to change the economy of the United States. The economy is not based on manufacturing anymore; we are part of a global econ-omy. We have many people who are primarily unskilled in the kinds of technology that are needed for the next century. America is in for a rough period.

Local 1199 is primarily women and about seventy-five percent of our membership are health-care workers. About forty-five percent are African-American, about twenty-five percent are white, and the balance is Hispanic and Asian. It is composed of everybody who works in a hospital, except for the doctors and administrators. Thinking about how things are different for the people in this picture today, the jobs in the hospital industry are very sought out jobs, because now the minimum salary is $400 a week. We have some of the best health care benefits in the country. We have training programs and schooling that helps you move up in the system. We have a pension plan, a scholarship program, summer programs for kids, cultural pro-grams, a job security program, housing programs, and all kinds of services that were not available to the Cruz family when this picture was taken in 1959. So, in that sense, we have come a long way. Now people like the Cruz family are part of a very powerful political institution. Those who want to be active can work to try to change society in the work place or in their neighborhoods. In that sense, things have changed a lot.

So-called minority communities are the most economically dis-advantaged people. Many of the images of them in the media today distort their real condition. For example, rather than see-ing a family like the Cruz family as a working-class family, struggling to make their life better, we see the images of male Puerto Rican drug addicts. The reality is that the Puerto Rican community is a combination of *both* realities. What we need to do is to change the socio-economic conditions, and then the images will change, otherwise we're going to continue to have images of people who are very poor and very disadvantaged.

Cruz family on strike at Mount Sinai Hospital, New York City, 1959.

Photographer unknown

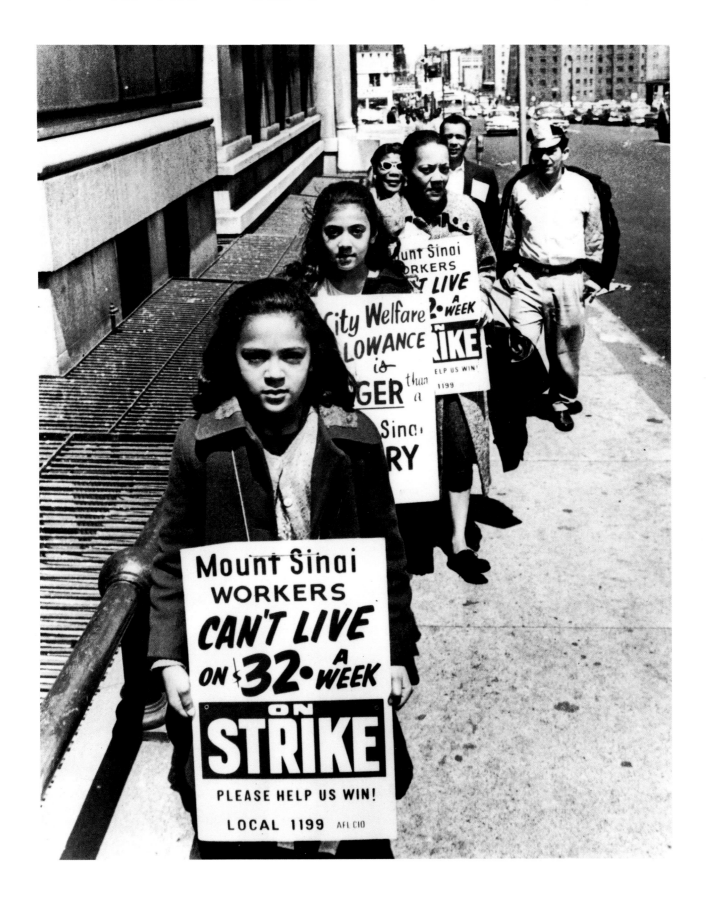

NAOMI CAMPBELL

I was in London when I first saw this photograph. Hugh Hudson, who was directing a movie about Josephine Baker, sent me a book about her life, because I wanted to test for the lead role. It never happened. I hope someday it does. I'm certainly not Baker's equal, but she's my hero. My mother was a dancer, and she loved Baker and used to play her music when I was twelve or thirteen years old. I was studying dance, and I can still hear my mother's voice, "You have to try to be just like her!" Josephine Baker was an inspiration for both of us.

People were frightened by her, because she had the energy of ten people and a great presence. She was not a conventional beauty, but was striking, crazy, and mysteriously dark at the same time. She exploded out of nowhere at the camera. But I love this picture of her because of the moon of light on her face and how her eyes tell everything about her life, which was not an easy life. I love her simple, satin dress. Her jewelry's wild! And her makeup is incredible! We'll never have that elegance again. But this shows an off moment, a beautiful moment. I think she's very vulnerable and probably insecure, and that comes across after you've seen a lot of pictures of her. You can see it in her films, too. From what you read, it seems all she ever wanted was be loved, and to have the right husband, a family, and her career. But she was unlucky in her relationships with men, and she went through many husbands.

My mom explained to me that Baker was an American who had a hard time getting a job in America, and had to go to Europe. When she came back to America after being a success in Europe, people still didn't accept her. Let's face it. Trying to be a dancer is not easy, and she was black. Two wrongs. But she never gave up, even though she was put down so many times. She wanted to achieve some peace in her life, because she went through so much discrimination that her message as

an artist was that everyone—no matter what race—should be united. You know, she adopted eleven children, all from different countries.

The discrimination she experienced is a little less today, but it's still out there. Today I can work anywhere, but it took a long time for that to happen, and there are still obstacles. An editor will say, "Oh no, you can't be on a *Cosmopolitan* cover, because we had you on it a few years ago, and you'd be the first black girl since then. Black girls sell *Cosmopolitan*." But don't you think black women buy *Vogue*, no matter what the color of the cover girl is. They wear the same kind of clothes, no?

In this picture, Baker's projection is very sad, and I've often felt this way. But when you're on the other side of the lens, you're always projecting. Sometimes when I'm doing pictures, the photographer has to change batteries or something's wrong with the light, and I'll just look off into space for a minute. I sometimes tune out, and people take that look and say, "Oh, stay right there, don't move." That's probably what happened in this picture. But her determination and toughness are there.

Modeling is a way of being another person for a few hours. Sometimes I walk down the street and people say, "Ugh, she's got no makeup on." They expect me to look like I do when I'm working. I like the fact that I wake up in the morning and get made up with wigs and heels and stuff, and that I wipe off my makeup and go home and become my real self. I do trust pictures, but not pictures made in my world, because I know what goes on. When I look at a picture of myself, I don't think I'm looking at myself. I'm looking at a picture of someone else. In that sense, a picture is successful only if I fool myself.

Josephine Baker, Berlin, 1928. Photographer unknown.

NAOMI CAMPBELL (b. 1970) is a model who has appeared in, and on the cover of, every major international fashion magazine.

144

When I saw this picture in a book at home, it was the first time I understood what art is. We lived with photography in my house. My father started to take pictures when he was eighteen years old in the 1920s. He was a news photographer for *Corriera della Sera*, a major newspaper in Italy. He knew all the tricks and had the intuition to know *exactly* when to take the best picture. He took pictures of Mussolini and worked throughout the war. My sister, who is eleven years older than me, took pictures, too. When she went to art school she started to be more interested in the *quality* of photography—the meaning of its formal qualities. She always had books about photography around the house. So I grew up with photography and the smell of the developer and other chemicals. I had my first camera when I was six years old. When I got older, I knew I wanted to be a photographer.

I remember the first time I saw this picture. It was in one of my sister's books. I even remember the angle that I saw it from. I remember thinking that it wasn't sharp, and I couldn't understand why something so simple would affect me so strongly. The complicated part of this picture has always been my reaction to it. For me, this image is the strongest picture I have ever seen about the human condition. It shows how the man is feeling about his life. He's got his bricks and he's going to build something. But what is he thinking? This bricklayer looks at *you* before you look at *him*. If you walk away, or move over here, he's still looking at you. He looks at you, but you don't know if he's happy or if he is in trouble. There is an ambivalence to this picture that is all about life. You don't know why you are here. You don't know why you have to do what you do. But he's standing solidly, he's really got pride. This person is telling you, "Look, we're all just the same. I feel the same as you." When I look at him, I feel as if I'm looking in a mirror, and this picture is from 1927. That's incredible.

People piled those bricks on him, and he'd climb up stairs. He's carrying a burden, but look at him. Look at that construction behind his head. It's growing, like an extension of his body. It's like a building on his shoulders, like architecture. The only real perspective is in the bricks behind his head. It's like a niche, everything in the picture points there. His brain is actually in the middle of an explosion, an architectural construction, like the human condition. I've got the feeling that in front of him there is a building going up. He faces what's going on, and yet the picture doesn't really tell you what's going on. I don't know if he's laughing. He's got that ironic, sarcastic expression, and it keeps changing. That's why I have looked at this picture all my life. Some people look at a picture for thirty seconds, some for years. It doesn't really matter because a picture is like life. You take out of life as much as you are able to take out of life, just as you take out of a picture as much as you are able to take out of a picture.

We all accept pictures. It's a yes or no response. In the last hundred years, our brains have been more and more computerized. Let's take an example: we decide to go to the movies to see a war movie. We buy a ticket and sit in the first row. There's Dolby stereo: war noises, tanks, and children getting killed. Wow! They are German or Vietnamese. Let's kill them all. It's actually a *reality*. Everything seems normal. It's not a fantasy. People are blowing heads off in the movie, and at the same time, we smile and eat popcorn. Suppose that when we get out of the movie house, suddenly, inexplicably, we are in Sarajevo. The same scene from the movie is now what you see *outside* the movie house. Tanks are coming down the street and blowing children's heads off. A sniper is killing a woman. Well, for me, as an image person, what's the difference?

Hod Carrier, Cologne, c. 1928. August Sander

OLIVIERO TOSCANI (b. 1943), a photographer whose work has appeared in international magazines, including Elle, Vogue, Lei, Paris Match, Mademoiselle, Stern, and Harper's Bazaar, has been the creative director of major advertising campaigns for Benetton and Esprit.

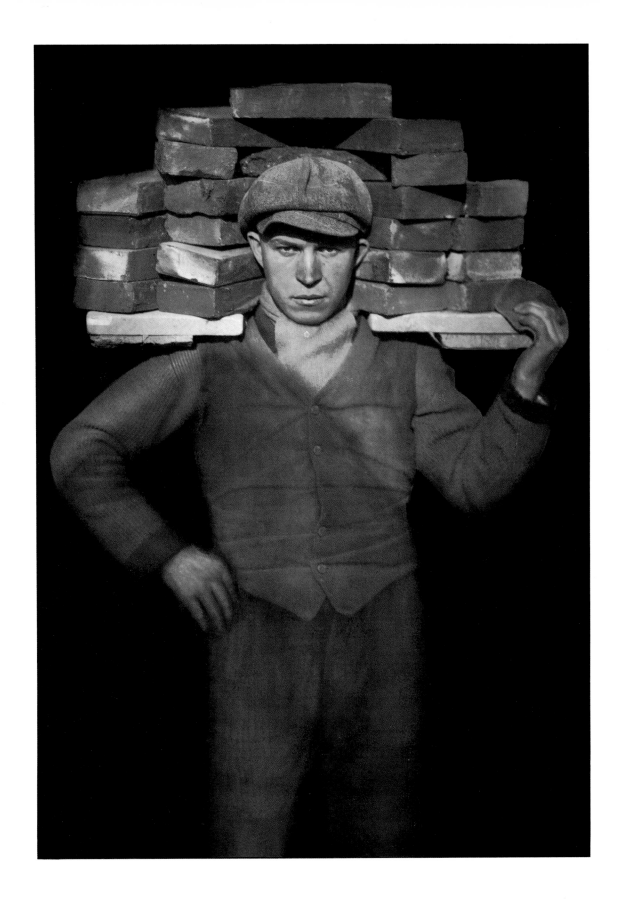

Nothing. To me, it is no different. For most people, there is a difference. When you see *real* war, it is not accepted. But if you see starving children on TV, that's OK. If the same starving child were sitting next to you, you would get a shock. But, really, what is the difference? Is it just a question of physical distance? That idea really intrigues me. In images there is such a thing as distance. Everything in a picture is just there, waiting. An image is an incredible engine that turns on, moves, and starts a reaction in your brain.

This is the only picture that is hanging in my house. I bought the print from Sander's son in 1969. I have books and magazines at home, but I don't have television. So this picture is *the* picture, the *only* one. My job in the world is to see, and this one picture stands for everything. My children look at it, too. When they were little, they would look at this picture and ask me all kinds of questions about it.

I've never tried to recreate this picture, but the directness of it is something that I try to use a lot. Remember when I said that this August Sander photograph was like a mirror? Do you remember the Benetton ad with the newborn baby in it? It was the most controversial of all the ads we've done. Well, that picture worked that way, too. The advertisement was so controversial because there are some people, not everybody, who do not want to be what they are. And they didn't like what they saw. There was nothing cosmetic about that picture, nothing nice. It became the most censored photograph in the world—including Great Britain, France, and Italy—in eighty of the one hundred countries we advertise in.

That's why I love what I do. It's great to be fifty and still learning. And now I'm learning that even being a photographer is changing. In a way, it's disappointing. Once a photographer could just expose the film, handle the camera, and know technical things. But now a photographer is more of a visionary, someone who envisions things. Real or unreal, it's still reality. Even a dream in a photograph becomes a human reality. The photographer of the future is somebody who is going to be a visual consultant, a total director, a *consigliere,* involved with design and even with politics.

It's already happening. Pictures go from being commercial to being editorial. They move from culture to culture, and as they move, the meanings shift, because every culture is missing something another culture has. When someone comes to a picture, it acts as a mirror that engages their nationality, their race, their education, their connoisseurship, their cultural level, their psychology, their sensitivity, their mental knowledge, their religion, everything. The more images that go through you, the more connected you get, or disconnected, if you don't want to get engaged.

You know how some people get sick at the sight of blood? Well, if I make a little cut on my arm right now, blood will pour out. It will be an upsetting mess. But we're full of blood. People who are horrified by blood in real life, are impressed by blood in pictures, because they have a chance, through a picture, to look inside themselves. Do you know what I mean? We become very impressed when we get to look inside ourselves, into pictures. *That's* the relationship we have with pictures. Every picture is a piece of the inside of ourselves.

JOHN EPPERSON

This is the picture, from *Bye Bye Birdie*. In the movie, Dick
Van Dyke owns a music publishing company, and he's a song-
writer as well. He has this client, Conrad Birdie, who is about
to go off to the army. Van Dyke gets the idea to pick a girl at
random from Birdie's fan club. Birdie's to go to her town and
kiss her on "The Ed Sullivan Show." Well, the girl is played by
Ann-Margret, and her boyfriend, played by Bobby Rydell, is
jealous of Birdie. In this scene there's a lot of tension between
all the characters. It's a big dance number featuring a bunch of
kids hanging out at the soda fountain while Birdie shows up
and sings "A Lot of Livin' to Do."

I saw the movie in 1963 in Hazlehurst, Mississippi, thirty miles
south of Jackson. I was eight years old at the time. It was a vis-
ceral experience for me, a transcendental moment. I remember
the lights and the color, and how the rhythm of the music kept
changing. I loved the choreography, with the dancers moving
like chickens. And they did this little kick step! There was
something sexual about it, but as a kid I didn't know what that
was. I didn't even know the scene was sexual.

I identified with Ann-Margret. She was healthy looking, and
she was the most colorful. She was sexy because of her costume
and her movements. She's supposed to be a sweet high school
girl who turns into a ferocious being with tons of energy!
George Sidney, the director, probably had a yen for Ann-
Margret. He had discovered her and directed her in *Viva Las
Vegas* and *The Swinger*, a very perverse film in which she plays
a human paintbrush. Ann-Margret was provocative.

I remember going to school the day after I saw *Bye Bye Birdie*
and talking about it a lot. Not everyone was as interested as I
was! I did the dance steps *every* day. It fascinated me that this
movie could affect me so much and others not at all. I thought

**JOHN EPPERSON (b. 1955) is a per-
formance artist whose cabaret char-
acter, Lypsinka, appears in clubs,
cabarets, fashion shows, and on
television in the United States and
Europe. Lypsinka is a runway model
and has been featured in men's and
women's fashion magazines.**

life should be, or would be, like this picture. I fantasized that
any party I went to would turn into a big musical number.

I went to the movies a lot because I wanted to get away from
the house, and my parents wanted me out, too. I was only
allowed to go on the weekends, and I went every *weekend*. I
saw all the musicals—*Gypsy, Li'l Abner*—and all the Elvis
movies. When I wasn't at the movies, my sisters and I would
entertain ourselves. We had makeshift costumes, and we lip-
synched to records.

What I do on stage now is a stylized version of what I enjoyed
as a child. In a sense, I'm still the kid in the school yard who's
taken things to a more professional, more thought-out, level. I
lip-synch tunes. My alter ego, a woman I call Lypsinka, is
based on Dolores Gray. The show is a montage of sounds,
combined with animated visuals, all steeped in artificial glam-
our. I'm fascinated with artificiality. That's why I like people
from movies and records, such as Joan Crawford, Lana Turner,
Paulette Goddard, Susan Hayward, Tippi Hedren, and some
you've probably never heard of, such as Faye DeWitt and
Louise Latham.

To many people, a man putting on a woman's dress is a politi-
cal act. I've never seen it that way. To me, it's just a form of
theater, not a big deal. I consider myself an actor. Pushed a lit-
tle further, I consider myself a drag performer. Pushed even
further, I might say a clown, a glamorous clown, in the tradi-
tion of Lucille Ball and Carol Burnett.

The period I'm really interested in is 1955–1965. Around
1967, with the sexual revolution, attitudes, dress codes, sexual
mores started to change, and it was the last year women wore
hats and dresses and gloves. During the years before 1967, a

149

weird energy propelled people towards fate. It's when acting and performing styles were boxed in. So scary. In 1959 *Imitation of Life*, a most absurd, stylized film by Douglas Sirk, came out. It was a big, big success. Sirk used to tell people, "If you want to make films you should study Euripides." His films are like Greek tragedies, where someone is always dying or sacrificing themselves. The actors and actresses are gods and goddesses. Today, there's no attraction to the idea of gods and goddesses because of television and the media.

I started seeing professional theater and road shows that came through Mississippi starting in 1972. I saw Julie Wilson in *Company* and Patrice Munsel and Pia Zadora in *Applause*. I was a big Liza fan. Then I started going to gay bars and saw my first drag performance, which completely frightened me, I think, because I recognized some of myself. So I stayed away from that scene for about a year. Then I was persuaded to go back with some friends. By that time I had read about people like Charles Ludlam and the Warhol scene, Charles Pierce in *After Dark* magazine. Drag performers took what they were doing very seriously. It was a sleazy setting. They were vulgar. It wasn't Lana Turner or Ann-Margret. They lip-synched to Dionne Warwick and Connie Francis. It was ridiculous, and that they didn't know it made it even more ridiculous. The scary part was that I realized how easy it would be to impersonate a woman. It seemed too easy.

I made money teaching and playing piano to move to New York, where I got a job playing piano for the American Ballet Theater School. In 1979 I finally found my niche at a place called Club 57, a little hole in the wall on Saint Mark's Place. Kenny Scharf, Ann Magnuson, and Keith Haring were there. I went to see the film *Beyond the Valley of the Dolls*, and it was another visceral experience, not only because of the film, but because there were all these kids my age, screaming at every little moment. I thought, "Here's a whole world I have yet to discover." So I started going to Club 57 to see films, and I did performances there. One was a lip-synching performance. Then we staged a ballet, which we choreographed on mescaline.

In 1982 I became fascinated by Richard Avedon's fashion photography. His fifties' photographs, the ones with Dovima, were very glamorous. My body type is similar to Dovima's, very long with the same eyebrows. I was fascinated with her makeup. I picked the name Lypsinka not only because of the implication of lip-synching, but I wanted to sound like an exotic fashion model. I thought, "Lip-synching. Dovima. Narratives." It all came together.

Over the years I've gotten sleeker. The sets and the lights have gotten slicker. My style of performing has gotten less cartoonlike, but I won't fully achieve the perfection I'm after unless it's on film. Putting it on film means more to me than performing live, because you can have more control, and because it was the first thing I related to in the arts. Film was and is definitely the most important thing in my artistic, creative life.

Still from *Bye Bye Birdie*, featuring Ann-Margret, 1963. Columbia Pictures

This is my youngest sister, Yvette, with her two children, Jennifer, the little girl in white, and Aniva, who we call Bebe. The kids are called the Oreos. You see why. Black and white. My sister had the picture taken in 1985 at Coney Island where we live. I was incarcerated when I got it, and I pinned it up on the bulletin board in my room with pictures of my father and my kids.

Yvette sent me the picture unexpectedly. I had been dying to get a picture of the three of them together, looking like a family, because somehow I knew that they weren't going to be together much longer. We didn't know then that the little girl was born HIV positive, but I knew she had something she was probably going to die from. It wasn't until two years later that we found out that my sister was HIV positive. Yvette was really shocked. She'd become infected through the little boy's father, the first man she'd been with. She's twenty-four in the picture. She was twenty-seven when she died in 1989. The little girl hasn't died yet! She's ten years old, and she's been on AZT for many years. We found out last year that the little boy is HIV positive, too.

Back then, I used to look at the picture and focus on the little girl, thinking she wasn't going to be around much longer. Today I look at the picture and wonder about a part of a generation that won't exist pretty soon. You see, I have a large family, twelve brothers and sisters, and I always thought Yvette would be around the longest, because she was the youngest. When my sister became positive, it woke me up to reality.

I came to prison in 1983 with a fifteen-to-life sentence for drug possession and sales of cocaine and heroin. It was my first time ever getting arrested. I used to hear bad stories about this jail, Bedford Hills. Betty's House, that's what they called it. My

attitude was, "I'm going up there and act bad. I'll have an evil look on my face, and people will stay away."

I hung out in the yard for the first two years of my bit. It was just like hanging out in the park, where everybody played music and got high. There was really nothing I had to do, except hang out. When I was maybe five years from the review board, I planned to start getting myself together, make a good impression, and let them see how I'd changed after ten years. The only terrible thing was that I wasn't with my five kids.

Things changed in 1987. I called home one day, and everybody was crying. I'd always had this feeling, that I tried to block out, that someone in my family would die while I was in prison. One of my kids or somebody. I thought maybe Jennifer, the little girl, had passed away, but they told me that my sister was dying. I was like, "What do you mean she's dying?" Then they told me she had AIDS, and I was like, "What are you saying she has AIDS? What is this thing anyway?" No one could answer the question for me.

Yvette wasn't just my little sister, she was like my daughter. I raised her. I spent the whole night trying to understand, "She's dying, and she's talking to me on the phone. Crazy! This is my sister!" I looked at this picture and said, "How can she possibly be dying?" All I knew about AIDS was that gay people and IV drug users were getting it. I knew she wasn't gay, and I knew she wasn't an IV drug user. I had no understanding.

A few days after the phone call, about three years after I'd been in prison, a person I'd seen around came up to me and started telling me about some group they were trying to create in the

AIDA RIVERA (b. 1956) is serving a fifteen-year to life sentence at the Bedford Hills Correctional Facility in Bedford Hills, New York.

Yvette, Bebe, and Jennifer, Coney Island, New York, 1985. Photographer unknown

facility for people who had AIDS. I thought, "Why is she asking me this?" It just blew my mind. I hadn't told anyone about my sister. Every time I'd see this person coming, I'd duck. One day she finally caught me, "Look we're having this big meeting. You want to come?" And I said, "Yeah, okay," because I just wanted to get rid of her. I was trying to avoid people knowing that my sister had AIDS, because somehow they'd think I probably had AIDS, too. I wasn't concerned about my sister. I was concerned about myself. Back then, in this facility, having AIDS was the worst thing. I had to live with these people for the next thousand years and all of the sudden, I'm going to make an announcement? When the day came, I just kept thinking, "What the hell. I'll just go in there and listen to what these people have to say."

It was scary walking into that room and seeing all the people that I knew from the yard! I made sure I sat down at the end of the table. I was very nervous. We went around the room, asking why people were there. Some people were just interested to know what was happening. Some people didn't even know why they were there. So the fourth or fifth person down the line got up and said she had AIDS. I almost fell out. Somebody I knew. She just came out and said it. I totally froze. Four people in the group said they had AIDS. And I just sat there looking at them. I mean talk about crying. Everybody was crying. I just came out and told them that I wanted to know what was killing my sister and my niece. I didn't even know I'd said it, and I didn't even worry about how they were looking at me.

But I left with this anxiety inside of me, wanting to know more. These people had something to tell me about my sister and my niece. We had another meeting. Eventually the prison brought in Montefiore Hospital, which did a training program. Every pamphlet they left, we read and reread and reread and

reread. I couldn't understand it, because I wasn't educated. I took reading classes, too, so I could learn to read everything about AIDS.

While my sister was sick, I started working in the prison hospital with women who were HIV positive. In every one of those women, I found my sister. I was able to give to them what I wanted to give to her, but couldn't because she was out there, and I was in here. I still see her in every woman who dies. I wouldn't have been able to get through the loss of my sister had I not had been able to care for those women.

The last time I saw Yvette was two months before she died. I got out on a special leave. She'd got very skinny. She was nothing like this picture. The real sister is the person in the picture. I can see, looking at this picture, what happened to my little sister and probably what's going to happen to her daughter.

In this picture Yvette looks very alive. She was always dancing in front of the Polar Express at Coney Island, swinging her head and flying her hands around. I look at her in this picture, and I say to her, "I'll bet you just finished dancing." I look at her eyes, and wonder if she's feeling the pain of knowing that she's not going to have her daughter. It reminds me of our last conversation. I told her, "Yvette, what are you doing? You're so thin." She said she wanted to go before her daughter. Back then I didn't understand, but I do now. I lost a daughter. I know that pain. In 1992 my daughter Angela died of cardiac arrest. She was eight. She had cerebral palsy.

I have to be honest with you. When I came to jail I didn't believe in anything. I guess I wouldn't have gotten here otherwise. Sometimes I still don't believe. Like when I lost my daughter, I had no understanding. I'm not the person I was,

but somehow I felt I was still being punished. My sister dying, my father, my daughter. When I found out that Bebe was HIV positive, it was too much. But then I started to believe again, because two months after I found out about my one daughter dying, I was given a granddaughter, who is now named Angela.

I always say that Yvette turned my life around. Had she not gotten sick, I'd probably still be hanging out in the yard, and not be connected to anything. Not be responsible, trying to forget the world outside. When I found out she was HIV positive, I said, "It's time to get off this merry-go-round." It was time to start looking at life for what it is, *reality* for my benefit, and for what I want to do for my kids and for her kids. Something changed me when I went to that AIDS meeting. It woke me up to the fact that she lived the life that I should have lived. She became HIV positive, and I didn't. I should have had AIDS.

This has become my life, working as an AIDS counselor. Our group has a program in this facility. We do counseling, show videos, and run seminars. We've even written a book. I found myself through the AIDS program. I was able to go back to school to understand what was happening. I got my associate degree in 1993. I'm eligible for work release in 1996, and then I can go out and continue my work at our AIDS outposts with the women who have left here. It's my life.

I rehabilitated myself. Prison didn't do anything for me. Every New Year's, I spend the day on my bed. It hits twelve o'clock, and I look back on what I did that year and where I'm going the following year. I've thought about when I got sentenced, how this female judge told me I was putting a gun at people's heads by selling drugs. And I looked at her and thought, "The bitch is crazy. She's gotta be out of her mind. I'm dealing drugs. I'm not shooting anybody. If I don't sell it to them, somebody else will!" I needed the money. It was the way I was supporting my kids. Today I know what she was talking about, because HIV kills a lot of people. This guilt came over me for what I had done. There's people here for murder, but I'm probably here for murder, too. I sold drugs on the street to women I've seen come in through this gate and saw die. I've come to the realization that the judge was right.

Over the years, I've talked to this picture. All the time. I ask Yvette how she's doing. I ask her if she's seen our father, because he died two months after she did. She was always afraid of the dark when she was a little girl, and I always had to sleep with the light on. One of the things I was afraid of just after she died—and I thought I was going crazy—was that she was in a morgue, someplace in the dark. So I started putting on a little night lamp I have in my room. This picture is above the lamp, and the light hits the picture. I make sure that the light is always on, even when I'm asleep. Sometimes one of my friends will walk in the room when I'm not there, and they'll turn the light off, because they figure I forgot. And I yell at them, "You have to leave the light on!" It's been on for the last three years.

So you see, this picture is important to me, because the three of them are all together here, and they're not together now. But somehow I know they will be again. When the little girl goes, and then the little boy goes, I'll be satisfied knowing that they're all together again, just like in this picture.

Note: Jennifer died on April 4, 1993.

This picture of my mother and me at Ellis Island was taken to use on the back cover of my autobiography, *Iacocca*. My publisher told me I needed something flashy, so I figured a picture of my mother would do the job. What does she think of my success? Silly question; she's my mother! She's proud. She worried a lot when she thought I was working too hard, but like any parent, she takes great pride in what I've been able to do in business and with my family. But there's a more important reason this picture is so important to me. This photograph means progress. This country was built on people working to make things better for themselves, their children, and others, just like my mother.

Back when I was six years old, and again when I was eleven, my parents took my sister and me to see the Statue of Liberty. My father walked me up all the stairs to the crown. Then he told me about how great it was to be free, and how great it was to be an American. My parents came through Ellis Island, worked hard, and built a great life in America. So my father went back to the symbol of it all, just to say thanks in his own way. I took my kids to New York a hundred times, to Broadway shows, to museums, to restaurants, and to shop, but we never thought about going to the statue. In fact, I never went back myself until 1982 when I was asked to lead the effort to restore the statue and Ellis Island. I had to ask myself why.

I don't know how we ever let Ellis Island get so run-down, but when I first set foot there, the rats owned it. The Great Hall reminded me of a desecrated cathedral, with seventeen million ghosts whispering somewhere in the rafters. No empty place was ever so loud. Seventeen million immigrants, our ancestors, first stepped foot in America here. They sailed past the Statue of Liberty and walked into the Great Hall with everything they owned bundled on their backs. By the 1980s, the building and

the statue were in lousy shape—years of neglect had gotten to them. I guess we just forgot about some things that should have been of value to us. It was as though the promise of the progress and faith I mentioned earlier, were fading with them. That tormented me more than the rust or the weeds or the rats.

Eventually, twenty million Americans contributed money to restore them, and we reopened the Statue in 1986 and Ellis Island in 1990. I guess I took on the job of raising money to say thanks to my parents, almost as a tribute to them. I learned from my parents that being an American means you're free. My infatuation with these national treasures came not so much from a sense of history, as from a sense of the present. We need them to remind us who we are, not who we were. As Americans, we have always had freedom, but we don't really appreciate it. We have an obligation to nourish freedom, to protect it, and then to pass it onto others. We owe it to our ancestors. I owe it to my parents. That's why I look at this picture often. It reminds me of the rare privilege I was given.

More than any other national symbol, this gateway for immigrants shows us two things: one, ethnic and racial diversity are powerful forces for good. And two, hard work and personal sacrifice are keys to a better life. Whether it's food, or dress, or the arts, music, whatever, the melting pot works. If we're losing control of our destiny, it's because we aren't facing up to our heritage. My mother never let me forget where it all started. Hopefully, Ellis Island won't ever let America forget.

LEE IACOCCA (b. 1924) developed a reputation as a marketing genius while working at the Ford Motor Co. from 1946 to 1978, working his way up to president in 1970. In 1978 he took over the ailing Chrysler Corp., leading it to financial success by 1984. His autobiography, *Iacocca*, is one of the century's best-selling books.

Lee Iacocca with his mother, Ellis Island, 1983. John Dominis

My mother brought me to Joseph Horne's Department Store in Pittsburgh in December of 1948. I still believed in Santa Claus and Christmas, the most wonderful day of the year. I think they did fifty-six of these photographs in an hour, and you had to, "Get your numbers ladies!" I remember the dress I wore—my favorite, pastel shades of pink and orange and yellow and green. I can remember waiting in the line and, at first, being very scared of this Santa Claus guy, who was up there with all those kids on his lap. "Merry Christmas. What's your name?" And I remember him being one of the few people who, when I said Ilka, didn't say, "What?" I had a doll named Peggy and I also had a newborn sister, Susan. My sister had a highchair, and I thought my doll needed a highchair. So I asked for a highchair, and when Christmas came, I got it.

At the time, I didn't know the picture was being taken. The sense I get from it is of anticipation. I'm talking to Santa Claus, but I'm sort of talking to the world. To some extent, Santa plays the role of a therapist. Being a therapist, one of the things I try to elicit from the people I work with is the excitement and the health that's always there. No matter how schlunky people are, or how bedraggled, or how world-worn, there's a person like this little girl inside of them. I often refer to this picture in my head as I do therapy. I don't think of myself as Santa Claus, but rather of therapy as the process where you feel really listened to, where magic and your dreams are elicited. It's a very useful picture.

I'm not sophisticated about photography, but I do use photographs in my practice. My husband, who is a psychiatrist, and I both show people pictures of themselves when they come into treatment and when they leave. There was one woman who walked around looking like the foster parents' plan ad: "You can feed Maria for thirty-five cents a day, or you can turn the page." I spent a lot of time in South America, where people are poor, and my husband works a lot in the South Bronx. But this was an adult from Queens, who had an incredibly pathetic countenance when she wasn't feeling too great. We couldn't figure out how to show it to her, because by the time we got her near a mirror, she changed her face. So we took pictures of her when she wasn't looking.

At some point in the course of therapy, I ask people to bring in pictures of themselves or their families or their spouses—whomever we are talking about. It facilitates recognition, "My God, by the age of three, I was already looking like an old lady." Or, "Look at how my mother is holding me!" Or, "Look how my father's *not* holding me." You see things in snapshots. People say, for example, "My father was the most handsome man in the world," and then bring in pictures of quite an ordinary guy. You see the distortions in people's perceptions. And there are some people who have no pictures, because none were taken of them, or they were thrown away, or they weren't valuable enough to keep around.

What's interesting to me is that pictures can help you along. For instance, someone brings in a picture of a family picnic and describes the event, or the picture, or the scene, or the people in absolutely rigid terms. To get them to try a new point of view, I say, "Gee, look at this," or, "What's happening over here?" They see things they've never noticed before. Pictures help you face things because it's all there in the picture, even though you've only let yourself see something the same way over and over again. Pictures free people.

ILKA PECK (b. 1945) is a psychotherapist, trainer in psychotherapy, and organizational consultant. She studied and taught music at the University of Vermont.

Ilka Peck, Horne's Department Store, Pittsburgh, 1948. Photographer unknown

A- 13072

I came to the *National Enquirer* in 1977, an English major, fresh out of college. I had had a job at a publishing company that paid $106 a week. Book publishing was a great business, but not very lucrative. So I came down to Florida, where my family had moved. I didn't even know what the *National Enquirer* was, but they had a job for a file clerk at the paper. To find out if I knew the alphabet, they gave me a hundred pictures and said, "Can you file these?" That was the extent of it. The job paid $185.00 a week, which was a lot of money. I filed celebrity photos, which was pretty mundane work, and something I thought I would do only for three months. I really wanted to go back to Boston to work in book publishing.

I was always interested in looking at picture of celebrities. When I was a kid, I had a lot of orthopedic surgery on my legs and was home sick from school a lot. I grew up in New York, and back then there was nothing but movies on TV all day long: "The Million Dollar Movie." "The Four O'Clock Movie." I became a movie addict. My fantasy was to be Pauline Kael. My father was a hairdresser, and at his hairdressing salon, there were always lots of movie magazines. So unknowingly, I had something of a background for the *National Enquirer*.

I had favorite movie stars at the time, such as Katharine Hepburn and Bette Davis. I was strictly a classic women's movie fan. It was like I was a fifty-year-old lady. No one at the *Enquirer* could believe there was this twenty-two-year-old kid in Florida who knew what I did.

Gene Pope, the founder of supermarket tabloid journalism, started out when he bought the *Enquirer* around 1955. It was the *New York Enquirer* then, a racing form. He paid $5,000 for it and turned it into a very successful blood and gore paper. In the late fifties and early sixties, he was selling massively. But in

the early seventies, when he got the idea to go in the supermarkets, he had to kill the blood and gore, because the supermarkets wouldn't put it in their stores. That's when the formula for the *Enquirer* evolved. There was always a big black-and-white celebrity story at the bottom. Ninety-nine percent of the time, it was a romance story. Then the banner headline would read: "NEW PROOF OF LIFE AFTER DEATH," "PSYCHIC PREDICTIONS," "UFO SPOTTED IN FLORIDA." The same type of headlines would run, over and over again. It was a unique formula, and it sold like crazy.

Before I started working there and saw a couple of copies, I thought there must be ten people in a back room smoking dope, but there weren't. The *Enquirer* staff was made of people from the *London Times*, AP and UPI bureaus, the *New York Times*, the *Wall Street Journal*. Their credentials were impeccable. The draw was money. Gene Pope wanted good people, because he really wanted "the untold story." He invented that phrase. Pictures were always an important element.

Elvis's death was the biggest tabloid event of the seventies. Everyone was thinking, "Twelve days from now, when we finally hit the stands, what are we going to have that nobody else is going to have?" From the photo end, the goal was to get the last picture of Elvis. We *had* to get the picture *nobody* else had. What we wanted was the *last* picture of Elvis, but the one that existed turned out to be a crummy picture of him driving through the gates of Graceland behind the window of his car.

Imagine the situation. I had only been here for two months, just a lowly file clerk who knew the alphabet. The news that he died came in at about four or five o'clock in the afternoon.

Front page, *National Enquirer,* **September 6, 1977. Photographer unknown**

VALERIE VIRGA (b. 1954) is a senior editor at the *National Enquirer.* **After graduating from Boston College with a bachelor's degree in English and communications, she began her career at the** *National Enquirer* **in the photo library.**

NATIONAL ENQUIRER

35¢

September 6, 1977 30586-2 LARGEST CIRCULATION OF ANY PAPER IN AMERICA

How to Be More Creative
PAGE 21

EXCLUSIVE....

ELVIS
THE UNTOLD STORY

....THE LAST PICTURE

A peaceful-looking Elvis Presley lies at rest in a copper coffin in the music room of Graceland, his Memphis, Tenn., mansion. The legendary singer was dressed in a plain white suit, a blue shirt and silver tie.

6 PAGES OF EXCLUSIVE STORIES AND PHOTOS STARTING ON PAGE 20

1 072120 SEP 6 1977

And all of a sudden, I see the mobilization of the forces of the *Enquirer*. Lear jets are getting hired. *Bags* of money are coming out. Teams are being put together and taking over *entire* hotels in Memphis. When this picture came in, it was top secret. I'll *never* tell you who took it, because it was part of an agreement made at the time. It was made by someone close to Elvis, obviously. We didn't get it by accident. It was shot on black-and-white 110 film, that's why it's so grainy looking. Don't forget, you're dealing with a very low light situation and a small camera.

Elvis's death was like watching a movie. I was *so* shocked and *so* intrigued by the picture that I loved it and hated it. I thought, "Dead people in coffins? We're going to run that on the *cover* of a magazine? Ugh." That's human nature, though, like driving by a car accident and stopping to look. It was fascinating and horrible. It didn't, seem like a breach of privacy. It was *Elvis*, after all. Anyway, there were never any conversations about the privacy issue. Everybody's response was, "We've *got* it!" Frankly, it is the biggest selling issue in the history of the *Enquirer*. Over six million copies! Copies were bootlegged and resold. 7-Eleven Food Stores in Memphis got robbed of their copies. You've got put yourself back to that time. There was real hysteria.

Since I hadn't been at the *Enquirer* that long, to me the whole thing was, "Whoa, what *is* this all about?" It made me aware of a broader world, and the overwhelming fascination of the American public with celebrity. I was interested in celebrity, but I guess I thought it was something I did secretly. That's always what the goal of the *Enquirer* was, to give you that "fly on the wall" picture. Which was easier then, because there wasn't the kind of competition there is now. Looking through the keyhole is fashionable now.

In the 1970s, it was "the *Enquirer*, oh, *that* rag!" Now you read about celebrities in the *New York Times*. Why? The fascination is simple. People have their own lives, and whether they're dull or not dull, they perceive them as being pretty routine. Get up in the morning, go to work, feed the kids, go to bed. The average person is not particularly wealthy. Since silent movies, celebrities have been viewed as gods and goddesses with millions and millions of dollars and posh lifestyles. It's pure escapism to be interested in them. The celebrity photographs people love most are the ones that show what a person is wearing, their homes, or their cars. People love the idea that even though celebrities are rich and have all this stuff, they still have problems. They get sick. They get divorced. They're still just *people*. I don't think it's vindictive. I think the public is sympathetic.

So what happened, in a very simplistic view, is that people in the media industry started looking at the *Enquirer* and its fantastic financial success. Then the tabloid industry took off! By the late seventies, daily papers around the country started their little gossip columns. People couldn't get enough of it. Then came tabloid TV and talk shows.

My job now is to assign, find, and negotiate for pictures. When I try to find a good picture for the cover, the first thing I think about is the name. But sometimes things just turn up. In your wildest fantasies, you'd never have dreamt that there would have been pictures of Fergie topless with some bald guy sucking on her feet! There are sources who provide us with information, and we decide whether to pursue a story with our reporters.

There are certain people we track all the time. We call them the five sisters, the one-name people: Dolly, Vanna, Cher,

Oprah, and Liz. Why are people interested in Vanna? You tell me. Why are people interested in Oprah? She's more tabloid that we'll *ever* be. People *like* being in the paper. They'll go out and beat their chests and say we're terrible, rotten, and horrible. But don't do them for six months, and they get upset.

We never set up phony pictures. We'd only photograph a dog that *could* ride a bicycle; we wouldn't tie that dog to a bike. We sit around, many a day and night saying, "We need some spreads. You call your stunt men, I'll call my jewelers. You call your animal people, I'll call Sea World." At Sea World, they'll tell me "Well, now we've got *three* killer whales that balance three guys on tips of their noses! Nobody's photographed that. You guys can have that first." I'd guess that a third of the pictures get done on assignment, a third are buyouts from around the world, and the rest are stock from agencies and paparazzi.

As I look at this picture now, I'm far less shocked by it than I was in 1977. Then I'd never seen anybody in a coffin. I look at it now and think it's actually a lovely picture, peaceful. I *really* do. In retrospect, relative to all the things that have been said about Elvis, it was a fitting tribute. Fans thought so at the time. It has an ethereal, soft look. It looks more peaceful because it's in black and white.

I have a wish list of pictures that I'd give an arm and a leg for. I'd like to do a swimsuit spread with Dolly Parton. It would be a first; she's never posed in swimwear. But the ultimate picture would be the private side of Jackie, whatever she does. Actually, I'd like to see her closet. Are her shoes numbered, or does she throw them on the floor like everybody else? Liz Taylor? No, we've kind of done it all on her. Actually, the biggest problem is that there's not that many stars out there anymore.

There are certain lines we won't cross. We're careful not to use graphic terms, particularly on the cover. We won't publish pictures of full nudity, or of children in compromising situations. Our readership is basically Christian, a moral majority audience. They are mostly women, and there're certain things that they are offended by. We had pictures of Madonna in a little G-string with a bunny tail, high heels, and nothing else on. Although we covered her breasts with little black boxes, we got thrown out of a couple of supermarkets and got a lot of letters. We'll never do that again, because people didn't want to see *that* in the *Enquirer*.

For me, *this* picture was when I *really* found out what the *Enquirer* was. Watching the whole process and the excitement, and I liked that and knew I wanted to be part of it. Getting the thing that nobody else had was *exciting* for me, like that gasp of realizing, "Yeah, I want to do that." It was like bungee jumping. I *still* get a rush when I get the big picture. Everyone remembers a picture. A lot of people can't even remember the end of a joke they heard yesterday, but they all remember this picture of Elvis in his coffin.

EDDIE ADAMS

This is one of my pictures—one of a few—that just bothers the shit out of me. I took it because I saw the guy's fist was still clenched. He's a Vietcong. I think he died with dignity. A lot of thoughts come into my mind when I look at this picture. Normally I would have passed right by. I won't ever take a picture of the face of a dead person; there are certain things you just don't do. The only reason I went down to get this angle is because his hand bothered me. The *fist* got me; he died fighting. It's probably right after he was shot, because in Vietnam, these bodies didn't hang around forever.

I've photographed in many wars, and I've often thought, "I'm going to get blown away. Why do we do the things we do? We're all going to die." I say to myself, "That could have been me." I've seen so many people blown away. It brings a lot of questions to my mind like, "What am I doing here? Why am I shooting pictures?" I don't have a solid answer. Life and death, all these things go through my mind. Your whole life is proving things to yourself, proving you can do things, which is another reason why I go back to this picture. From the time I took this picture, it's bothered me. I just can't avoid it.

I had never seen anything like it before. First, I got in close on his hand, which was caked with mud, and photographed it razor sharp. But then I shot it from this low angle, with the people in the background. They look puzzled. What could have been going through their minds? The man on the bike looks like a Buddhist. He's got one leg. What's going through his mind? I don't know. Maybe they were looking at my camera. I've found out everybody loves cameras. I've been to camps where the bodies are stacked like a display, and little children will stand in front of those bodies, smiling at the camera.

EDDIE ADAMS (b. 1933), photographer of fashion, entertainment, sports, and politics, is best known for his coverage of wars. He was awarded a Pulitzer Prize in 1969 for his photograph of the execution of a Vietcong lieutenant.

Dead Vietcong, Saigon, 1968. Eddie Adams

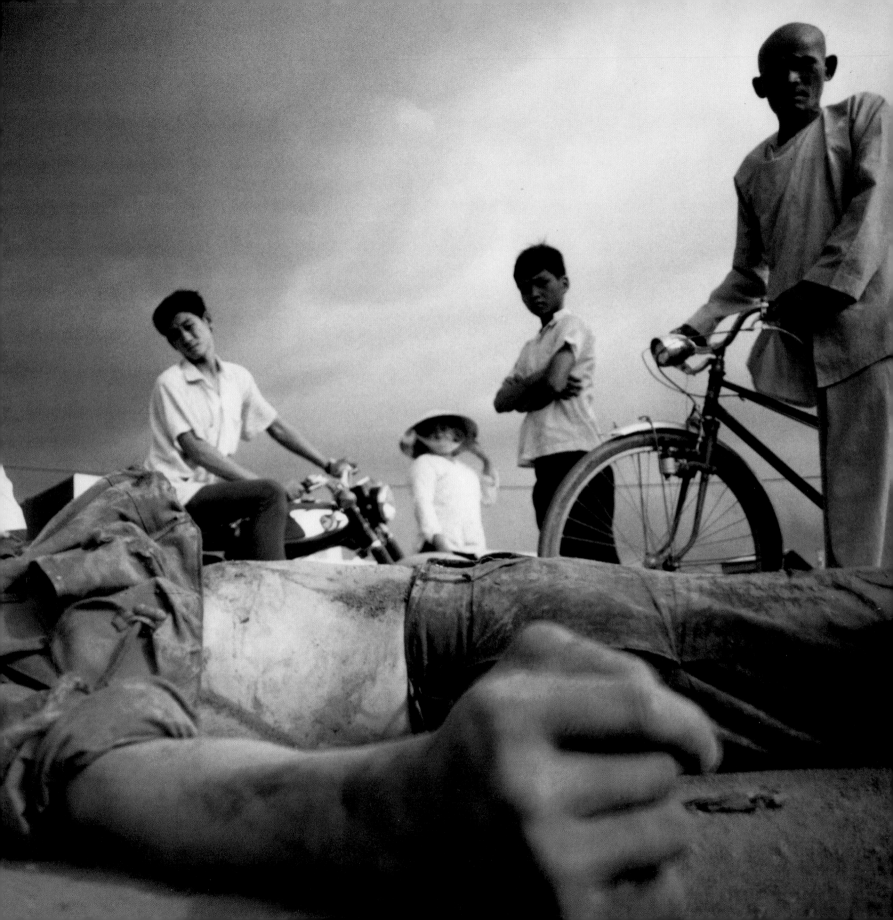

People think that they have to smile for a camera. They could be starving, but it's a camera.

I was in Saigon in May 1968. It was probably my third tour and I'd been there about five months. I spent over two years in the country working with Associated Press, doing whatever I wanted. There were no restrictions. We'd go from battle to battle, a handful of hard core photographers, writers, and TV people. Say the First Cavalry was in a battle. We'd spend a couple days with them, because that's where the pictures would be. Then we'd go back to Saigon and get drunk for about two days. Then we'd go out with the First Infantry Division, because they'd be in the middle of another battle. From there we'd go with the Marines into another battle. Most photographers in this group saw more of the war than any military man. And because of that, your chance of getting killed was a thousand times greater.

I was in 150 battles in Vietnam, but I saw the Vietcong only a couple of times. If I'd had a chance to follow the Vietcong around, I would probably have done it. When I work, nothing political enters my mind. It's one human being to another. My subject could be the worst person in the world, and I could like him if I was on a one-to-one basis. I've photographed the presidents of a lot of countries. If you are a writer doing an interview with the president of a country, he's guarded and suspicious, because you're writing everything down. He doesn't trust his cabinet, doesn't trust his vice president, and doesn't trust the people around him. But a photographer is harmless. If this photographer, who doesn't really give a shit about politics, which I don't, is there, the man will open up and tell me things he'd never tell anybody else. I respect who I photograph, maybe that's part of it.

This picture's nothing like the picture I made in Saigon the month before, the picture of Colonel Loan shooting the Vietcong lieutenant in the head. *That* picture's been forced down my throat. It hurts me and it bothers me, not only because it's destroyed General Loan's life, but because there are other things *I've* done. It's like an actor who plays on a television series and can't break the mold. But let me go back to the very beginning, and I'll tell you about it.

The Associated Press office was an old building occupied by the German embassy. We shared offices with NBC. The other networks were scattered around the city, so we worked pretty close together. We'd hang out together and take fresh head shots just before we'd go into a battle. We figured if we got blown away, we'd have film of each other.

Anyway, this particular day, NBC heard about a battle taking place in the Chinese section of Saigon. They came over to the office and said, "Hey, does anyone want to come along? We're going to take a ride up there." I said, "Yeah, why not?" It was slow, nothing else was going on. This was in April 1968. I rode with them, and we parked our car a couple blocks from where the action was. It was really quiet. Nobody was on the streets. We heard a few sporadic snipers. There were Vietcong inside a pagoda, and the South Vietnamese police and military were shooting at them. We only spent about a half hour there, it was such a minor scrimmage.

As we started walking back to our car, we see the South Vietnamese police grab some guy in the doorway of a house and start leading him down the street. The normal reaction of any news photographer is to follow the action until the guy is put into a van and taken away—just in case he swings at somebody or somebody swings at him. So we follow the guy to the

corner. All of a sudden, some other guy comes out of nowhere. I didn't even see him, even though I was only about four or five feet away. Then I see this guy go for his pistol. As soon as his hand goes up, my camera goes up, and I make the picture. I thought he was going to threaten him, I didn't know he was going to shoot him. Later we found out that the picture was taken at the exact instant that the bullet entered the lieutenant's head—the United States military analyzed the shutter speed and the speed of the bullet.

I felt absolutely nothing when I took the picture. But I walked away from the scene because of what I saw next. When the Vietcong hit the ground—I'd never seen anything like this before—maybe because the shot was at such close range—blood spurted out of his head four or five feet in the air, like a water fountain. I couldn't handle it. When it was over, I took some pictures of the body as people walked away. Everything was so quick. "They kill many of my men and many of your people." That's all the colonel said, and he put his pistol back and walked away.

I dropped the film off at the AP office and said, "I think I got some guy shooting somebody. I think it's on there." But I wasn't sure. The film was edited in Saigon. Everybody in the office said, "Nice." I wasn't too impressed. But when it went out on the wires, the world reaction came within a few hours. We started getting messages from New York. "Who is this guy? What's he all about?" They wanted a follow-up story on him because the picture was creating a fuss. The next day the reaction was, "Demonstrations are starting. Your pictures are being blown up." I knew *nothing* about why.

While this was going on, AP kept asking for a story about the guy who did the shooting. The bureau chief said, "Stay the

fuck away from him." And I said, "No, I want to do it." And he said, "All right, go ahead." So I went to the colonel's office, knocked on the door and said, "I want to see the colonel." Some assistant said, "He's busy." He wouldn't see me. I did this for two weeks. Finally one day they brought me in his office and Colonel Loan came up to me and said, "The only reason I'm seeing you is you were so persistent." Those were his exact words. He invited me in, and here's the spooky part. I'm sitting on one side and he's on the other side of his desk. He got up and leaned over to me, his nose against mine, and said, "I know the photographer who took that picture." Then he went back. "I'm sorry," he said. "I know the *Vietnamese* who took that picture." Then he sat back down again. His exact words. But he put his nose right up against me and scared the hell out of me. I ended up staying with him for the next week doing a picture essay.

He was wounded very badly in Vietnam. When he got out of Vietnam, he opened a pizza parlor in a shopping center in Virginia, and he'd never made pizza before in his life. Over a period of time I'd visit him—in the hospital and at his home. I respected him, and I felt guilty. I still feel guilty. The last time I saw him was at his pizza parlor. His friend, who was in counter-intelligence in the CIA, helped support him in the restaurant. I walked in, and he looked at me from behind the counter. I said, "General, you haven't changed a bit." He said, "Eddie, you have. You've gotten very old." He got me right back. I went to the bathroom and on the wall in graffiti was, "We know who you are, you fucker." He closed the restaurant recently. I said, "Let me do a story on you and what this picture has done to your life." He said he felt he'd done the right thing, but that he was very mixed up. I said, "Look, just for you. I don't care. It's not going to benefit me. It's for you."

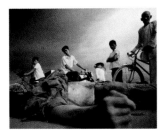

There's film footage of the shooting, but it's not what you remember. You remember the picture. This is why I'm a still photographer. You do a still picture, and it's here today and it's here tomorrow. You can go back to it, see it the next day. That picture's in a history book. If you get your picture on video or film, it's put in a can, and you can't show it. Who has access? It's gone until somebody pulls it off the shelf and puts it back in the tape deck.

Look, I was scared, especially when I wasn't working. I did feel that there was this invisible steel shield around me. I've seen guys right next to me get it and guys over there get it. With that camera raised, I have more balls. When I put it down, I'm not a photographer, I'm just a civilian. I'm more vulnerable without it. If I die tomorrow, then I die tomorrow.

Nobody wants to die, but it's going to happen. We know that. This photograph reminds me that I have so many things to do. It really bothers me, because I hope that before I do die, I do something I really like. Then I wonder *why* I have so many things to *do*. It's like a circle. Because I do. I want to direct a movie to prove it to myself—just one. I want to do a documentary. I know it'll be good. I want to be an art director for a year. And there are so many pictures to make. We're all going to go, so why devote your energy to something you've already done? This picture may bother me more than any other I've made, but I'm glad I made it. I can *remember* making the picture. *This* one. The other one—the shooting—I just try to erase that.

I saw this picture in the *Los Angeles Times* in December 1992, and the caption underneath it reads: "A woman whose husband was killed by mortar shells visits his Sarajevo grave in 10° below temperatures." We've all seen newspaper pictures that are interesting, but this picture stopped me. I thought the dark symbolic content of the picture, juxtaposed with the raw human emotion of this woman mourning at her husband's grave, was perfect. In this picture, there are ancient archetypes. On a certain level, it could have been taken 15,000 years ago, 100,000 years ago. You could have seen woman mourning man, killed by senseless violence, and *surrounded* by symbols at any time in history. It's an ancient story, yet a modern one. Now it's 1992, and we're still dealing with the same senselessness. Now it's Sarajevo senselessness. It doesn't seem to change.

This picture is about a constant faith. God looks down on her *and* him. She's looking down at her husband, and the crosses are looking up at God. Even in ten below temperatures the cross points *up*. I'm moved by the juxtapositions between what's above in the sky, and what's below in the ground. There is a line past which this woman *cannot* move, symbolized visually by the earth itself. She's above the ground and never again can she join physically with the man she loves. She might have had sex with him last night. He was in her body, and now he is under the ground. She will never be able to touch him again. *Except* in faith.

The crosses say that God has not forgotten. In the midst of her grief, in the midst of her sorrow, in the midst of the injustice and cruelty and violence of the world in the midst of the senselessness of Sarajevo today, God cares. We look to God not only to ease our pain, we look to God to get over this shit that keeps happening. You don't go through pain and look to God only for *solace*. If we look to God enough, this horror won't even go

down any more. That's what this picture says to me.

Anyone who pays attention to a picture like this will ask, "What can I do?" This picture raises questions about our effectiveness and our excellence, particularly in the desire we have to transform the world. It has less to do with what we do and more to do with the *consciousness* with which we do it. Action that comes from shallow consciousness will end up in shallow action. The issue in life is, have you, or have we, not yet gotten to the point where we have experienced, in the depth of our being, the hideous unnaturalness of the way in which the world experiences life? Once we get that, on some level, we are never the same again, and we have a passion. The more deeply we feel something, the more personal authority infuses our actions.

I believe that the creation of the world that *could* be is a more powerful vibration than fighting the world that *is*. I believe that lighting a candle is more powerful than cursing the darkness. I believe there is a love that casts out fear. If there is enough love, what this picture shows won't happen. In the presence of love, fear cannot exist. That's what the spirit teaches us. And all of us can help, through words and actions.

The woman in Sarajevo is traumatized by war. *God didn't do this*. We did. Human beings, at any given moment, can choose again. You and I have a choice. Will we live our lives today doing something meaningful, or will we live our lives selling and exploiting darkness? It's a question I ask every day. You live a noble life or you don't; it's up to you. Faith means knowing that not only can we not heal the world without God's help, God cannot heal the world without our help. We're the lamp, he's the electricity. And there's no light shed without both.

The form of the work we do doesn't matter at all. Some people

MARIANNE WILLIAMSON (b. 1953) lectures on spirituality. Her teachings are based on *A Course in Miracles*, a self-study system of spiritual psychotherapy. She is the author of the bestsellers *A Woman's Worth* and *A Return to Love*.

are writers, some are actors, some are scientists, some are teachers. It doesn't *matter* what you do, or even if you work, as the world defines it. The choice that matters is will you do whatever you can? Once you decide that you *desire* to serve, you start to change. Then we're just more inspired, more interesting, more charismatic people. Service lifts you out of yourself, and in that place outside yourself, you find yourself. Service is the zeitgeist of the times. Spiritual seeking without service is self-indulgent. If we only have that, then what we see in this picture will go on forever. Put the spirit into action, and the world will change. No more war widows. No more rent hearts.

A4 TUESDA

A woman whos

Bush

A woman visiting a grave, Sarajevo, *Los Angeles Times*, December 29, 1992.

D E

■
tel
un

B
T

J

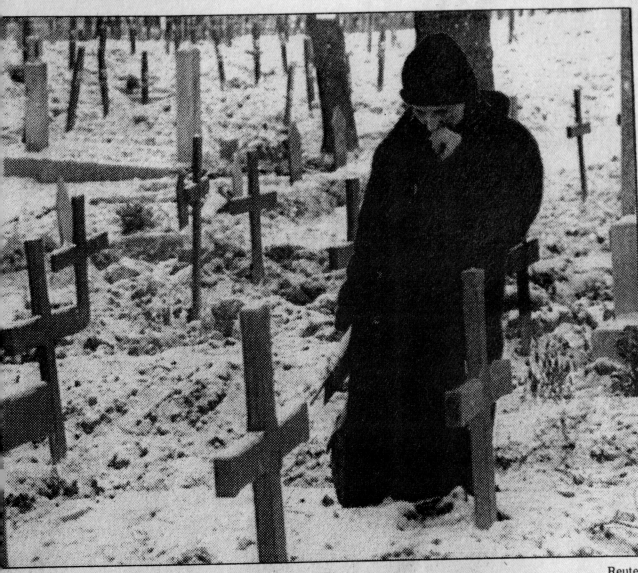

nd was killed by a mortar shell visits his Sarajevo grave in 10-below temperatures.

rns Ser

I started in photography after I got married. My husband was a photography instructor, and we began to photograph weddings together. I would fluff up the bride's skirt and do a lot of unimportant duties, and I would feel useless. I asked him if that's all there was in my future, and he suggested that I go to Professional Photographers of America School. I studied with Jay Stock, and that's where I saw this picture of Jay's wife and daughter eighteen years ago. It's what I want to portray in every picture I make. There's no background and no distraction. You can tell the mother just adores the baby and the baby looks so sweet. Look at the mother's arm. It's so caring. Doesn't it touch you?

I learned pretty quickly that it's important to make pictures that have something a little different in them, as opposed to the same old thing, like wedding pictures with everybody lined up in a row. So when people say, "I just want the regular pictures," I feel frustrated, because I like to show the love between people.

All professional photographers—art, portraiture, and wedding photographers—strive to become masters. I look at all kinds of portraits to get ideas about composition. I go to museums. I went to Holland and studied Rembrandt prints. I'm always looking at magazines, and I buy a lot of books. You need to change, because if you keep doing the same thing, and people come back to you over and over, pretty soon, they've all got the same picture.

JUNE HILL (b. 1930), a photographer for over fifteen years, owns the Fine Art Studio in Minneapolis and is an award-winning children's portrait photographer.

Even if most people say they want something different, they still want you to document all the little traditional high points. They absolutely want photographs of the important people who are guests. They also want to show how much the event costs. So, you try to get pictures of the ice sculptures.

A lot of times at weddings, emotions and tensions can run high. There is often friction between the mother and daughter. So you'll do this and do that, because everybody has her own idea about how they want things to look. Although the boss at a wedding is supposed to be the bride, it's usually the bride's mother. We had one wedding where the bride had a profile like Mitzi Gaynor, just darling, with a little, upturned nose. I don't remember taking profiles of the girl, but the mother kept saying, "Don't take any profiles of her, she doesn't have any chin."

Wedding photography has changed since I started. If you look at an album that's ten years old, you'll see double exposures that show couples standing in a champagne glass, with sheet music behind them. People don't want that anymore. We recommend that before the wedding, we photograph the bride by herself with her flowers in a pretty place. Then we have the groom come and see her, so they have a few minutes alone together. If everybody is standing around, and the bride just walks in for a picture, the groom can't really tell her how much he loves her. She feels foolish. He does, too.

The feeling in this picture is what I want all my pictures of children to be like now. When the moms are sitting there, holding their babies, hugging them, and giving them kisses, the only thing I do is ask, "Would you mind sitting over here when you do it?" Sure these pictures are romanticized, and the wedding pictures are, too. That's because people want to see pictures as beautiful and happy as they can be.

Mother and child, 1963. Jay Stock

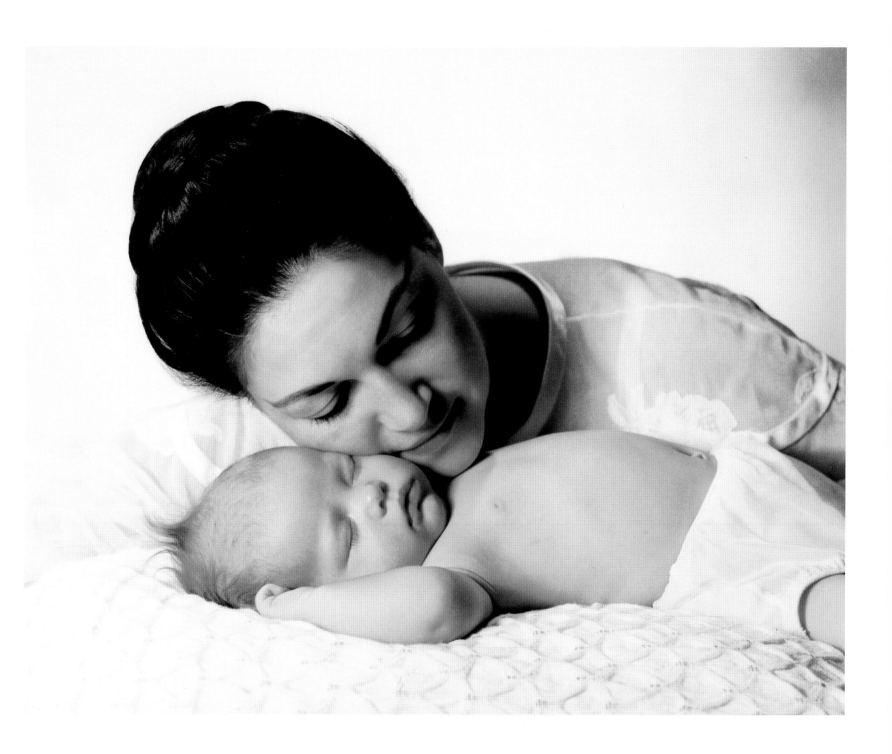

No doubt you've seen this photograph of the children in Birmingham as the fire hoses were unleashed on them in 1963. This picture exposed the most despicable in us, and it brought the best out of us, because no one seeing this picture could be neutral. No matter how strong the water was or how armed the police were, the innocence of those children and the morality of their cause was stronger than the water from the hoses. This photograph was taken at a peaceful march. As usual, people were given three warnings before the police took action, and they did not move. Part of nonviolent resistance is to remain wherever you are. This photograph showed that the demonstrators' will was stronger than the oppressors who unleashed the hundreds of pounds of water pressure from their hoses.

These were the pictures of the spring of '63. They were commonplace, reproduced in scores of magazines and newspapers. They were important because we did not have any influence, at the time, over the pictures that got into the press or the media. White people were holding the cameras. White people were taking the pictures of us. What you see here are African-American youths fighting back for dignity, fighting against the enforcers of the old, immoral order, fighting to end the humiliating loss of dignity.

They are well-bred, well-dressed young people, college students, trained in nonviolence in workshops, who learned how to win through passive resistance. It was moral jujitsu. What seemed like a small action could have a big effect, could be very powerful. White people were embarrassed by the violence of this photograph. When a photograph like this received a lot of attention, the movement won something. A picture like this made the determination of African-Americans public.

REVEREND JESSE JACKSON (b. 1941) founded the Rainbow Coalition in 1984, a political organization aimed at uniting racial minorities, the poor, peace activists, and environmentalists. He ran for the Democratic party Presidential nomination in 1988.

Jets of water blast civil rights demonstrators. Birmingham, 1963. Charles Moore

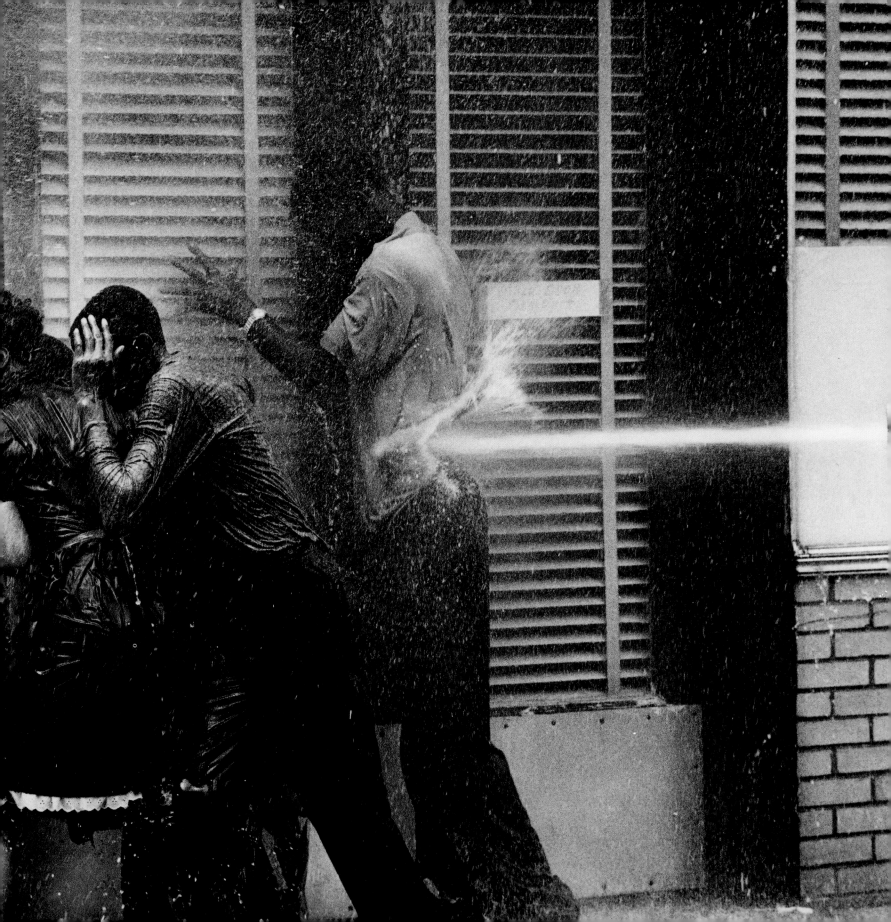

One of the paradoxes of the time was that the poor people did not fight back; poorer people accepted their places in the back of the bus, in the kitchen, on the welfare lines. It was those who had the ambition of higher education and dreams who fought back to make America more inclusive. During the movement, there was both a sense of helplessness and a sense of power. The power was in the resolve to change things. The helplessness was in, "I can't get there now. There's a sea between us. Hold on. Help is on the way." Then it all came together. The student movement was counterculture. It was counter everything you'd been taught. It was all about fighting back for dignities, like in this picture. Fighting to get respect. "I am a person."

I had to stand with my generation. I was in school at North Carolina A&T at that time, and I was involved in sit-ins. The sit-ins had begun on February 1, 1960, in Greensboro, and at that time, I was still at the University of Illinois. I didn't go to Greensboro until September, and by the fall, the movement had died down somewhat. Things had returned to a certain normalcy. But a few students carried it on, and there was a constant challenge to me about getting involved, for some reason that I never quite understood. By the spring of '63, when I was at A&T, the movement had heated up again. It was during this period—about when this picture was taken—that we were marching and being arrested.

One Sunday afternoon, a group of us had just left jail, and we were searching for ways to turn up the heat. About 600 or 700 of our fellow students were locked up in a senior citizens home built for 125 people. We marched two or three miles down the road to the site of the home. The National Guard had its guns and paraphernalia. They had dogs, too, and cars with flashing blue lights. I can see it as I speak. There was the element of

fear. You see the police, and you know they're a threat to your life. I saw our classmates leaning out of the windows, saying, "Please get us out of here. We don't have any air." They were overjoyed because they saw us coming down the street, marching and singing like we had come to rescue them. And we had.

And as I stood there, I began to weep uncontrollably. As I wept, that water washed away any of the doubts and fears I had about participating in the movement. Something happened. I saw the system naked. I saw it without pose. I saw it face to face for all of its brutality, and its ugliness, and the depth of its venom. I saw all of it, and I was no longer afraid. I made a commitment to fight for the rest of my life. I began to speak and preach without notes, decrying the wickedness of the system. The difference that day was that I spoke with pathos, passion, directness. I spoke as well as I've ever spoken since. I was speaking to all of them: the students, the police, the press, those behind the bars. I was speaking to all of them. I spoke with moral authority, without any fear or calculation. I was prepared to live or die. It was a transcendent moment.

I realized then that words speak pictures. With words you can stir up the imagination, and you can paint scenery. You set context. In the beginning was the word. And the word was with God. The world was spoken into existence. That's power of the word. The movement had its own language and rhythm. Speaking epigrammatically was at the heart of the language of the movement. Since we were so often misquoted by the media, we learned to speak in short, pithy terms—quotable terms—so the media was less able to misquote us. "Penetrate and capture order. Demonstration without hesitation. Jail without bail. Forward march." You can hardly misquote that. When people speak in rhymes, they communicate. Musicians rhyme. Poets rhyme. The same kids who cannot remember

three pages of a history book can remember both sides of a double jacket album, because of how the language is put.

But words become vapor, and words blow in the wind. Except for some sticky stuff in your brain called memory, you have nothing else to go on except physical recall. That's why pictures are important. Pictures freeze a moment in time, and they can live in one's memory, just like this one lives on in mine. That becomes the power of a picture. At the time there were some films made of demonstrations or of events like this, but in many cases, it is the still picture that persists in our memories. Now there are more moving pictures, like the videotape of the beating of Rodney King, which sparked the Los Angeles riots. They are very powerful, too, but this photograph has power, even thirty years later, because it was a still photograph that the media picked up and it became symbolic. It got into history books. This is one of the photographs that sums up the entire movement.

There were times when we were about to be arrested in which the media was present. Certainly, the oppressor did not want to be seen. I remember one of the most dramatic things I did during that period was marching one day into Morrison's Cafeteria downtown, and as I was walking toward the door, leading a group of students—CBS television had cameras there—the boy who owned Morrison's Cafeteria came out and stopped us. As I saw the cameras rolling, I said, speaking in very direct language, "I would like to eat in this restaurant." "You cannot eat here!" I knew from the inflection of his voice that he was out of control, and as a quarterback, I'm going to be under control. I had him because he was out of control. I said, "We want to eat here." "Can't eat here!" I said, "But we are Americans." "You can't eat here!" "We're hungry, we have the appetite, and we have the money." "You can't eat here!!"

"We expect to be able to eat here because it's the American thing to do." I knew the contrast between stating the basic proposition—we want to eat, we have the appetite, we have the money, we are Americans—and him screaming we couldn't eat was something America had to come to grips with. And I knew I'd won that round. All of it was on film which CBS still has someplace.

You see, the media has more power than the politicians who make laws, or the bankers who make money, or the police who carry weapons. Because the media has appraisal power and it determines the worth of things. Using photographic images, the media deletes, distorts, emphasizes, and de-emphasizes. African-Americans and Hispanics are projected in photographs every day in five deadly ways. We're projected as less intelligent than we are, as less hardworking than we work, as less universal than we are, as less patriotic, and as more violent than we are. Those images are projected onto the minds of our neighbors and peers, who see those pictures everyday all day on television and in the press.

When I grew up in Greensville, no African-American's obituary was ever illustrated with a picture in the paper, no wedding pictures were ever in the paper, no cotillion pictures were ever in the paper. Only if somebody was caught murdering or stealing did they make the paper. Maybe once a year a picture of our school team ran, and we were always the state champions. The white team was featured in the paper all the time. I understood, even at that time, the media's power to project and to represent reality. What gets through becomes reality.

DAVID BYRNE

As a young person, you grow up looking at images all the time. And then all of a sudden, sexy images start having a different, direct, and really powerful effect on you. Pornography's one of the stongest kind of images that can affect people. Your response may be all in your head, but it doesn't feel intellectual at all. Such pictures make you feel a little bit out of control. Your biology, your physiology takes over, and you're helpless in front of an image like this one. The image has you in its grip. Your defenses are down; you're vulnerable. In fact, you're not entirely yourself anymore, or yourself as you'd like to present yourself to the public. And so to protect yourself, you don't look at these kinds of images in public places.

This image is reproduced in an S&M book called *A Country Place*, from the 1960s, but I think the picture might be older. Who buys S&M or spanking books? I've bought a couple, because I think it's important to know about all aspects of human experience. But I picked this picture because it's unique. Formally, it's beautiful, even though the reproduction of the image is so poor. The picture is amateurish; it's not slick. Often it's homemade images like this one that evoke the strongest response in people. When I look at this picture, I don't have a great feeling of sensuality. In fact, there are other pictures in this book that may be stronger emotionally, more shocking. But this picture is something else. If you've never seen anything like it before, you wonder, "What is going on?"

It was probably made in someone's living room by a window with the shade pulled down. The composition is off-center, so it makes things seem even more peculiar. It makes you notice the woman's arm and the ropes going to her buttocks. The other figure, you assume, tied up the woman. But maybe they're just having a conversation, and the woman on the right is saying, "How you doin' down there? Feelin' all right? Can I

get you some coffee?" So this picture is a contradiction. What you see is the passionless portrayal of intense passion, which is the very contradiction of S&M—getting pleasure out of pain. That's what's strange about the picture.

I don't get any sense of eroticism from it, although I'm sure it works on that level for someone. For me, this image is ritualistic. What's going on here is packaging, like the traditional Japanese art of wrapping small objects like eggs. This image is more confusing than traditional pornography in a really interesting way. You're confused in a way you haven't been confused before. Your bearings are cut loose. You have to ask yourself, "How do I deal with this?" because you don't have a pocket to put this picture in. You can't say, "I don't understand exactly what's going on there." You ask yourself, "Who's this for? How does it affect me?" It pulls you in and pushes you away at the same time. It does things that, in a small way, liberate your mind.

Looking at a neutral picture like this one becomes an intellectual exercise. You can think about it. Trying to figure out this picture is more like looking at art than at conventional pornographic images. Because it's artistic, I can project onto it. I might be wrong, but I don't suppose the person who made this picture had the same kind of perceptions I have about it.

Speaking as a male, I can tell you that at a fairly young age, you discover that pornographic images have a really strong impact on you. You find out that a piece of paper—a photograph—can shock you or stimulate you or confuse you. We have a four-year-old child, and I've seen how she responds to visual cues. It's been said that children and animals are attracted to

DAVID BYRNE (b. 1952) is a singer and songwriter known for his work with The Talking Heads, a band which he cofounded in 1975. He is currently working with the record company Luaka Bop, which promotes popular music from around the world.

Illustration from *A Country Place*, 1960s. Photographer unknown

big eyes and that big eyes symbolize something friendly, because young animals and young children have big eyes in proportion to their faces. Look at Mickey Mouse, for instance, and how his eyes got bigger and bigger over the years, and how children became more and more attracted to him. My daughter couldn't even talk, but the minute she saw Mickey Mouse, it was boom! Love at first sight. So certain visual icons, put together in the right way, set off a built-in trigger in the mind.

Men respond to visual icons in a similar way. Whether they're looking at breasts or facial expressions in the model, or a pose or a posture. It's not preposterous at all to say that what they're responding to is a gesture that's saying, "I'm yours, come and take me," or even "I'm more powerful than you." One could almost lay out a series of abstract lines, removed from the human body, and they'd probably trigger similar responses in men, who'd say they're breasts, torsos, eyes, and poses. I'm making it sound overly mechanical, but I think there's an element of that response in one's response to this picture. Maybe men are more fantasy driven in this way. I read somewhere that women are less visually oriented when it comes to sex. Maybe women react more to the relationship of one person to another.

People are very affected by sexual images. That's why they are forbidden—they make you out of control. There's an American Puritanism that tells you to keep the lid on things at all costs. Intellectually, one has to say that pictures like this one should be out and available in the world, that there should be no censorship. On the other hand, I do think there are a lot of images, not this particular one, that push biological buttons and can stimulate or confuse people in ways a person may not quite be ready for. They may take advantage in certain ways. Not that those images should never be available or seen. If I ask

myself, should they be spread all over for everyone, I don't have the answer.

I have another magazine from this same era, a beefcake magazine of guys posed in togas next to Grecian columns. The pictures in it look a lot like Guess Jeans ads, or Bruce Weber's or Herb Ritts' pictures. Those photographers lift a lot of their style from this kind of black-and-white material. Muscle guys with great haircuts posing in Calvin Klein ads have a very campy Greek or Roman style. I was walking down the street wondering why there is a preponderance of homoerotic imagery being used to sell things to straight men and women today? One theory is that in a society where sex is repressed or suppressed, the opposite, in this case up-front sexuality, always surfaces. It's part of human nature, of human desire. With the explosion of sexually transmitted diseases and AIDS, with sex being dangerous and almost forbidden, sexual images have become more valuable and pervasive. I have a feeling that in advertising, movies, and rock videos, the idea is, "Let's stimulate everyone. Let's get everybody really excited, because they can't do it anymore." It seems really cruel and perverse. On one level, people's desires can't be satisfied, but the thinking seems to be, "Let's stimulate them to the breaking point. Let's keep working them up to a fever pitch so the only way to relieve their anxiety is to buy some underwear or a CD."

I find when I'm watching ads on TV or on MTV, there are lots of images that are incredibly sexy, but they don't mean anything. The way they're cut and their velocity take the meaning out of them. There's no context, or very little. They push buttons at random. Pure iconic images are just thrown at you, and you're left kind of riveted, yes, but empty. Visual drugs.

I first saw this picture in 1986. I was hearing a case that involved landlords and tenants. The landlords' complaint was that they didn't know who their tenants were. They had rented a studio apartment to two gentlemen, but any number of people were coming and going, day and night.

The landlords, a young Soho couple, lived in the building. They said they wanted to limit the number of people who lived in the apartment. What I suspected from prior cases, and learned was true in this case, was that this was one more example of a social phenomenon that has been going on for decades. Different groups of people, who come to America from different countries, make their start in the same way. Many immigrants survive by sharing living space and sharing costs.

Now, what in fact happened in this case was, and this is quite common, that males came from Korea or Vietnam, and all lived together dormitory style. The truth of the matter is that there were never more than four or five people in the apartment at any given moment because each worked extraordinarily long hours—night shift and day shift. The beds were always in use. They took turns sleeping, and there was enough room for everyone because everyone was gone most of the time. Everyone was working very hard to save a little bit of money to bring other members of the family to the United States. When the family arrives, they find a family apartment.

The two or three tenants who were in court spoke very little English. We had an interpreter for them, but they shrugged their shoulders no matter what was asked. Then this photograph was offered into evidence. The landlord had taken it. When it was handed to me, I thought of it as a wonderful image. Then, I processed the information in it. And while I don't remember my exact response—I do remember thinking

PHYLLIS GANGEL-JACOB (b. 1930) was appointed to the New York State Supreme Court in 1989. She has been a faculty member of Baruch College Law Department, and was a founding member of the Coalition on Women's Legislative Issues.

that the tenants should be given credit for being hygienic. I thought it was so marvelous that each of the people had his own cup, his own tube of toothpaste, and his own toothbrush.

The landlord had taken other pictures as well. The furnishings in the other photographs revealed lightweight bunk beds, two or three levels high, sold in neighborhood stores. It became apparent that there were at least eleven people living there. The landlord insisted that there were *many more* than eleven, but there were certainly eleven beds. I moved on to *why* they were there, *what* they were doing, what did it *mean*, and how much of a *burden* of it was it on the landlord and the other tenants.

The photo *did* impress me with the number of people who were living there. It was a very wonderful exhibit and it struck me differently that I might have expected. I was very, very moved by this image. What's important about his picture, and this event, and this case, is that people who come to this country, work hard, and live together perhaps dormitory style temporarily. In a short time they move and are replaced by other newcomers. This was the landlord's complaint. They didn't know *which* eleven people would be there because this was an ever-changing group. One would "make it," leave, and a new immigrant would arrive.

My grandparents were immigrants who met and married in America. My mother, her sister, and her brother lived with their parents in a tenement apartment like this, and my mother told me that there were always strangers sleeping in their apartment. There was always a "greenhorn"—someone who had just come over, who slept on a cot in the kitchen. My aunt Ray, who is eighty-nine years old, lives in Connecticut, drives a car, and walks miles, loves to tell stories about how, when she was six, as soon as a "greenie" came, she had to climb on a chair to

take the pitcher off the top of the icebox, run down five stories to the beer garden across the street, have them fill it up with beer, and bring it back up the stairs to welcome the newcomer. The exercise appears to have served her well.

So as I looked at this piece of evidence, I was thinking how wonderful it is that these people come, that they work so hard, and they save their money, and they live this way so that they can eventually bring their families over. I can't remember the decision I wrote. This particular case may have been settled.

Litigants frequently use photographs as evidence of a condition or event. Some cases rise and fall on photographic evidence. My current caseload is largely matrimonial cases. Photographs are used all the time. There is frequently photographic evidence of spousal abuse or household furniture and furnishings or houses that are being appraised.

When photographs are presented in a court case, you have a witness on the stand who identifies the exhibit. In this case, the witness would have been the landlord or the person who took the photograph. The landlords' lawyer would have handed the photograph to the landlord and said:

Q. "Do you recognize this photo?"

A. "Yes."

Q. "Did you take this photo?"

A. "Yes."

Q. "Where was this photo taken?"

A. "In the building on First Avenue and First Street, Apartment 5."

Q. "Is that the apartment occupied by the respondent?"

A. "Yes."

Q. "When was the photo taken?"

A. "On September 21, 1985."

Q. "And this is a fair representation of the conditions as they existed on that day?"

A. "Yes."

Lawyer. "Judge, I offer this photo in evidence as defendant's Exhibit A."

And at that point the photo should speak for itself. It should require no explanation. Now that doesn't mean that there aren't photos that require explanation. Should that happen, the person who took the photo or who knows the premises, explains the photo. In case involving automobile or trip-and-fall accidents, you might have a photo on a street or some woman standing on a corner. The person who identifies the photo might say, "This is Hudson Street, looking north." You can have a witness describe what is going on in the photo. How do you know they're not lying? Well, how do you know that every witness is not lying about everything?

People do not fake evidence, and if they do, their case is weak. Faked evidence rarely comes across. In my experience, people come to court and mainly tell the truth. There's something about the courtroom and the robes. If questioned just a little bit, if probed just slightly, people tell the truth. Sometimes, quite amazingly to their detriment. I'm very impressed with this. Now, what they will do is fudge or avoid saying anything. That's why you have to keep probing and listening, until you get down to where they must respond. Does that mean that I think there's never faked evidence? No. But when I look at a photograph, I basically have the sense that I'm looking at some form of the truth.

You can always go to the scene. In this case, it was probably a

Photograph introduced as court evidence, 1986. Photographer unknown

small room with bunk beds against each wall in addition to the sink pictures in the photo. When you enter you see a whole room, everything. But in this photo, these mugs and toothbrushes and toothpaste tubes are central and undiluted by everything else. They are the focus. Look at this tube of toothpaste. I think it's from Korea. I though it was interesting that everybody used Colgate, except this one chap who must have been the most recent arrival. So you see this, and it stands by itself quite impressively.

Had I walked into the room and found all of this on the sink, just as in this photo, but there had been only *one* bed, nothing more than a pair of trousers, one shirt, one set of linens and towels, and one cake of soap, what would I think? I would think, "Did anyone move out? Did they know the judge was coming? Do people just come here to rush their teeth? Did the chap just move in and this is what was left over from the last tenant?"

But this photo was used by the landlords to represent the conditions in the apartment. The cups and toothbrushes were not placed there to create false evidence. If in this case, the landlord said, "And I went in there and saw mugs, and tubes of toothpaste, and eleven toothbrushes," that would have been much less dramatic evidence. The words would not have the same impact. Photos provide the opportunity to describe things with enormous impact. Often greater than words. It puts things in context. It draws your attention to the evidence. You have an additional descriptive language. You have a *visual* image that remains in your mind, because a photo sometimes lives with you longer than words do as you're thinking through a case.

When you listen to a case on trial, a judge takes notes. But there are things in the course of a trial that impress you, things you remember. And each side wants you to remember different things. They want to impress you with their story. A *story*— that's really what this photo is. It's the difference between a storybook that has pictures and a storybook that doesn't.

Now, of course, this photo could be interpreted differently. The landlords could have been introducing the photo to prove that the tenants were not maintaining the apartment properly. But I must say that judges learn to sort the wheat from the chaff. If someone introduced this photo as evidence of dirt in a landlord-tenant case, I'd find it weak. But if someone was introducing this to me in a hospital case or in something involving a dentist's office, or a restaurant, it would be serious. If a husband or wife were showing me something like that as a sign of poor housekeeping in a matrimonial case, I'd say "What about the other spouse?"

But what I really thought when I first saw this photo, and what I still think, is what a remarkable image it is. I thought it was bright and colorful, quite fantastic. I thought the Colgate Company could use it in advertising. Aesthetically, it's an interesting photo to me, and would be even if it had never come up in trial. It's almost like a painting, as good as any Jim Dine I've seen. That's why I've put it up on the wall in my chamber, because it's wonderful and goes well with the other paintings by Knox Martin. It looks terrific in here, in its orange frame, hanging on top of my law books, the law of the State of New York.

Diane Dillon: We chose this frame from Orson Welles's *Othello* because the movie is symbolic of our lives. Emotionally, it represents where we were at as an interracial couple in the mid-fifties. We were going through a tremendous amount of turmoil with our families, our friends, and each other. And his image is a good illustration, it's something I'd want to do. It's a sublime composition: the fact that it's off to the side, the intimacy, and the angles of these two faces up close. Who would do that, so large, on a screen? You usually want to get a panoramic view on a movie screen, but here's this *intimacy* that Welles zeroed in on and made huge.

Leo Dillon: The image comes out of darkness. The white face exists, and then out of the darkness, a black face is formed. There's the rage in the scene that's so strong. Othello is about to kill. It's one second before he puts the candle out and kills Desdemona. When you add the suspicion of two people of different races, who have been trained to distrust each other, it's enough to tip you over the edge.

DD: The movie is also a male/female thing. He was stronger than she was. There were issues of jealousy, possession, power. It was conventional in that sense.

LEO and DIANE DILLON (b. 1933/ 1933) are award-winning illustrators of children's books. They received the Caldecott Award for illustrations for *Why Mosquitoes Buzz in People's Ears* and *Ashanti to Zulu* and have illustrated ten American Library Association Notable books.

LD: This image certainly summed up what we were feeling.

DD: It also summed up great composition. When we do a book, we tell the story through illustrations and we're always conscious of composition, but it's the *emotions* we spend a lot of time trying to get across. We've worked together for thirty-four years since we met at Parsons School of Design in New York in 1955. We were both studying graphic design and advertising. We actually met each other's *artwork* before we met each other, and decided *that* was the person we had to

compete with, because their work was so good. We'd fight about our work. If one person's work got hung in a better place than the other in an exhibition, it was good for a fight or two. When we weren't fighting, we were helping each other. It was an emotional roller coaster. We started out as hostile friends, and over a period of time, we began to become more interested in each other. We knew that the only way we'd ever survive was to join forces. We couldn't carry on two separate careers. It would have been bloody murder.

LD: It was not pleasant. We realized that we had to blend.

DD: At first we would start out with one piece of paper and two pencils. It was, "Yeah, your's is all right, but look at *this!*"

LD: I remember that everything Diane did I thought I could never equal. And I'd really brood. Stay up nights. She'd done a cover, when we were at school, and I kept it by our bed. I'd wake up, stare at it, and think, "God, I dislike her!" It was really the work. Her work was more than I could understand.

DD: Yes, but I felt the same way.

LD: At first our collaborative work was trial and error.

DD: We learned to pass a drawing back and forth. One of us would start it, and the other one would come in on it. Each of us was still trying to pull the drawing back to what our *individual* vision was. We fought constantly. We were afraid to go to sleep at night, because we didn't know what the drawing was going to look like in the morning. It was not until we got our

Following pages: Still from *Othello*, featuring Orson Welles and Suzanne Cloutier, 1952. Castle Hill Productions

first Caldecott Award in 1976 that we really thought about what we did. When we started doing speaking engagements, the idea of a third artist cropped up. We decided to talk about ourselves as a *third* artist, because our collaboration produces something neither one of us would produce separately.

LD: Once we understood that we worked *together,* the good things I saw Di do were no longer a threat, and I was able to accept them as my own.

DD: There was a wonderful rescuing aspect about it. When there was something I couldn't bear to look at for one more day, and I just didn't know what to do with it, Leo would say, "It's there. It's all there. I'll take it." He'd put some highlights on it, glaze it, and the thing would just blossom. We have developed into a smooth working machine now.

LD: We always try to change off. If one person draws an illustration first, the other paints it. Then the first person paints and the second draws.

DD: In the 1960s we were doing advertising as well as working for Time-Life on a science series. We did corporate reports, liners for albums, magazine illustrations, whatever we could get.

LD: An editor called us after they saw our covers for young adult books and said, "We'd like you do this children's book." With a book, we could say anything. We could weave a world of our own. We didn't think about it consciously at the time, but it's quite a responsibility doing children's book. We wanted children to see a positive image of themselves.

DD: We found out later that children's book illustration was separated from the field of illustration as the *fine art* of illustra-

tion. It was a career in itself.

LD: In children's books, there has to be a way to escape into the dimension of flatness. That's why children's books with photographs don't really work. Styles change and they look out of date. You have to abstract things so the mind has something to play with, rather than having it presented to you *fait accompli.* Maybe a children's book of photographs would go over like gangbusters in a society that did not know photographs, a society that used flat design. By using photographs, you'd be presenting them with magic.

LD: We do use photographs in our work though. We photograph each other, our child, and our friends. No one escapes.

DD: Photographs have played a very important role in inspiring us. We think of a photograph as someone else's creativity, so we would never copy one. If we wanted a misty scene, we'd look through a photography annual and find photographs that inspire us about what happens with the colors of mist. *Ashanti to Zulu* is a book about twenty-six African groups, and in it we set out to show the costumes, the dwellings, the landscape, the artifacts, and the ceremonies of each tribe. We couldn't travel to Africa, so we had to rely on photographs.

LD: Illustration *has* changed. I know very good illustrators who have given up painting and gone to photography because it's first hand. To work from the photograph is to be separated from the life. The photograph is life, once removed.

DD: Now there's a lot of concentration on computers. Rather than using computers as a tool, they are becoming an end in themselves. Drawing is *our* vocabulary. We can't think something through unless we can get it down in a drawing.

LD: Through it all—our struggles as a couple and as illustrators—we've always been fans of Orson, the divine Orson. You know, Welles used to hang around in Union Square with cartoonists. They said that he was forever coming around, looking at the panels they were working on, and he'd say, "That's the essence of movie making." When they saw *Citizen Kane,* they said, "He got it from comic books." In school, we followed everything he did. We knew what he was up to when he was making *Othello,* because we read articles about how he had taken a job in an Italian spaghetti western to make some money to continue the film. Welles was the pure artist. When he died, I can honestly say we were saddened. We thought, "Boy, there's a twentieth-century genius, gone."

In 1943 when I was nine or ten years old, my father took me to my first Broadway play—Paul Robeson in Othello. At the curtain, when Othello kissed Desdemona, who was played by Uta Hagen, everyone in the theater—and the audience was predominantly white—stood up and applauded. I never really thought much about it at that age, but I think about it now. At a time when this country was really steeped in racism, to see a thing like that! It never left me. It was another world. Later, when Di and I were in school, we dressed as Othello and Desdemona for a costume ball.

DD: As an interracial couple, we had a real chip on our shoulders. The more stares we got, the more defiant we became. We'd sit down in a subway, immediately find the person who was staring at us, and stare back, so they *couldn't* look at us. One wild Sunday, we went to the Guggenheim Museum, and people were staring across the ramps at *us,* instead of looking at the paintings. We even got an anonymous letter about an interracial couple in Boston, which described how the woman had been held down and forced to watch the man being beaten to death in front of her, with a little note attached, "This could happen to you." We were worried we would get kicked out of school if they found out. We tried to keep our relationship secret. So, with all this turmoil, we could really identify with the movie. The Sturm und Drang in the movie was normal for us. From an art standpoint and from an emotional standpoint, it had a tremendous impact on us. The movie was an intense metaphor for our relationship. We were living it.

LD: It might seem as if what we were doing was courageous, but we were too goddamned angry to think about courage. We were always angry. We were angry at each other. We were angry at the world. It was mostly out of fear, or out of tension. The one thing that has changed since then is that the kids I see together today, who are in interracial couples, *know* they're about something. We didn't do it as a cause. We did it in spite of other peoples' opinions. We knew it would have been easier not to be together. I guess it was love. We just had to do it. It was a compulsion.

LD: The only other time I remember feeling what it could be like for racial tension to ease up was in the sixties. We were all together, everywhere you'd look—Woodstock, Jimi Hendrix—color didn't matter. But it didn't last long. The day extraterrestrials land on earth, which some people are saying will be in 1994, is the day that racism will end. That's the day there will be no difference between races, between sexes. We will all be odds with *them.*

That's Edward Bennett Williams, the most famous criminal lawyer of our time, and this picture shows his exuberance, his lust for life. He had cancer when this picture was taken at a Redskins game in 1982, and he fought cancer for thirteen years. One of the brightest and bravest men I ever met. A natural lawyer, a great lover of sports, a pal, a friend. I got this picture because once when we were sitting in his office, I said I really wanted a picture of him. He said, "Would you like this one?" It was on the wall. The photograph was obviously taken at a touchdown. It was in '82, and he was the president of the Redskins. Soon after this, he bought the Orioles, devoting himself full time to baseball. It's a picture of victory, exultation, the joy of living.

Williams defended some of the most famous people of our time. Who didn't know him? He was Jimmy Hoffa's lawyer, and the only time he didn't represent him, Hoffa was found guilty. He represented Joe DiMaggio, Frank Costello, Joe McCarthy. He defended and won the insanity plea for David Hinkley, the guy who shot Ronald Reagan. His law firm represented Ollie North, even though he, personally, wasn't crazy about North. He was a Republican who became a liberal Republican, and at the end, he was a Democrat. He's been called the Clarence Darrow of this era, the defender of lost causes. The best lawyer *ever* in this country.

He died with grace. I remember the day we were walking down Connecticut Avenue, three weeks before he died. He had lost all that weight, he was gaunt, but still went to work every day. He tried everything. He had surgery done. He had liver, then lung cancer, and when he knew he was going to die said, "There's got to be something after this. Gotta be, or else this is madness. A cosmic joke. It *can't* be a cosmic joke." I knew him nine years and admired his wisdom, his uncanny ability to see

right into things. You know, my father died when I was ten. Ed embodied everything I would have loved in a father. He liked to touch you when he talked to you. A very physical person, a hugger. My father wasn't.

He was also hysterically funny. After I had my heart attack, we were down in Florida eating a meal. And I'm looking at the menu, and he suddenly starts: "See, you gotta eat that chicken without skin. See, see how cancer's better? I can eat anything." After my heart attack, we'd be at the ballpark and players would walk over and say: "Hi ya, Larry. How ya doin?" And he'd say: "Hey, I got cancer. Ask me how I'm doing." He could kid about it.

I learned so much from him. I'll give you an instance. In the '83 playoffs, the Orioles, before they went to the Series, were playing the White Sox, and had lost the first game. We all got into the press elevator. There were too many people in it, and we went below the bottom floor, hitting the bottom. The lights went out. We had no air. I had heart trouble. Even Gordon Liddy would have been scared! Williams said that no one would know where we were. So first he's mad. We had lost the game. The phone in the elevator ain't working. Then his anger turned to frustration. So now we're all standing there, talking. Suddenly, Williams says, "If we all talk, we're going to use up all the oxygen in here. If you want to say something, it better be important. Raise your hand. I'll acknowledge it. We got to have a leader, I'll be the leader."

Ten minutes passed. A half hour. He said: "I'm going to say a prayer. For those of you who don't care about this, I'll understand." And he said: "We just left the baseball game. A mean-

LARRY KING (b. 1933) has worked in radio and television broadcasting since 1957. "The Larry King Show" is heard on more than 365 radio stations nationwide. "Larry King Live," broadcast worldwide, is CNN's highest rated television program.

Edward Bennett Williams, Oriole Park, Baltimore, 1982. Jerry Wachter

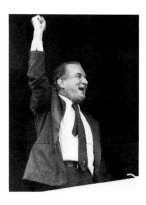

ingless game, and I was complaining a half hour ago about how we lost. Suddenly the game seems trivial. You have our life in your hands." And as he said "Amen," the door opened. I swear to God. We climbed up the ledge, and then he went back to being angry again. He stood for leadership. He had a sense of belief in himself and in forces stronger than himself.

Law, he loved. He was never erratic in the law, he carefully measured things. He was always extraordinarily prepared, whereas, I work unprepared. But he admired me, he loved my interviewing style. And I loved watching him. He would talk softly, deliberately, to make the jury lean forward and to force their attention. When he stood up in a courtroom, it was like magic. Prosecutors looked at him with envy. But sports was his passion. At a baseball game, he'd be nuts. Nuts! You'd have to douse him. Ball one, he's already lost the game. He'd go into mass fits of depression. He said he was a pessimist because it was sensible.

Images were always very important to me. When I was a kid growing up in Bensonhurst in Brooklyn, I went to the movies every week at the Loew's Oriental, the Benson Theater, the Marlborough Theater Deluxe. I remember that when television came, I'd look at baseball games in the window of a store. I remember my friend Herbie getting the first set of anyone I knew, and we'd watch the test pattern and say, "Something's coming, something's coming!" I remember my first set, the Emerson—the horizontal never worked right. Television came in in our neighborhood in '47, I guess.

When I was a kid, I looked at newspapers and magazines every day, every week. We had eleven newspapers in New York then. The *News,* the *Mirror,* the *Journal,* the *World Telegram and Sun.* I read the *Daily Worker,* the communist paper, and

Compass PM. I wanted to know everything. One of my earliest memories is listening to Red Barber and Arthur Godfrey on the radio. Red was my hero. I wanted to be him. I wanted to be Godfrey. I wanted to be a radio broadcaster. That was the only thing I ever wanted to be.

My whole dream has come true. Now I do both radio and television, and words and pictures are both important to me. Good words make pictures. Barber was a great baseball broadcaster, because when he broadcast you saw the game. You're born with that knack. I have that knack. I take no credit for it. I had it when I was young. I like being immediate and people want immediate gratification. That's why television made *Life* magazine extraneous, and that's the difference between my show on TV and my show on radio. On TV, the person is right there. When Ross Perot was on the show, you heard him *and* saw him. If you watched me with Bill Clinton and you liked him, if he moved you, if you liked the way he looked, what the written word would say about him the next day was meaningless.

I'm successful because of the way I work, because I communicate. I use the same curiosity I had when I was a kid to communicate now. Here's what I saw, here's what I'm telling you, here's what I'm asking. It's all part of a picture. It's inborn, you have it or you don't. Ed would have loved what's happened to me. I look at this picture a lot, every day. I think I hear his voice. He made an indelible impression on me that has never really gone away. When I sit in the new stadium in Baltimore, I think about how Ed would have loved sitting there. And then, I can almost feel his presence. I don't believe any of that spiritual stuff, and I don't believe that Ed's in this room, watching over me. But I have a connection with him that won't go away.

What I love so much about this picture is its fictional quality, the amazing scenario it suggests, on top of its formal beauty. It's not so much a narrative, as a mood. It's about longing, a mood that really draws me in. It's me, this picture, because I always think what makes me work *is* longing. Not desire, the feeling never gets that strong. Longing is feeling something's missing, and you are trying to complete it. A fantasy. As I get older, I find myself on the phone in this position in my bed all the time. Every time I do, I think of this picture. So I relate to this picture in basic ways. I also love it because it's a woman's world. Her lover is missing, and she is clutching the pillow in place of whoever's not there, the woman or the man she's really dreaming of. It's a picture about a woman in the city. She's not a suburban woman; she's not a rural woman. She's definitely confident and it's an urbane picture.

This just says so much about modern woman to me. I mean, she's alone in a bed, right? And she looks beautiful. She looks like she's totally wrapped in her own emotions. You know, I've had it with women-as-victim pictures. A woman at this point is the farthest thing from a victim, or at least she's just on the verge of *not* being a victim. It's time to stop. I think that in the next fifteen or twenty years, it's going to revert. *Men* are going to be the ones in dresses—not in dresses—but in regalia, and women are going to be the ones in business suits. It's a little crazy, like Buck Rogers or something, but in fact, I don't think it is very far away from the truth. I feel it already.

I love the mood. I just find it so touching. To take this picture really requires a great deal of guts, because the photographer's so vulnerable, exposing himself to capture that moment, and there's nothing fancy about it. It's just a black-and-white picture—really gray and white—but there is *color* in it, you know. In the shadows. The wrinkles. Look at those tones of gray in

her face. When I think about something that's black and white, like a photograph, I always think it implies color. This picture has a specific color, a pale, fleshy, pink color. That morning light color that sometimes makes things look pink. Very, very pretty light.

You know what I love about Mr. Penn's work? It never descends to the common denominator; it always lifts a person up. What I also adore is that it's not slick. Never! Even Mr. Penn's most still, dead, inanimate objects are *not* dead at all. Even his most composed pictures. I mean the man works in a studio from nine to five every single day, and his pictures are so alive! A girl can be completely composed like this one, but there's a thought, a gesture, something in her eye. Or maybe there is nothing in her eye, but he uses that vapid nothingness to his advantage, which is real genius.

The body of Mr. Penn's work is so intimidating, but in fact, this picture came into my mind in the first instant I was asked which photograph represents something in my history. I don't remember where I first saw it. Wherever it was, in a book or in a magazine, it was big on the page. I remember it had a plain white border all the way around it. It didn't bleed off the page. And I've remembered it since I was a kid, thinking, "Boy this is some photograph!"

Formally, this picture is wonderful. It's taken from the ceiling, like a voyeur. As a fashion designer who appreciates textures and beautiful things, that little nightie she's wearing is fascinating to me. I'd love to see the rest of it. And even the pillows are just wonderful—huge, giant, square pillows. It's divine.

In the picture, you can make out the nightie that goes into the sheets that go into the pillow that goes into the bed, and it's as

ISAAC MIZRAHI (b. 1961) apprenticed with Perry Ellis before opening his own women's wear business in 1987. Now an internationally acclaimed fashion designer, he has received the prestigious CFDA Designer of the Year award three times within four years. He has designed costumes for the ballet, movies, and Broadway shows.

if the light itself makes clear the difference between each part. You just *feel* the texture, like a painting. That's why I always love black and white so much. Early black-and-white photographs and early black-and-white movies are thrilling. There's something about them that is so vulnerable. And that's why I love this picture, because it's like a painting.

This picture is also essentially American. In America you're always living for the future. That's why it's possible to be poor here, because you don't give a damn. Tomorrow you won't be poor. Or in six months you won't be poor. Whereas in France, you're born into a specific role you can't escape. If you want to be a designer you have to work for years and years in an atelier, which I think is great; it's one perspective. After fifteen years you finally get a raise. Then, all of the sudden, you're a manager, and after fifty years, you're the designer. That's why Yves St. Laurent is so baffling; he was only twenty when he became chief designer at Christian Dior!

And the idea of longing pertains to America as well. One is born here, or comes here, and has the ability to fulfill whatever one longs for. You can think of longing as a sort of romantic feeling, something being absent, but I'm speaking of it in a more complicated way. That notion of wanting to fulfill what *appears* to be absent or what *feels* absent. Some of my favorite works that I have created are about longing. When I look at something I've designed, and it looks like it's longing for something, it thrills me, because it *is*. It's longing for a real woman.

I look at things differently than other people do. When I look at something, I always look at what that thing implies and the opposite of what it implies. I look to the idea. So when I look at this picture, I don't see a cuddly woman, I see a fiercely complicated woman who is having a moment. It's like

Shakespeare, you know. The reason *The Merchant of Venice* is so brilliant is that you really can't tell if Shylock is a villain or if he's a hero. That's why I never think, "Oh Shakespeare's such an anti-Semite." On the other hand, if you read Edith Wharton, you know she's a giant anti-Semite, because what she writes isn't poetry; everything is much more obvious.

I love reading Shakespeare and seeing his plays. He always inspires me. And my collections always specially refer to feelings about one of his plays or another. You know, it's very hard for me to think about what winter clothes are going to be like in the middle of the summer. So if I read one of Shakespeare's winter plays, like *Hamlet* or *King Lear*, and I'm suddenly *in* the winter. Or if you read *As You Like It* or *A Midsummer Night's Dream*, you are in the summer. That's how this picture works for me, it's like a fragrance that makes for a certain emotional recall whenever I need it.

Girl in bed, on telephone, 1950. Irving Penn

This picture was taken during the 1992 Olympic games in Barcelona by Tony Duffy, who I have known a long time. Tony is great about showing me all the pictures he takes of me, and I get to say which pictures I like and which ones I don't. A lot of them I don't like. I'm very critical. I don't like setup shots, like portraits. I prefer action shots because you're not pretending; you're doing the real thing. When I saw this picture for the first time, I did what I always do. I critiqued it. I studied it so I could understand how to throw the javelin a little farther, to see where my body position was, and if I was doing anything right versus what I was doing wrong.

What this picture tells me is that right before I was getting ready to release the javelin, I was a little tense. I can tell because my eyes are squinting. Sometimes I squint because I try to focus on where I'm trying to throw the javelin. I put an imaginary target at a certain distance and try to throw *through* that point. Sometimes right before I'm ready to release the javelin, I tighten up, because I want to throw it *really* hard. But throwing hard is not the key to throwing far. The key is being relaxed, just allowing the javelin to come out of your hand. In this picture, I can tell that I am *not* relaxed. I can see the tightness through my neck and arms. The movement is fine, the positions are okay, but I'm like a rubber band, so when I release the javelin, it's going to pop, instead of flowing like water. It turned out that this was not a good throw. So why *this* picture? It keeps me humble and allows me to continue to challenge myself. It reminds me I am not as good as I might think I am.

I like pictures because I like to see progress. I believe that there's a beginning, middle, and end to everything. When I look at pictures, I'm looking at where I came from, how far I have come, and where I'm trying to go. If I find myself getting out of step with reality, if I think that I'm better than someone,

that's when I'll flash back to pictures from a time when I didn't have what I have now. And I'll appreciate them and realize that if I don't continue to work hard, I can fall back to where I was.

When I do endorsements, my image is a concern, but I don't pretend that I'm one person when I'm in public and another person behind closed doors. On the field I try not to worry about whether my hair is in place or if my nail polish is on right. I try to concentrate on what I want to do. Image is important; and sometimes it's all camouflage. On the outside you can look one way, but if the inside is not together, it will rise up, because that's who you *really* are.

When I see my picture in magazines or on product packages, it's *strange*. You say to yourself, "Wait a minute. Is that *me?*" I might think a picture of me looks gorgeous, but I want my friends to recognize me. If I walk by a picture of myself and I'm with friends, it's kind of interesting, because they'll say, "Oooo, look, it's *Jackie Joyner-Kersee*. Look at *her*." And I'll be saying, "Wait a minute. Oh, my god, I don't even recognize myself."

Am I comfortable with being an image, a sports hero? Well, yes and no. I work with a lot of different people, but I don't do it to be a hero. Maybe people have read about me and think I'm different because of my accolades. But I'm not. If I could touch someone, in *any* kind of capacity, I would ask them to be great human beings. That's all I try to strive to be.

JACKIE JOYNER-KERSEE (b. 1962) has competed as an athlete since 1985 and in the 1988 and 1992 Olympics won three gold medals. She currently competes in the heptathlon, long jump, and hurdles.

Jackie Joyner-Kersee at the Barcelona Olympics, 1992. Tony Duffy

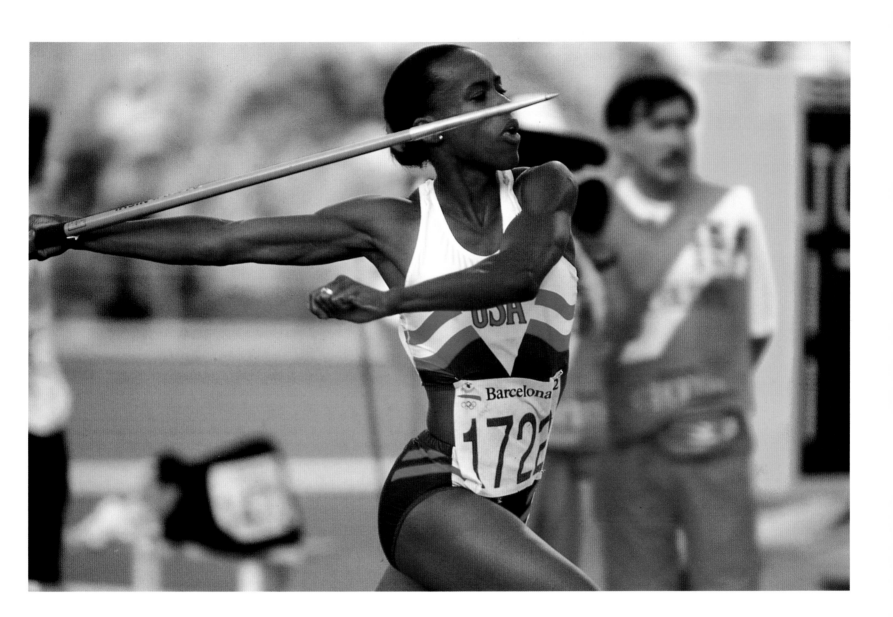

This photograph is about the future, and I can't think of a more important moment in my life. It shows an unprecedented private meeting I had in 1993 with Daisaku Ikeda, and it reminds us how people of very varied opinions and unique personalities from two different cultures have an opportunity to work together on a mission of world peace.

Dr. Ikeda is the lay leader of millions of Buddhists, and he has traveled the world for more than a quarter of a century, meeting with world leaders, striving for world peace. He said this meeting, between the two of us, was very special for him. It was for me, too. In his concern for human rights, Dr. Ikeda is ahead of many people in this century. He is a calm spirit, a humble man, a man of great spiritual enlightenment. We met for about an hour and talked about my life and challenges concerning the youth in our countries.

We are two people who respect the differences between our cultures. Difference in cultures can and must coexist, but we can come together. Our meeting can serve as a model for anyone. So the photograph of our first meeting is very important because it is history in the making.

When I was arrested December 1, 1955, for refusing to give up my seat to a white male passenger in Montgomery, Alabama, no photographers were present. The only pictures taken were mug shots at the police station. Fortunately, those pictures were not put in the paper, but my name and address and the area where I lived were often published. The same was true of other African-Americans. Similar information on white individuals who were segregationists and antagonists to the civil rights movement was not published.

At the time of my second arrest, in 1956, a photograph of me

being fingerprinted was carried on the front page of the *New York Times*. And the day the buses in Montgomery were finally integrated, reporters from *Look* magazine waited outside my home until I got dressed, got into a car with them, and went downtown, where they had me get on and off buses, so they could take the picture that has become so well-known. Most people think it was my first arrest.

There is still much to be changed in America and in the world. And change comes either by strong encouragement or force. The voting rights bill, desegregation in schools, we know that these things were forced. And during twelve years of Republican administration, not very much attention was paid to civil rights in this country. Therefore, many racists became very comfortable and didn't have to worry about things changing. Change causes controversy, that's the way it always happens.

In working toward world peace, one begins with self. The picture with Dr. Ikeda and me is important to human rights. I'm just another person who was considered a troublemaker instead of a peacemaker. This photograph is another opportunity for world peace.

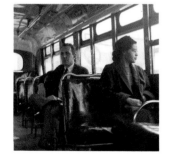

ROSA PARKS (b. 1913) is a civil rights activist. Her refusal to give up her seat on a Montgomery, Alabama, bus to a white passenger in 1955 led to a U.S. Supreme Court decision outlawing segregation on city buses. Since 1984 she has protested against the South African government's policy of apartheid.

Rosa Parks meets with Daisaku Ikeda, Los Angeles, 1993. Yasunori Ushida

MARTHA STEWART

My father took this picture in Poland about 1934 where he went on a trip when he was a student studying Slavic languages at Columbia University. Poland is where my mother and father were born, and where his mother and father were born. The original photographs from this trip are in a wonderful little album with an Egyptian cotton cover, which my mother safeguards and barely lets me touch. Fortunately, when I grew up, I had this enlargement made of the picture that my father took.

The pictures from his trip to Poland are the first photographs I ever saw. And this was the picture I loved to look at most. I appreciated it the minute I saw it. I wanted to travel to Poland, because my father always talked about it. Our relatives still had farms there, and I liked the idea that we were farmers and reaped the soil. But what struck me most at the time was, "Oh boy, Dad took this picture." Photography was something he spent a lot of time at. He loved to photograph and had a beautiful eye. He talked to me about pictures all the time, about what was a good picture, about composition, film, contact sheets, and prints. That's where my interest in photography comes from.

This picture's had a great impact on the way I look at photographs. I also like it because there was a story behind it. A story about Poland, my father's trip, our relatives, and how they grew things. I always wanted to know where flour came from, and this woman is reaping wheat and oats and barley. Growing things has always been a big part of my life. I grew up in Nutley, New Jersey, where we had a big garden, and I learned all about farming from my father.

When I was a child in school, probably in the second or third grade, we made little books. We learned how to bind, to sew, to make board covers, and to cover them with wallpaper. When

we were done, we pasted little color plates of our favorite paintings in our books. That's how I started to learn art history. I had never been to a museum, but Millet's *The Gleaners* was one of the first paintings I knew and loved, and so I pasted it in my little book. I said to my dad, "Your photograph looks exactly like this painting." I'll never forget that.

When I'm trying to get people to pay attention to information, especially in my magazine, pictures are more important than words, because they are what you see first. I don't know anybody who *reads* a magazine before they look at it. The first thing you see is the image, even if the story is very good. I want my pictures to show the real thing, to be as clear and as beautifully done as possible, to show the most detail possible, and yet, not be stiff or intimidating. I want everybody to feel they can attain whatever we picture in the magazine. They can see it. They can find it. They can own it. They can make it. And I want people to be able to do things as well as to feel good about what they're doing. So our pictures always have to have that sense of reality. It's perfectly possible to achieve in life what's shown in our pictures. That's why people pay attention. There's nothing in any of the pictures we use that you can't make for yourself and that won't look like the pictures.

What I'm trying to get across in my work is tradition, information, and education. People rely on pictures to carry information and tradition. In all the work I do, I'm trying to keep knowledge alive before it disappears. Pictures are terribly important in keeping information alive, because they keep people interested in learning.

There are a lot of things in life that don't get photographed.

Poland, c. 1934. Edward Kostyra

MARTHA STEWART (b. 1941) is the author of best-selling books about lifestyles, including *Entertaining*, *Weddings* and *Christmas*, as well as "Secrets of Entertaining" videos. She is editor-in-chief of *Martha Stewart Living*, a consultant to the K-mart Corporation, and makes frequent television appearances.

200

That's why we do so many how-to pictures. We try to show in detailed, but simple, pictures all the aspects of an activity. And the more complex the pictures are, the better I like them and the more time people with spend with them. We did an article on how to wash a car, and people said, "It's so full of information! I can't wait to wash my car!" What people want to know most now is how to get things done. They're tired of just cruising through a magazine full of pretty pictures. Several years ago, people had a lot more money than they do now, so they hired people to do what they find pleasure in doing now. I don't mind stretching people's imaginations and challenging them, because I never underestimate people's abilities. I've tried very hard to talk up to people, to give them more than they can possibly need, in the hope that they will learn. If they see an upholstered chair, they look at every little detail and wonder how it was made.

I always do things myself, because I realize that if you don't learn how to do things yourself, you don't get a sense of accomplishment or gratification. The other day when we were shooting a piece for television, something went wrong with the stove, and the repairman came. I stood there and watched him repair the problem. He asked, "What are you doing?" and I said, "If it happens again, I want to know how to fix it." And he said, "Well, that's for *me* to do." And I said, "*You're* not always here. Why are you trying to hide this information from me? You should be a teacher." People who make or fix things should be happy to share their knowledge. But a lot of people keep knowledge to themselves and a lot of secrets have died. That's why my objective for the next twenty years is to record how-to information either in pictures or on film.

What do I see into this picture? First of all, it's backbreaking work. They use this fabulous rope to tie up the wheat, and the whole bundle must not be terribly heavy. Look at the landscape. It tells me how beautiful Poland must have been before the war, and I love the cumulus clouds. From the first time I saw this picture, I wanted to learn how to harvest wheat. I love what the woman has on her head, and that she's wearing a skirt and a blouse. I can drive by a field, and I can identify what is in the field, but a lot of people can't. They do not know a potato from a tomato, but I have learned to look at everything very closely.

Pictures help us to be observant, because we have time to look at them, instead of just zooming by. We learn from pictures, and the more we look at them and through them, the more strongly impressions are engraved on our brain. That's what photography does for me. I remember almost every picture I've ever seen.

LEANZA CORNETT

The image that Miss America has is very wholesome and pure, and it's always been that way. But about four years ago, the Miss America Organization implemented a program for woman to speak out on social issues they have a conviction about. My personal platform is AIDS affects us all. Miss America talking about a controversial issue puts it in a different light. People who didn't listen before are listening now—young girls, teenagers, and especially young women of child-bearing age, one of the groups most at-risk of contracting AIDS. As Miss America, I can reach a different audience than Magic Johnson or even Elizabeth Taylor. I spread the facts and dispel the myths to middle America.

This picture motivates me to speak out and do more than I'm already doing. It's of the AIDS Memorial Quilt when it was in Washington, D.C., in 1992, probably the last time it'll be shown in its entirety, because it's gotten so large. You can see some people down in the corner, which gives the picture scale. There are *over* 23,000 panels in the quilt now, and that doesn't even represent twenty percent of what's out there. There are over 23,000 people who have died of AIDS in Florida alone, which is my home state. This picture tells you that the scale of the AIDS crisis is enormous.

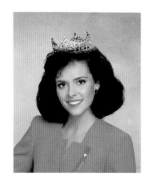

LEANZA CORNETT (b. 1971), Miss America 1993, works to raise public awareness about AIDS. Prior to winning the Miss America title, she worked as a volunteer in Florida for children living with AIDS. Her professional goal is to perform on Broadway and in the movies.

Every single panel represents a death, and it's just adding up and adding up. The more we talk about AIDS, the fewer panels there will be. Also, looking at this picture makes me mad. These are people that other people loved, and still love, and have had to let go of. The fact that it's right on the Mall in Washington forces the government to look at it, and it makes me think about what the government is or is not doing in comparison to what I see individuals doing. When the government gets involved, as much as individuals are involved, *that's* when change may really happen.

I got involved in AIDS work about a year ago, when I was going to school and working at Disneyworld, where I was the Little Mermaid. I started volunteering at an organization called Hope and Help in Central Florida. I grew up in the theater community and that world's been struck pretty hard. I saw friends getting sick and wanted to do something about it for them *and* for myself, to make *me* feel better.

When I first started volunteering, I did a little bit of everything, answering phones, whatever. Then I started working directly with people, sitting in on support groups, and I started to meet and really see the people who had AIDS: heterosexuals, homosexuals, Hispanics, all different groups. It put a different face on the disease. My friends, who were living with AIDS, were my *friends.* I started to see everyday people who were sick, women who have kids, men who have wives, your normal everyday Joe Schmoe. That *really* did affect me.

That's when I got involved in taking care of children. My job was to be with the HIV positive kids and just let them be kids. They spent so much time in and out of hospitals and clinics, it was sad and maddening as well. There was a little two-and-a-half year old named Stephanie, and she had to wear a backpack that held a device that hooked her up to medicine she knew, even at her age, was important for her survival. To live like that every day is not a normal childhood. So I'd go outside with the kids, watch movies, and read to them. It was what we called educational play.

About four years ago, when I was seventeen, I competed in my first local pageant because I needed money for college. Competing in the Miss America Pageant system was a good way to get scholarship money, as well as a great way to be on stage and perform. When I moved down to Orlando, started

working for Disney, and got involved in AIDS, that's *really* when I decided I wanted to be Miss America. I knew that Miss America had the ability to speak out and be heard. Not only would the title provide me with a $35,000 scholarship, a new car, a new wardrobe, and all the great things that accompany it, but it would give me the opportunity to have a platform, to make a bigger difference. As Leanza Cornett, I could do something. As Miss Florida, I could do something even more, but as Miss America, I'm doing a greater service. If you are a celebrity, people look up to you. It's your responsibility to be a positive role model. I always tell people that I don't expect everyone to have the same conviction I do about AIDS. There are other issues out there that need to be taken care of, but I've taken this one on, and I'm putting forth my best efforts.

People need to realize just how rewarding it is to get involved in an issue. Many times we get so wrapped up in our own little worlds that we become insensitive to the needs of other people. We need to start realizing that AIDS is *everyone's* disease, *everyone's* issue. A decade ago, it seemed as if it was the *other* person's disease, but now it's not. At the end of my speaking engagements, especially to high school groups and teenagers, I ask everyone who has been touched by AIDS to stand up. It's gotten to be a large group. The statistics are incredible. One out of every two-hundred-and-fifty teenagers will die an AIDS-related death. All that people sitting down have to do is look around them and see that AIDS is just a desk away.

Another thing I'd like to see change is the level of compassion we have for people living with HIV and AIDS. People are still avoiding the disease. They treat people who have it as if they *are* the disease. They avoid them and shun them and mistreat them. That's got to stop. The minute you turn somebody away, it's the old Bible story: I was sick and you took me in, I

was hungry and you fed me. That's exactly what's going to happen with AIDS. You turn people away, and you, yourself, are going to be turned away. You help people, and you, yourself, are going to be helped. Once people start learning that—if they start learning that—then positive changes will be made.

Walking down the walkways of the Quilt is a very emotional experience. It's sad, probably the most somber experience anyone could have. There are a lot of tears. The Quilt's been compared to the Vietnam Wall, because it's a personalization of loss. Every single day, new names and panels are added. You can almost look at the Quilt as if it were a garden. This may be abstract, but you see so many different colors, designs, symbols, and shapes in the Quilt. It shows you just who AIDS is really touching—so many colors and shapes and sizes. The Quilt, and this picture of it, is an accurate representation of what this virus has done.

The AIDS Quilt, Washington, D.C., 1992. Mark Thiessen

MARY STEICHEN CALDERONE, M.D.

These little photographs were taken many years ago on my father's wonderful high wood terrace, which was a central part of the house he built with his wife, Dana, overlooking a pond in Ridgefield, Connecticut. That part of Connecticut was almost all country then with very few houses, lovely and wild. He is sitting with my uncle, Carl Sandburg, and they are talking, while in the background, my daughter, Francesca, dances. These men had been devoted friends since Carl married my father's sister Lilian. The photographs don't have great artistic merit, but they hold an awful lot for me. As those two brilliant men carried on their discussion, every once in a while, they would comment about what my daughter was doing. When Carl and my father were working together, or doing anything together, they were always conscious of what the children needed or wanted. I can't remember who took these photographs, but most likely it was Dana, who was a talented photographer in her own right.

I treasure these photographs because these two men, who are deep in talk, are aware of my daughter. To both of them, children were important and were to be dealt with at any time. They always gave the children the satisfaction of knowing that, and in turn, they received pleasure from watching them.

To me, the reality of these photographs talks about why we are here—to care for each other, to value each other—that's the feeling these small photos evoke for me. It's what has always interested me when I look at a picture. I respond to what I know and to what I feel. What else is there?

Once in a while, when I was a child, my father would ask me to pose for him, and once in a while I would do so, but I found it frightfully boring. Just one more effort. He wasn't the tame, still observer early on. He wanted me to come in and make a

picture for him. Finally, when he mastered photography and knew exactly what he wanted—who, when, and how—I didn't count so much. But I did know that his photographs were beautiful. In fact, he formed my capacity for beauty. His works were around our house.

Sometimes my father invited me to come into the little shed where he mixed his darkroom chemicals. I'd see the red lights they used in those days and would be allowed to hold things or to see the photographs he was developing. It always kept things going between us, and I felt very much a part of his life. It took quite awhile, though, for me to get into photography. Even when I had a camera, I was not particularly interested in pictures. Now photography gives me one kind of pleasure, which is looking at photographs as art, and another that has to do with the stories photographs evoke—my history, for one thing.

My father's photographs very definitely let me see into his feelings. He was a remarkable man. Everything I am, I am because my father started me out that way. He was tremendously respectful of truth, any kind of truth. In fact, his work is about seizing the truth. He's always been a hero of mine. He knew how to get what he wanted out of himself, and from him, I learned there's nothing shameful about deciding what you want to do and doing it. In retrospect, that was a remarkable lesson to learn at a point in time when not very much was expected from girls.

You see, when I was a little girl, things were happening that were very important for me. Between the ages of five and ten I met interesting and exciting people. Many friends—artists,

MARY STEICHEN CALDERONE, M.D. (b. 1904), a pioneer in the study of human sexuality and sex education, has been an influential figure in Planned Parenthood–World Population. She has authored and coauthored many books, including *Release from Sexual Tensions*, *Family Book about Sexuality*, and *Talking with Your Child about Sex.*

Edward Steichen, Francesca Steichen, and Carl Sandburg, from a family album, Connecticut, 1950s. Dana Steichen

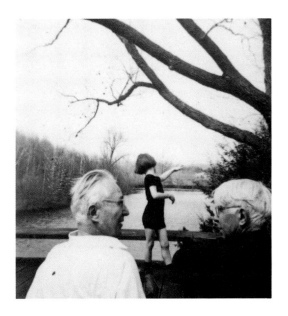 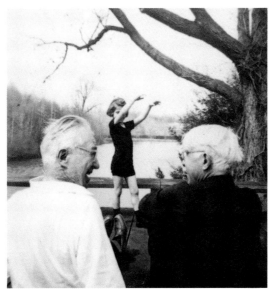 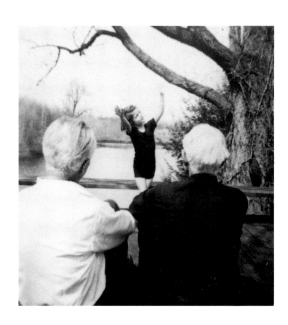

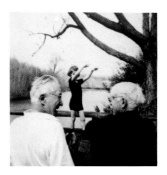

writers, sculptors—visited us each summer at our home in Voulangis, just outside Paris. We had fun, with dinners served outside by a little gal from Brittany, who could hardly speak proper French. My mother trained her, and we'd have very simple but delicious meals. It was wonderful growing up with flowers and plants, music and pets, and talented people coming and going.

France, of course, was home, but I left at the start of World War I, when I was twelve. I didn't ever go back to live there. I stayed in the United States with people who helped us when we first got here. It was a difficult time. My parents were divorced, my mother had gone back to France with my sister, and my father was hard at work and couldn't take care of me.

I was an intellect, having been intellectually guided, so to speak. I wanted to solve all the problems in the world and understand everything I was doing and what I was going to do with it. All of it! I was very lucky that the Leopold Stieglitzes said to my father, "You leave Mary with us. We will give her a home, and she will go to a good school." So I went to Brearley, one of the truly great schools, and it was wonderful for me. I had two teachers who made me very strong. The biology teacher, whose name I don't remember, was one. She took me up and we worked a whole year together. And then there was Miss Dunn, a greatly admired woman and a great intellect. She set a high standard for me, and she enjoyed working with me, which was important because she did not try to tell me what to do or how to do it.

I went to college at Vassar, and there I was not a great student, but I managed to graduate. My first instinct was to follow an art career, even though science had worked so well for me at Brearley. So I studied acting with the Moscow Art Theater in New York City. But after spending two years with them, I realized acting was not for me. Then I took the Johnson O'Conner Research Foundation tests, from Mr. O'Conner himself, and that aptitude testing revealed that I would do well in medicine.

By then I'd married and had two daughters, one of whom died at nine, and was divorced. So I had to go out and make a way for myself and my remaining child. I remember putting her, my dog, and everything I could think of into a rented car and starting out for the University of Rochester Medical School where I was going to pursue a career in nutrition, which seemed easier than medicine. Fortunately, on my way I stopped to see a classmate from Brearley, and she was very helpful to me. She said, "Mary, don't take anything less than the best and know everything that you can." So when we got there, I finally made the decision I would go into medicine.

It wasn't usual for women to pursue medicine at that time. However, when Mary Steichen got *interested* in something, she got interested in it. At Rochester it was acknowledged that I had good marks, and I said, "I want to study food for children." I knew that children were not getting the right food. And they said, "That will be fine." But it didn't take me long to realize that I wanted to understand not just about food, but about the bodily functions of children—all of it. So I decided I should get really good training as a good old MD. I knew I could decide later what I really wanted to do. I had good marks, graduated, and went on to get a public health degree, but I never really practiced clinical medicine. What changed the course of my life was that I knew two women in the New York City Health Department. They said to me, "Mary, you have to get to work. The best person to help you is the man who is Deputy Commissioner of Public Health, the best one in the whole of New York City. You go down, and he'll give you

some work to do." What I remember now is that I went in to meet this man. His name was Frank Calderone, a brilliant, serious physician-administrator. I began working with him, I married him, and I had two more children, one of whom is the little dancer in these photographs.

I don't know how, over the years, I got interested in sexuality. Everything but sex was taught in medical schools. It was a real taboo. I thought it was a false fear—puritanism. I had been a masturbating child, and my mother punished me by buying mitts of aluminum and tying them up to my elbows. I went to bed with them on. That was saying the *wrong* thing about the *right* thing. On the other hand, my father was a very sexual being. Although he never said anything directly to me about sex, he communicated that everything was okay. Perhaps, that's where it started. When *I* got interested in human sexuality, I decided *everybody* was going to get interested in it! I approached the subject by first taking on large issues, like birth control and planned parenthood, but there were people in this field already, like Margaret Sanger and Allen Guttmacher, and they were doing a good job. In addition, it was becoming clear to me that, before anything, we had to understand sexuality first. So I began making talks here and there to various groups and doing a great deal of writing. Eventually, I co-founded the Sex Information and Education Council of the United States.

I think my work made possible comfort in an area that was full of discomfort. My main philosophical approach was to understand what is very powerful in your life. It's interesting that this is also how I've looked at my father and his work. And certainly that's the philosophy my father passed on to me early in life.

Today, I'm approaching my nineties, and my family and the pictures around me are my life now. I've outlived most of the people in the photographs I look at every day. And even though they're only memories, I have *no* sense of loss at all about life.

You know, my uncle and my father felt that women are greater than men. And they certainly were ahead of their time in thinking that women have qualities of thinking and feeling and understanding that the world didn't value highly enough. Those little snapshots and my memory of those two great men watching a little girl dance, enjoying the moment and each other and valuing her as important to their world, speak to me about my life, the way I was raised, and what should be joyful and important to all of us.

The photograph appeared on page twenty-five of *Life's* issue of March 23, 1959, as an illustration of Hawaii's achieving statehood. Its caption read: "Dancing Wahine sways through a Hawaiian number for 30,000 spectators assembled in Honolulu Stadium for a special show to celebrate new statehood." It totally filled its page, which measured ten by fourteen inches in *Life's* generous Eisenhower-era format.

The word Wahine struck me, for one thing. The young woman's beauty, for another—her svelte midriff, her exposed navel, her perfect teeth, her cluster of earrings, her fishnet stockings with that hint of whorishness. The expression on her face, between glee and agony. The sea of faces behind her. Her curious aloneness in front of that sea, facing the other way, on what appears to be an otherwise deserted stage. Is she one of a chorus line? Whence comes the music she is swaying to, the rhythmic impetus hoisting one dainty heel up from its slipper and swirling the threads of her skirt and her bra? What force has all but shut her eyes? The camera has caught a Dionysian mystery: it has caught ecstasy.

Sunlight sits nakedly on the stage boards, on her extended arm, on her brow and clavicle. A delicious twisted strip of sun catches the top of her backside. Though her costume has a tawdry nightclub feeling, we are outside, in raw daylight, as at a bullfight. In the crowd, many of the faces are laughing; all along the fall of her black hair, white smiles flash out. The crowd to the left of her isn't quite so amused. She is, perhaps, amused. What can the joke be that has ignited all these smiles, a musical joke we will never hear, here in this sunstruck stadium over thirty years ago?

Her perfect face seems a mask, a mask of glee, with the eyes not joining in. Genuine joy, self-forgetful, appears to have broken

through the stage decorum whereby pretty young dancers mechanically smile—the pretense of jubilation has yielded to the real thing. But in what exact proportion does emotion mix with artifice? Why are we slightly afraid of this girl in her grandeur, her baubles? Why does she seem a slave, a captive to the moment—is it the harness, the collar of studded ribbons, that she wears? Note also the wrist heavy with bangles, and the wedding or engagement ring on her left hand, which is splayed by her crotch. She is racially exotic, which ups the current.

What I above all remembered of viewing this photograph, at the age of just twenty-seven (my birthday the very same week), was the ambiguous vehemence of her face and body in their arrested motion. Three decades later, I am surprised by how much leg she shows, how insubstantial her skirt is. I wonder what has happened to her. If she was twenty then, she is over fifty now. Overweight, I would imagine, fat on breadfruit and the junk food of statehood, with only this photo to prove her former crowd-transfixing beauty and maenadic animation. I see that many of the faces above her right arm look worried. I worry, too, that time has treated her cruelly. She deserved the best, for being so glorious a Wahine in this sunlit split second of celebration, of motion, of life.

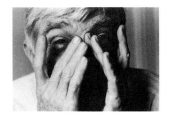

JOHN UPDIKE (b. 1932) is the author of forty novels, including *Rabbit Is Rich*, *Rabbit at Rest*, and *The Witches of Eastwick*, as well as short stories, poems, and cultural reviews. He has won the Pulitzer Prize, the National Book Award, the American Book Award, and the National Book Critics Circle Award.

Dancer sways for 30,000 spectators celebrating Hawaii's statehood in Honolulu Stadium, 1959. *Life* magazine, March 23, 1959. Leonard McCombe

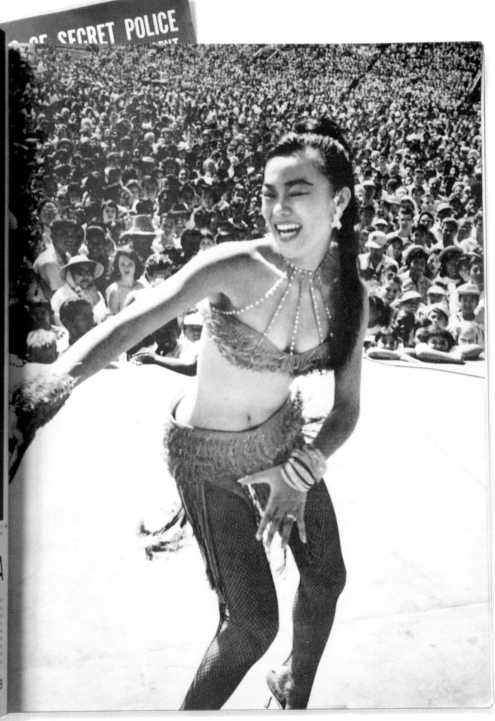

SECRET POLICE

THE HULA

...it a light from southern...
...an statehood. Th...
...and the House ac...
...il in just four day...
...in the next fe...
...and elect a ne...
...new island state...
...rsey over whethe...
...the *Aloha Sun*

see page 58

I was working as a freelance photo editor in 1972, looking for photographs to illustrate a book. At any given time, I worked for about twenty different clients, so I was looking at pictures all the time. I found this catalog, probably because I was looking for photographs made between 1920 and 1930. This photograph on the cover was one I'd never seen before. Since the history of art photography is about the circulation of the same two hundred photographs, it wasn't frequent that I came across an art photograph I had never seen.

What made this photograph so interesting was, and still is, its sexual ambiguity. I thought, "Is it a man, or is it a woman?" When you first look at it you see the kimono. In a non-Asian context, you think of a kimono as something that women wear. But in an Asian context, a kimono is as likely to be worn by a man as it is by a woman. When you look at the body more closely, and you see that completely flat belly and the articulation around the groin, you think it's got to be a man's body. Even skinny women don't have that kind of delineated articulation where you can see the vein over the hip bone. And then, there are the hands, the way they curve around the knuckles, the articulation of the fingers, that's something you can associate with dancers. But it's also a body that's completely hairless and smooth, which codes it as feminine. I think it's an Asian man, because that would account for the completely smooth, hairless skin and the delicacy of the hands.

I really stared at this picture when I first saw it. Then I flipped to the inside cover to see who had made it. I knew it was taken by a woman, which makes it significant in and of itself. It turned out to be by Margrethe Mather, one of the women photographers who Edward Weston worked with, and, I imagine, appropriated from. That gives another dimension to it. The

photograph's title, *Semi-Nude*, also begs the question as to whether it's male or female.

Part of my interest in the picture is that it reminded me of what Roland Barthes called "the terror of uncertain signs." Normally, the first response anyone who isn't a curator of art photography has to a photograph is, "What is it?" That is the *first* question we ask. Confronted with an image that is ambiguous or hard to read, before you even think about anything else, you try to fix the meaning that isn't apparent. But when it's about fixing the meaning on the level of gender, the stakes are particularly high, because the one thing that we need to know, psychically, in any encounter with another human being—is it a man or is it a woman? Why? Because our world is organized on a foundation of sexual difference. All other differences are built above and after sexual difference. That's why sexual ambiguity in life, in art, and in representation is *always* a problem for people.

For me, the ambiguity only increased my fascination. Typically, art photographs, photographs about the body, play in some way with the notion of the nude. The aesthetics of the nude work in one way when it's a female nude and another when it's a male nude. And in constructing a nude art photograph that is obviously contrived not to give you that information, but to allow for a free play of projection, it seems to me that Mather was onto something.

It's all about the flatness of photographs, too. The way she's cropped this picture, there's no depth, no illusionistic placing of the figure in space. It's so self-consciously artistic. Mather abstracted the nude, so that what you see is a triangle of flesh

Exhibition catalog, *Semi-Nude*, ca. 1923. Margrethe Mather

ABIGAIL SOLOMON-GODEAU

(b. 1948) is a professor of art history, author of *Photography at the Dock: Essays on Photographic History, Institutions, and Practices,* and a widely published critic specializing in modern and contemporary art, feminist, and critical theory.

PHOTOGRAPHY REDISCOVERED

AMERICAN PHOTOGRAPHS, 1900–1930

and a play off of the geometry of the flat patterns with the curves of the wrist and fingers. If there were breasts, you would know right away whether it was female or male. But her framing of the photograph at mid-chest level takes away that marker of sexual difference, just as pulling the bit of kimono over the groin disguises the most obvious marker of sexual difference.

That phrase by Barthes, "the terror of uncertain signs," makes me think about this photograph particularly, and something else that happened to me the year before I saw it. A friend of mine from many years earlier had undergone a sex change operation. Somewhat unusually, she had changed from being a woman to being a man. Most sex change operations are in the other direction. I knew she had become a man over a six-month to a year period, during which I hadn't seen her at all. So the story of her transformation was immediately known by everybody who knew her and many people who didn't.

One day, I was walking along the path in Harvard Yard, and I saw this man come into my field of vision. As I got closer, I suddenly realized that this man was, in fact, this woman I had known as a woman. When I got close enough, I saw the face, and the face was so recognizable that I remember I stood stock still. My heart started pounding. *Pounding.* It was "the terror of uncertain signs," in the most literal sense. There was the moment I recognized *him,* and I must say him, and he recognized me. Even in that instant of panic, I thought, "Well, I must act properly and correctly." So I smiled, "Hello," leaned over to kiss him, and the first thing I felt was the stubble on the cheek of this person who had been a woman. I then had the presence of mind to say, "Well, a lot has changed since the last time we saw each other," And he, being even more clever than me, said, "I guess you could say I'm a self-made man."

That instant of panic is not unrelated to the first question I think everybody asks of this photograph. Is it a man? Is it a woman? If that is not clear, if that is not unambiguous, if that is not a *certainty,* then what is? In the most profound philosophical sense, we're all trying to have various forms of certainty in our lives to manage the terror that nothing is what it seems, that maybe nothing is fixed in our knowledge of the world. Maybe what we think we are is not really what we are. You can see how that kind of anxiety about the blurring of boundaries translates into homophobia, translates into the real dis-ease that people feel about drag queens, about transvestites. And whatever Mather thought she was doing with this elegant, self-consciously abstracted, two-dimensional play on the three-dimensional illusion of photography, it seems to me that on some level, she was very conscious in hiding the markers of sexual difference. She was producing an image that would strike at the very heart of everybody's desire for certainty.

Although there are volumes of photographic criticism arguing that photography is no more truthful to empirical reality than any other form of representation, the fact remains that the photo finish in a horse race or the evidence submitted in court is predicated on the notion that photographs represent an inarguable, indisputable evidence of the "real." This is why some people argue that the structure of looking at a photograph is akin to the structures of fetishism. Fetishism is about, on the one hand, unconsciously believing in something because you want to believe it, and on the other hand, knowing that it isn't there. It's about both disavowal and projection.

The desire to believe that photographs are true—and I suspect that most of the choices that people made in this project, of the photographs that matter to them or have influenced them—has to do with this belief that what is represented in their photo-

graph somehow proves, somehow testifies to, a particular "reality." It could be any emotional reality, historical reality, or political reality that they need to hold on to. Our investment in the truth of photography dies very hard, even at a historical moment in which we have new photographic technologies that allow images to be fabricated. But I'm sure there are very few interviews that that began with the admission that a photograph could be totally fictitious, imagined, or mediated. Even the flag raising at Iwo Jima is, of course, a staged and fabricated photograph.

I would say that I'm generally more interested in photographs that do not self-consciously and artistically play with ambiguity. Art photography staked its claim as art, by saying, "No, no. This is not evidence. This is not a slice of the real. This is about the artist's subjectivity, imagination, the transformation of the world." Well, to me, all of that is very tiresome and not very interesting. It is only because the ambiguity that is played with in this picture is precisely about sexual ambiguity, that it is redeemed as an art photograph. I loved it *despite* the fact that it's an art photograph, not because it's an art photograph.

Given that I have seen thousands and thousands of photographs in my professional life, not to mention—like every other human being in the universe—having seen hundreds of thousands of photographic images in everyday experience, it is amazing that there should be photographs that have staying power and singularity. Barthes, in his wonderful book, *Camera Lucida,* talks about photographic images that affected him, that *pierced* him, and somehow provoked an unconscious response. You can assume that the photographs people talk about in this project are photographs that matter to them, that have some durable, unforgettable meaning that, ultimately, is not available to intellectual analysis. So no matter *how* much they say about

them, you can never get at what speaks to them in that picture.

It's probably like the function of the dreamwork. When you recount the dream you remember from all the dreams you have in a single night, it's a selective process. Everything you're recounting is on the level of the dream's apparent content. But what made that dream memorable, what made it matter so that it was retained the next day, has to do with levels of meaning that are typically not available to conscious interrogation. Those are the meanings that get excavated in a psychoanalytic context, where you explore association after association after association, and with much work start decoding the latent content. I think you don't *ever* exhaust a dream, but I think that in so far as you pursue a systematic and concentrated interrogation of it, you get to meanings that you never knew were there.

I was making photographs of cracks in sidewalks and close-ups of walls in 1952 when I was a sophomore in high school. I was a compulsive creator—painting, sculpting, taking photographs, and acting, thinking of it all as one thing. Someone showed me a copy of Henri Cartier-Bresson's book *The Decisive Moment*, and it changed my life and my own photography. Not that I started taking photographs like this one, but it changed my concept about photography—the idea of there being a single moment when you can capture your subject in a photograph, what Cartier-Bresson called "the decisive moment."

This is the picture in the book that I keep coming back to. The composition is what's so interesting. Look at the position of these people. The man in the center, where his arm is. The woman to his right, the way her hands are up and she's pulling on what looks like a piece of chicken. The woman who's sitting to the left of the man in the center, how her hand is up. She's obviously just taken a bite or is about to take a bite. The man pouring the wine, the way he's sitting, and the way his face is turned just enough so you see it. What is so wonderful is that all of this is just *there*. You can't really compose these elements. The fact that the shoulder of the man on the left is just barely on the edge of the frame and how he sits on the bottom of the frame. We have to remember that Cartier-Bresson doesn't crop his photographs, so the way the picture is framed is incredible.

I understand that Cartier-Bresson often would find an interesting composition, set up his camera, and wait for something to happen within the context of the composition he wanted. It wasn't that he was sneaky, but he was so cool about taking photographs that he never interfered with what was going on. He never asked people to pose. If you're an actor, people are constantly tell you to pose, "Do this. Do that. Would you move this way? Would you move that way?" When all they

have to do is fucking move *themselves* to get another angle. Why don't *they* move instead of asking me to turn and do this and do that?

For years, from 1961 to 1967, I used to carry a camera with me everywhere, but I don't now, so I don't really feel I'm a photographer. When I started to direct *Easy Rider*, I stopped taking photographs. I couldn't carry a camera, write, act, and direct. I just couldn't. I would lose the camera. So that was the end of it. Besides, using a movie camera is photographing. Even though I've stopped taking photographs, I still look for compositions out there in the world. I just turned to another area.

You see, the idea of a decisive moment has a lot to do with acting. It's straight out of Strasberg or Stanislavsky, the idea that there is a moment-to-moment reality. You don't have presupposed ideas about the next moment. You just live in the moment you're in. When I'm directing a movie, I know that when an accident happens, it can work for me. I think Jean Cocteau said, "Ninety-eight percent of all creation is accident. One percent is intellect and one percent is logic." It's all about learning how to make the accident work for you.

But this picture is different. It's not an accident. I don't know what this photograph means, but I do know that I'm looking at something that's exceptional. For Cartier-Bresson to make the effort, take that walk, go that distance to where in the next second he would be intruding in those peoples' lives is just amazing. And to express it all in a term he called "the decisive moment." That's exactly what it is.

DENNIS HOPPER's (b. 1935) acting career began at age twenty when he had a role in *Rebel Without a Cause*. He has directed many films including *Easy Rider* in 1969 and *Colors* in 1988.

Sunday on the banks of the Marne, 1938. Henri Cartier-Bresson

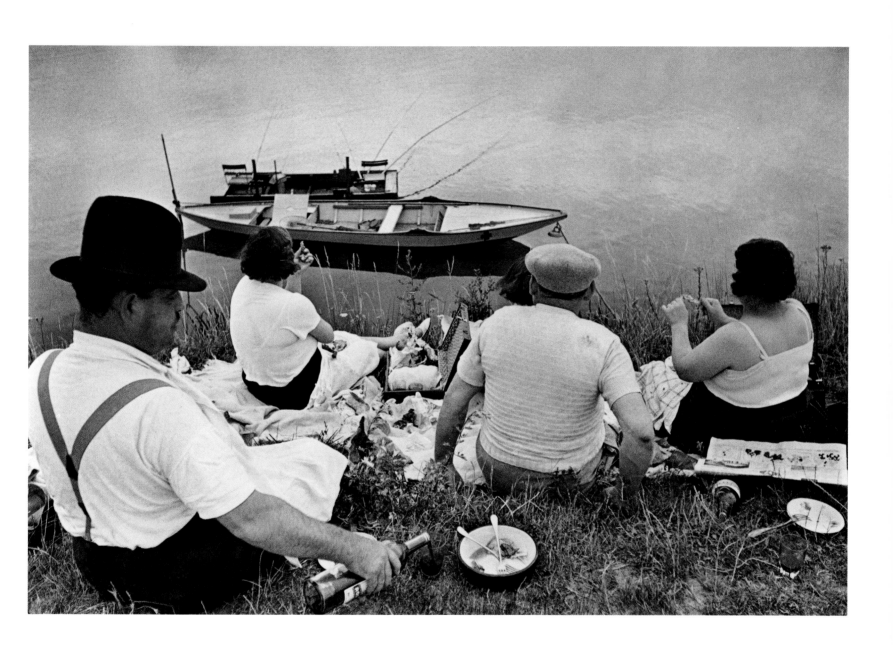

ARLENE GORDON

On May 4, 1928, my father's twin sisters had a double wedding, and I was the flower girl. I was four-and-a-half, the only child at a formal evening wedding. I remember all the fuss they made about me and how I took my assignment very, very seriously. I doled out every rose petal stingily, which made everybody laugh. I wanted to make sure I had some left by the time I got to the end of the aisle. I also remember the pain from the hat, which was made to order. I'm sure it was the beginning of my aversion to wearing hats. I still have the dress.

The picture is very representative of the 1920s. The brides in their short dresses and cloche hats. The men are wild, the short one in particular. They're very stiff in their white ties, tails, and top hats. It was the night of the wedding, and the photograph was probably taken right after the ceremony on the Astor Hotel roof. I saw the picture after the wedding, when my parents got a copy. But I really remember the picture more from my teenage and adult years, when we would look at old photographs and think about how funny everyone looked.

When I was asked to pick a single photograph for this project, it was hard to pick *one,* because *all* my memories are photographs. This one kept coming to my mind, because it's a period piece, and I guess that I look at the people in it, and remember how a picture *can* look. On the surface, everything looked so great. Then I think of all the things over the years that have happened to everyone in the picture. What each person has had to cope with, and how well they've coped or how poorly. From their individual perspectives, their lives were affected as dramatically as mine. And who's to judge? People think because I've lost my sight, it's the greatest tragedy. I know people who have lost a fingernail and to *them,* it's the greatest tragedy.

The photographs I remember are reference points for me now that I'm blind. I use my memories of photographs to remember what people looked like, what has happened. You know, people say that my grandson Eric looks like my son did at his age. So I go back to how Andrew looked at eleven. I think of Andrew and *picture* Eric. I have a picture of my daughter-in-law, and though I've never seen her, I have a strong sense of how she looks. It comes from touch and the way she presents herself. I have photographs all over my home. On the piano are the wedding pictures of my son and my nieces. I have not seen any of them, but my son describes to me, so I picture them.

I lost my vision at the end of January 1968. I was forty-four. Before I lost my sight, I was very visual. I went to the movies a lot. I looked at magazines. I remember Margaret Bourke-White's and Carl Mydens's pictures of the Sino-Japanese War, which I'm sure did as much to influence us as the TV images of Vietnam did. I remember those pictures vividly.

I continue to go to the movies. People who go with me for the first time always want to fill me in on details, and I say, "Shhhhh, keep quiet." I'd rather listen, and if I hear something's happening that's germane, something that might make a difference, I'll ask about what I can't figure out. Look, there's no question. I miss *some* things. But I'd rather pay attention to the dialogue and whatever comes through on the soundtrack and draw inferences. *You* might not pay attention to it, but I hear all the breaths, get all the locations. I've often found that sighted people miss things in the story, because they're so busy with the visual stimuli.

ARLENE GORDON (b. 1924) was associate executive director of The Lighthouse, Inc., a vision rehabilitation organization from 1973 to 1990. Previously she was a social worker at Columbia Presbyterian Medical Center. She is the coauthor of *Accounting: A Social Institution.*

Arlene Gordon at her twin aunts' double wedding, Astor Hotel, New York, 1928. Photographer unknown

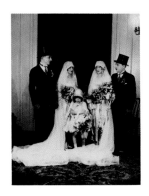

I watch television, but what do I like about it? Not very much. I'm a PBS fan, because I find the distraction of commercials terrible. I like "Masterpiece Theater," and the good coverage of news events and major stories. And now, I have descriptive video. If you have a stereo TV, there's something called secondary audio programming. On PBS, there are several shows where if I hit the SAP button, I get a description of what's on the screen over the second audio channel, in between the dialogue. And it's fabulous, absolutely fabulous. The descriptions are very neutral. No judgments. The voice is sort of sotto voce, and it only comes on during pauses. I use a lot of sophisticated technology: a computer and a scanning machine that converts print into sound. It makes a very big difference in my life. I have a talking calculator, a talking alarm clock, and a talking scale in the bathroom, all made for sighted people.

You often hear that blind people develop other senses to compensate for their loss of vision. But your senses don't become more acute unless you use them. That's why it's so important for a person who is losing vision, or has lost it, to get rehabilitation, some help in learning how to interpret. How to pay attention to the odors that come from the vegetable store or the popcorn in the theater lobby. I can practically tell you the time by the sound of the traffic. Even in the country, the birds don't usually sing in the middle of the night. When you see a blind person walking down the street with a cane, that cane is giving them information they've learned to identify. The sound of an echo from an open doorway, of passing under a canopy or an overhang, the texture of the ground. There are so many clues, but you have to learn to pay attention to them.

What I miss about not having sight is the freedom to do physical things easily, not have to think about them. I'm a great walker, and when I'm home working, if I could see, I'd love to go out for a walk. What else do I miss? The fact that I don't see my grandchild? That goes without saying. I avoid thinking in those terms. It's too painful to talk about. My son is a photographer, and although I've never seen his photographs, people tell me what they show.

I am aware of the bombardment of images that exists today. And thinking back, I can't always be sure whether I'm remembering a photograph or whether it was TV. I have such vivid images of the Kennedy inauguration, for example, which I did see. I remember Jackie with her muff and boots and the snow. And I think, "Well, was that a photograph or was that on TV?" But the photographs of Jackie at the side of the coffin and John John saluting, there's no way you can ever forget. I have my own images of man walking on the moon and the space shots. They give such wonderful descriptions that if you read, and if you've seen before, you can visualize an event.

I don't *try* to make up images for the every person I meet. When I meet a new person, I pay attention to what he says and how he projects himself. There's no reason for me to invest energy in constructing an image. I don't take a first reading based on appearances. I pay attention to content. Shortly after I lost my sight, I participated in a seminar. About a year later, I saw the woman who ran it and said, "How come we never got drafts of the lectures? Particularly Dr. so-and-so's paper?" And she said, "You thought *that* was a good paper?" And I said, "It was marvelous, so ahead of its time. I've been waiting for it." And she said, "That's interesting. Everybody else was turned off, because he showed up for the seminar in shirt sleeves and an open collar. They said his paper was awful." Well, the paper *was* radical, but it was never produced because of what he *looked* like. So you see, all of us have our own images of the way things are.

ACKNOWLEDGMENTS

Talking Pictures is a project that depended on the generosity, understanding, and cooperation of countless people. Without their help we would never have been able to get to the people we were interested in interviewing. Each person interviewed spent valuable time with us, answering our questions and probing the meaning of their picture choice. The photographers whose pictures appear in the book were generous in letting us reproduce their work. We thank them all.

Our colleagues at photographers' studios and in archives and picture agencies helped smooth the way. They include: Janice Ackerman, Index Stock Photography, New York; *Art & Antiques,* New York; Woody Camp, Woodfin Camp and Associates, New York; Jocelyn Clapp, The Bettmann Archive, New York; Doris Fong, *Life* Picture Sales, Time-Warner, Inc., New York; Robert Gurbo, André Kertész, Inc., New York; Tom Grischkowsky, Museum of Modern Art, New York; Ron Mandelbaum, Photofest, Inc., New York; Genya Markon, The United States Holocaust Memorial Museum, Washington, D.C.; Jennifer Miller, Magnum Photos, Inc., New York; Barbara Millstein, Brooklyn Museum, New York; Diane Nielson, Center for Creative Photography, Tucson, Arizona; Jeff Ourvan, Soka University, Calabasas, California; Elizabeth Partridge, Imogen Cunningham Trust, Berkeley, California; Neal Peters, New York; Gerd Sander, August Sander Archives, Cologne; Aaron Schindler and Jeffrey Smith, Contact Press Images, New York; and Nina Schoenbaum, Black Star, New York.

Friends and colleagues helped on every front. They include: Yoni Akiyama, Michael Almereyda, Kay Anderson, Susan Bergholz, Robyn Bonderand, Irene Borger, Rich Brennen, Anne Buford, Margaret van Buskirk, Francesca Calderone-Steichen, Sarah Caplan, Bennett Carlson, Arlene Caruso, Katherine Chapin, Alix Colow, Alex Constantinople, Judith Crane, Jade DeRu, Henry Edwards, Virginia Edwards, Ramiro Fernandez, Valarie Foster, Niel Frankel, Gerhard Frenzel, Jane Friedman, Peter Galassi, Bronya and Andy Galef, Jamie Gangel, Philip Gefter, Linda Gottlieb, John Gould, Parry Grogan, Alvin Hall, Jayne Halsman, Yvonne Halsman, Steve Harris, Ted Hartwell, Mary Haus, Todd Howe, Deborah Irmas, Yusef Jackson, Katherine Jeffers, Susan Jonas, Diane Keaton, Joe Kelly, Phyllis Kind, Susan Kismaric, Sylvia Kleinman, John Ladley, Charles Lahti, Julie Leach, Elaine Lord, Mary McGinnis, Susan Magrino, Leslie Mann, Eric Marano, Pacy Markman, Elizabeth Mastroieni, Dorothy Melvin, Pierre Menard, Joanne Merlin, Lisa Miller, Jim Moore, Gale Murray, Barbara Nagelsmith, David Newhall, Roberta Olden, Myra Outlaw, Robert Peacock, Gilles Peress, Lisa Phillips, John Podracki, Patricia and George Rosato, Sam Rudy, Carlos Sandoval, Nina Santisi, Lauren Shakely, Hedda Sharapan, Carmen Silva, Michel Slubicki, Linda Smith, Ray Smith, Elaine Steele, Dr. Cynthia Stuen, Nancy Sturdee, Sunny Taylor, Gail Towey, Alice Trillin, JoAnne Verberg, Ed Walloga at Greater Talent Network, Inc., Paul Wilmot, Lawrence Wolfson, and Beckie Wriggle.

At Chronicle Books we would like to thank Caroline Herter for her enthusiasm for this project and her continuing support and appreciation of our work, and Annie Barrows, our intelligent and sensitive editor, who worked with us to shape the book.

Our gratitude to Karen Brosius, Marilynn Donini, and Stephanie French at Philip Morris Companies Inc. who understood how *Talking Pictures* needed to reach a wide public. Without their support the project would never have realized its potential.

The exhibition would not have been possible without the intelligence of Charles Stainback, the help of Phil Block, Ann Doherty, Art Presson, and Steve Rooney, and the additional support of Cornell Capa, Lisa Dirks, Willis Hartshorn, and David Zaza of the International Center of Photography.

CREDITS

Endsheets: Amy Wood, Metuchen, New Jersey; 12: Linda Solomon, Birmingham, Michigan, courtesy Norman Lear; 13: Magnum Photos, Inc., New York; 15: Diana Lynn Ossana, courtesy Simon & Schuster, New York; 17: Frank Powolny, Collection of Larry McMurtry; 18: © 1993 Stephanie Chernikowski, courtesy Julie Galant, New York; 19: Yvonne Halsman, New York; 20: Laura Deyarmin, Los Angeles, courtesy Gina Greco; 21: Retna Ltd., New York; 23, 25: 3M, St. Paul, Minnesota; 26: Marvin Heiferman, New York; 27: Wilma Wilcox, New York, 30: Armando Valero; 31: Contact Press Images, Inc., New York; 33: Alice Springs, courtesy Bruce Weber, New York; 35: © 1978 Imogen Cunningham Trust, Berkeley, California; 36: Charles William Bush, Los Angeles, courtesy Joan Rivers, New York; 37: American Legends, Seattle; 38: Graves and Associates, Princeton, New Jersey; 39: Lorenzo Appolonia, Fotoscientificadi Broia e Finzi, Parma; 41: Ruben Guzman, San Francisco, courtesy Sandra Cisneros; 43: Mary Jessie Garza, San Antonio; 45: Diana Mara Henry, New York, courtesy William Kunstler; 46–47: *Life* magazine, © Time-Warner, New York; 50: Darren Keith, New York, courtesy Radu Teodorescu; 51: Palomar Pictures International, courtesy Photofest, Inc., New York; 54: Collection of Irene Borger, Los Angeles; 55: The Estate of André Kertész, New York; 57: Eric Boman, courtesy Tiffany & Co., New York; 59: Collection of John Loring, New York; 60: David Teller, Alameda, California, courtesy Benjamin Spock, M.D.; 61: Wide World Photos, New York; 64: Eric Boman, courtesy Condé Nast Publications, Inc., New York; 64–65: Peter Lindbergh, Paris, courtesy Condé Nast Publications, Inc., New York; 68: Peter Cutte, courtesy Unistar Radio Networks, New York; 69: *Life* magazine, © Time-Warner, New York; 72: Danny Bennett, New York, courtesy Tony Bennett; 73: *Life* magazine, © Time-Warner, New York; 74: Ed Watkins, courtesy Stanley B. Burns, M.D., New York; 75: The Stanley B. Burns, M.D., Collection, New York; 78: Thomas L. Kelly, courtesy The Body Shop International, West Sussex, England; 78–79: Black Star, New York; 82: Kurt Leece, Saginaw News, Saginaw, Michigan; 83: Linwood Albarado, New Orleans, courtesy Coleen Salley; 84: LuAn Lorenson, New York, cour-

tesy Lucille Burrascano; 85: Black Star, New York, courtesy Center for Creative Photography; 88: David Crommie, San Francisco, courtesy Charles Schulz; 89: courtesy Charles Schulz, Santa Rosa, California; 90: Department of the Army, Washington, D.C.; 91: Brian Lanker, Eugene, Oregon; 93: © 1991 Chiat-Day, Inc., New York; 95: David Levinthal, New York; 96: James Hamilton, New York; 97: Museum of Modern Art, New York; 99: John Marchetti, Minneapolis, Minnesota, courtesy Robert D. Gehrz; 101: courtesy McGraw-Hill, Inc., New York; 102: Walter Andersen, Monterey, Massachusetts, courtesy Alice O. Howell; 103: Basilus Presse, AG, Basel, courtesy Alice O. Howell; 104: Alan David, courtesy Robert Peacock, New York; 105: courtesy John Denton, Hiawassec, Georgia; 106: Jean–Pierre Bonin, New York, courtesy Duane Michals; 107: Collection of Duane Michals, New York; 109: Michel Comte, Los Angeles, courtesy Diane Keaton; 111: courtesy Diane Keaton, Los Angeles; 112, 113: courtesy John Baldessari, Santa Monica; 115: Walt Seng, Pittsburgh, Pennsylvania, courtesy Family Communications, Inc., Pittsburgh; 117: Collection of Fred Rogers, Pittsburgh, Pennsylvania; 118: Ellen K. De Forest, Hartsdale, New York, courtesy Peter R. De Forest; 119: © 1949, L.L. Tillery, courtesy Peter R. De Forest, Hartsdale, New York; 120: Lynda Rodolitz, New York; 121: Robert S. Halvey, Philadelphia, courtesy Bobby Cunningham; 124: Michael Geissniger, courtesy National Public Radio, Washington, D.C.; 125: courtesy Nina Totenberg, Washington, D.C.; 126: Ray Charles White, New York; 127: Brooklyn Museum, gift of the estate of Wallace B. Putnam; 129: Karsh, Ottawa, courtesy Harold Prince; 130–31: State Museum of Auschwitz, Oswiecim, Poland, courtesy of U.S. Holocaust Memorial Museum, Washington, D.C.; 132: John Engstead, courtesy Ginger Rogers, Palm Springs, California; 133: Wide World Photos, New York; 134: David Seidner, courtesy Robert Miller Gallery, New York; 135: Bernard Plossu, Paris; 136–37: Mary Ellen Mark, New York; 138: Don Pollard, New York; 139: Governor Mario Cuomo, Albany, New York; 141: Miller Photography, New Hyde Park, New York, courtesy 1199 News, New York; 143: courtesy 1199 News, New York; 144: Steven Meisel, New York; 145: Bryan Hammond, Essex, England; 146: Benetton/Colors, New York, courtesy Oliviero Toscani; 147: ARS, New York, VG Bild-Kunst, Bonn; 149: Albert Watson, New York; 151: Columbia Pictures, Collection of Neal Peters, New York; 152: Lynda Rodolitz, New York; 153: courtesy Aida Rivera, Bedford Hills, New York; 156: John Dominis, New York; 157: John Dominis, Index Stock Photography, New York; 158: Marilynne Herbert, Katonah, New York; 159: Collection of Ilka Peck, New Rochelle, New York; 160–61: Bill Graham, courtesy National Enquirer, Lantana, Florida; 161: © 1993 National Enquirer, Lantana, Florida; 164: Bill Pierce, New York; 164–65: Wide World Photos, New York; 169: Albane Navizet, Random House, Inc., New York; 170–71: Reuters/The Bettmann Archive, New York; 172: Lance Hill, Minneapolis, courtesy June Hill; 173: Jay Stock, Marlens Ferry, Ohio; 174: D. Michael Cheers, Washington, D.C., courtesy The Rainbow Coalition; 174–75: Black Star, New York; 178: George Hurrell, courtesy David Byrne, New York; 179: Collection of Ford Wheeler, New York; 181: David McReynolds, New York, courtesy Phyllis Gangel-Jacob; 183: Collection of Phyllis Gangel-Jacob, New York; 185: Lee Dillon, Brooklyn, New York; 186–87: Castle Hill

Productions, New York; 190: John Raoux, Orlando, Florida, courtesy Larry King; 191: Jerry Wachter, Collection of Larry King, Washington, D.C.; 193: Douglas Keeve, New York; 195: © 1950-renewed 1978, Condé Nast Publications, Inc., New York, courtesy Irving Penn, New York; 196: Christopher Glenn, courtesy Allsport, Santa Monica; 197: Tony Duffy, courtesy Allsport, Santa Monica; 198: Reuters/The Bettmann Archive, New York; 199: Yasunori Ushida, courtesy Soka University, Calabasas, California; 200: Stewart Ferebee, courtesy Martha Stewart, Westport, Connecticut; 201: courtesy Martha Stewart, Westport, Connecticut; 203: Kathleen Frank, Miss America Organization, Atlantic City, New Jersey; 205: Mark Thiessen, The Names Project, San Francisco; 206: Mark Czajkowski, Princeton, New Jersey, courtesy Francesca Calderone-Steichen; 207: courtesy Steichen Family Collection, Pennington, New Jersey; 210: Elena Seibert, New York; 211: Life magazine, © Time-Warner, New York; 212: Teresa Espana, Santa Barbara, California; 213: Whitney Museum of American Art, New York, and Center for Creative Photography, Tucson, Arizona; 216: Norman Seeff, Los Angeles, courtesy Dennis Hopper; 217: Magnum Photos, New York; 218: Andrew Gordon, New York; 219: courtesy Arlene Gordon, New York.

Staff for *Talking Pictures*

Copyeditor: Jane D. Marsching
Researchers: Lynda Rodolitz, Lely Constantinople, Tori Winn, Aileen Tse, Meg Smith, Amy Wood, Deborah Fleig, Ceridwen Morris, and Laura Herbert
Designer: Lawrence Wolfson Design, New York
Additional Photographers: Niel Frankel